To Phil - Christmas 1982.
 Our Love
 Mom & Dad

To Phil - Christmas 1982.
 Our Love
 Mom & Dad

NATURE
PHOTOGRAPHY

PHalarope Books

PHalarope Books are designed specifically for the amateur naturalist. These volumes represent excellence in natural history publishing. Each book in the PHalarope series is based on a nature course or program at the college or adult education level or is sponsored by a museum or nature center. Each PHalarope Book reflects the author's teaching ability as well as writing ability.

The Art & Design Series

For beginners, students, and working professionals in both fine and commercial arts, these books offer practical how-to introductions to a variety of areas in contemporary art and design. Each illustrated volume is written by a working artist, a specialist in his or her field, and each concentrates on an individual area—from advertising layout or printmaking to interior design, painting, and cartooning, among others. Each contains information that artists will find useful in the studio, in the classroom, and in the marketplace.

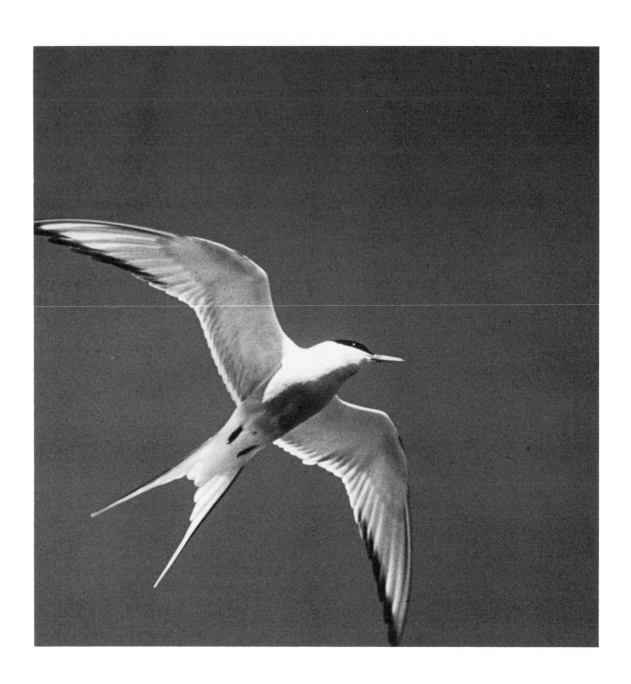

STAN OSOLINSKI

NATURE PHOTOGRAPHY

A guide to better outdoor pictures

A SPECTRUM BOOK PRENTICE-HALL, INC., Englewood Cliffs, New Jersey 07632

Library of Congress Cataloging in Publication Data

Osolinski, Stan.
 Nature photography.

 (PHalarope Books) (The Art & design series)
(A Spectrum Book)
 Bibliography: p.
 Includes index.
 1. Nature photography. I. Title. II. Series:
Art & design series.
TR721.O85 778.9'3 81-5161
 AACR2

ISBN 0-13-610428-2

ISBN 0-13-610410-X {PBK.}

This Spectrum Book can be made available to businesses
and organizations at a special discount when ordered
in large quantities. For more information, contact:
Prentice-Hall, Inc.; General Book Marketing;
Special Sales Division; Englewood Cliffs, New Jersey 07632

THE ART & DESIGN SERIES.

COVER: *Photograph by the author (100–200mm
macro zoom lens; four electronic flashes on
manual mode of operation; exposure calculated
for strobe-to-subject distance).*

10 9 8 7 6 5 4 3 2 1

Editorial/production supervision by Eric Newman
Page layout by Marie Alexander
Color insert designed by Christine Gehring Wolf
Manufacturing buyer: Cathie Lenard

PRENTICE-HALL INTERNATIONAL, INC., *London*
PRENTICE-HALL OF AUSTRALIA PTY. LIMITED, *Sydney*
PRENTICE-HALL OF CANADA, LTD., *Toronto*
PRENTICE-HALL OF INDIA PRIVATE LIMITED, *New Delhi*
PRENTICE-HALL OF JAPAN, INC., *Tokyo*
PRENTICE-HALL OF SOUTHEAST ASIA PTE. LTD., *Singapore*
WHITEHALL BOOKS LIMITED, *Wellington, New Zealand*

To Ron Martin, for his trust, for my freedom, and mostly for his "discovery" of me;

and to Otis Sprow, for helping to restore fresh vision to weary eyes.

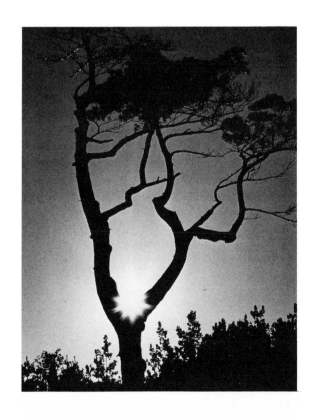

Contents

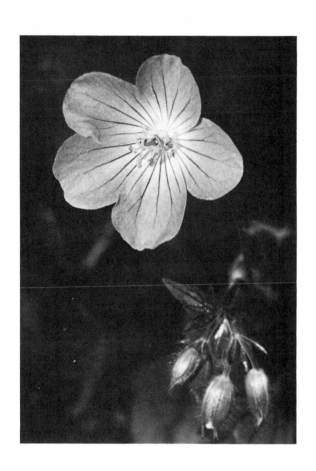

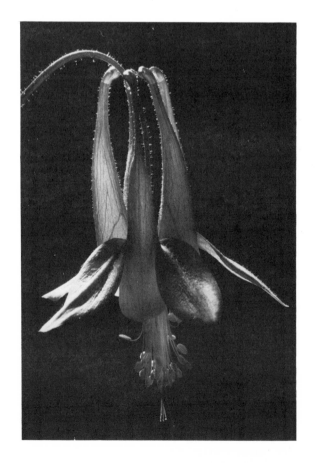

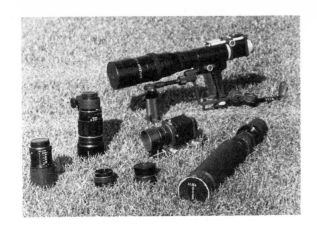

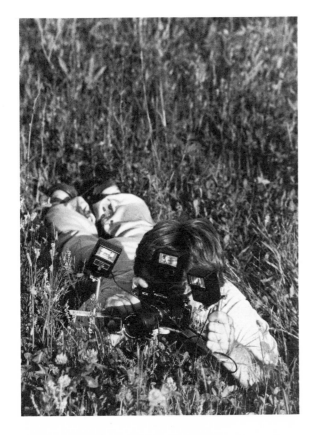

CHAPTER SIX

*Developing composition
and control* *96*

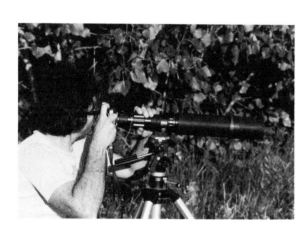

CHAPTER SEVEN

In the field *114*

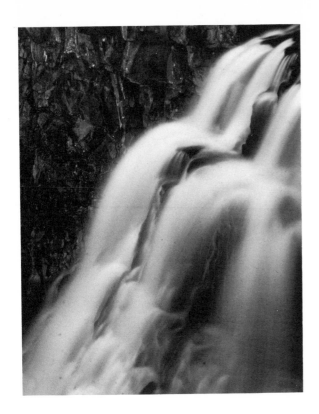

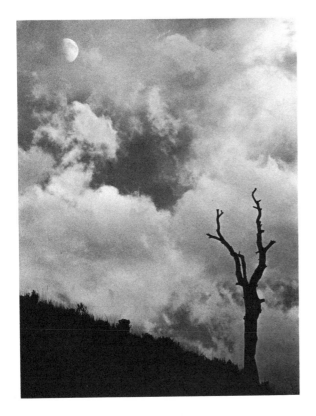

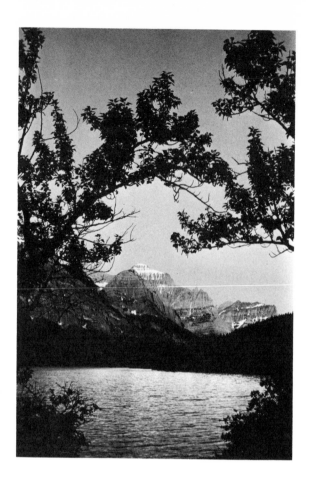

Preface

You may not be a professional photographer. You may teach accounting, or perhaps you weld pipes. You may design bridges, take care of babies, or sell real estate. But, whatever the case may be, if you have purchased this book, I must assume that you also share an admirable enthusiasm for the hobby of photography along with an abiding interest in the world of nature. Perhaps you even dream of developing your hobby into a vocation or a career.

In this book, I would like to explore some of the ways in which I believe it is possible to make that photographer in you a more sensitive natural-ist and that naturalist in you a more capable photographer. No pretense is made to claim that this book represents an exhaustive encyclopaedia of photography. Rather, I have tried to present a practical volume on nature photography that is aimed essentially at that fast-growing army of outdoor photographers who find pleasure and pictures in a world devoid of skyscrapers and condominiums and shopping centers. The techniques and information set forth here attempt to be a valuable aid in the only classroom that really counts—the classroom of the field.

You do not wish to be bogged down in a

maze of scientific formulae concerning unknown chemistries and optical aberrations. No, you just want better pictures. Neither do you feel any burning passion to memorize the Latin name of every butterfly and mushroom you encounter. No, you just love to tromp in the woods, inhaling the scent of fresh pine and listening to the chatter of birds and squirrels. But it is equally true that you'd never even consider taking that hike without your camera in hand; you probably pack a gadget bag with an accessory lens or two plus an electronic flash and a filter stack. You've even been known to lug a tripod on those special days when your bio-rhythms are up.

Unfortunately, more often than not, your photos of your outdoor adventures provide a never-ending source of frustration and disappointment. For every success, you find yourself garnering somewhere between nine and four thousand failures:

> "Why is so much of that flower out of focus?"
>
> "Those ducks didn't look like that through the camera."
>
> "I used a telephoto; why is that chipmunk so small?"

Do these sound familiar? What can you do to eliminate these and similar puzzling failures? For now, read on; afterwards, go out and shoot; then, shoot again; and finally, shoot some more. Throughout it all, may you enjoy yourself, your camera, and your corner of the world of nature.

Acknowledgments

Whenever one goes to say thank you, there is always the possibility of forgetting or omitting someone whom you do not wish to neglect. Therefore, to cover that contingency, right here and now I would like to thank *all* of those along the way who have in some manner contributed to, or made possible, whatever success I have achieved. Beyond that, I would like to thank in a special way the following:

My brother, Karl, for introducing me to and initiating me in what once seemed the arcane, labyrinthine ways of the 35mm camera;

John MacFarlane, for a skillet of hot dogs and for his appreciation of my photography that years ago somehow launched this whole business;

Mary Kennan, editor of Spectrum Books, for her faith in my abilities, for her patience with my eccentricities, for her assistance in the preparation and refinement of this manuscript;

Otis Sprow, for the contribution of his technical expertise, for the many hours spent in a darkroom printing most of the photographs for this volume, for the camaraderie shared along the frosty trails of dawn, and mostly for the laughter of "dead weeds" and rocky pears;

"Clear Mountain" and "GP" . . . just for "being there";

Mother Nature, for the plants and animals and landscapes that I have been privileged to enjoy; for the world of peace, beauty, and joy that permits me to live an incredible lifestyle that I would trade for no other.

Thank you all!

NATURE
PHOTOGRAPHY

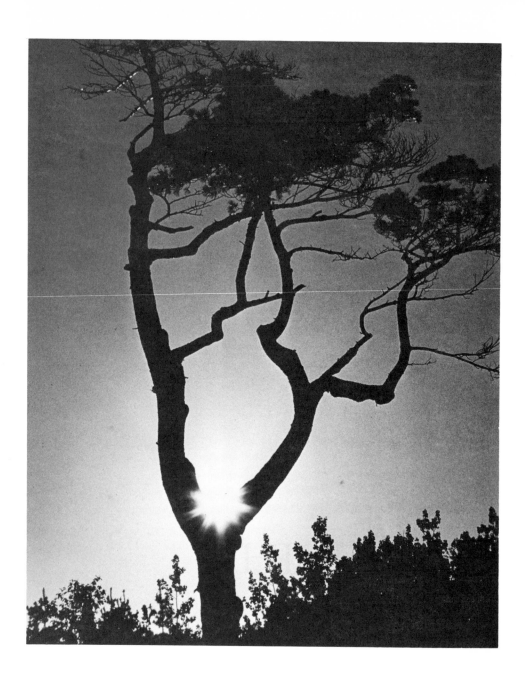

WOULD YOU AUTOMATICALLY CONSIDER someone a baseball player who knows the names, batting averages, and fielding percentages of every major leaguer? No? By that same barometer then neither should you label as *photographer* someone who knows all the laws of light, all the equations governing depth-of-field, and every characteristic of the latest cameras. The person described in our first example *could* be a baseball player, but might just as easily be an umpire or, more likely, an avid fan. Just as an athlete is measured by performance on the field and not by statistics in the head, so a photographer is determined not by knowledge *per se*, but rather by

deeds on film, by photographs. I think that this is an important distinction, especially in an age such as ours that pays so much homage to technology. Although I like to consider myself an outspoken advocate of the scientific method, I am not a great believer in the power of technical knowledge to change feelings and emotions, two powerful considerations in photography.

A Philosophy

I would like to think that this book is as much a volume on *philosophy* as it is on photography, a

CHAPTER ONE

Getting started

treatise concerned with *attitudes* as much as it is with techniques. Perhaps this inclination derives from my own personal experience. Although I make my living at photography, I am acquainted with many others who know far more than I do and yet they have never had so much as a single image published or exhibited. I mention this not to belittle knowledge nor to diminish the importance of technical competence in photography but rather to emphasize the point that each person need acquire only that technical information that is essential to succeed in a chosen area of endeavor. In addition, although knowledge may provide the data necessary to yield correct exposure or proper depth-of-field, it does not produce the "eye" that will "see" a well-composed or strikingly lit subject.

People commonly ask me what camera they should purchase, where the light meter is on a model ABC–123, or how many lines per millimeter their new Super Snoop telephoto resolves. Stated simply, I do not know; but neither do I feel incompetent nor ignorant. I am not a camera salesman. The questions posed have no point of reference to my portion of the world of photography. There is no need to know the answers to irrelevant matters. But if these same questioners were to ask me where to find a killdeer's nest or

why I chose a Novoflex 400mm lens over all others, I would be able to competently resolve their lack of knowledge because those questions do pertain to my photographic world.

I also raise the question of knowledge for yet another reason. I believe photography to be the stimulating marriage of science and art, the wedding that indissolubly unites aesthetics with mechanics. One of the two nicest compliments ever heard about this photographer's work came from a viewer who remarked to a mutal friend, "He sees with his heart, not with his eyes." For me, that is the excitement of nature photography—to combine science and art to touch not only the physical eye, but also the eye of heart and mind. Obviously the most aesthetic image in the world is perfectly useless if it is six stops underexposed; but the technically perfect image without mood or feeling can also be no more than the result of some chemical reactions. At the heart of my photographic philosophy lies the belief that inside every photographer there is a feeling or a thought that is yearning to be exposed on the film. At the moment the photographer releases the camera's shutter, that feeling or thought leaps from inside the human and onto the film. The success or failure of the image depends on how well that translation has been achieved.

Using This Book

Basically, then, this book can be viewed as an attempt to help you better achieve that transferral, that emigration from human mind to camera body. I have tried to create a very personal account. In many ways I have attempted to write an almost conversational text, as if you and I had happened to sit down and started to talk about my experiences in, and your questions about, nature photography.

For the most part, I consider this a handbook of techniques designed to improve essentially those skills associated with 35mm color transparency photography. Much of what we shall share, though, such as composition, I think, is valid for all forms of photography, from pocket cameras to view cameras; other concepts, such as exposure control, for example, will not apply to negative film in the same way as to positive film. Furthermore, you must take into account some of the problems inherent in a book designed for the purpose of introducing you to a world of color but doing so with mostly black-and-white images. Finally, concepts that have been broken down or separated for purposes of discussion and analysis in reality are not so readily distinguished or divorced from their interrelated ideas. For that rea-

Figures 1.1A, B, and C
The importance of technical perfection in photography is emphasized by these three photos of a burrowing owl—the first badly underexposed, the second correctly exposed, and the third grievously overexposed.

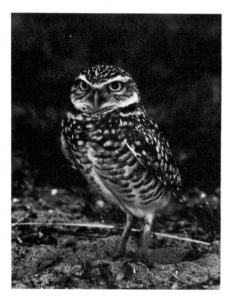 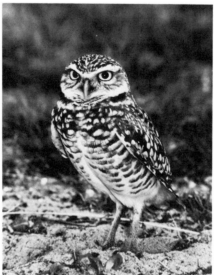 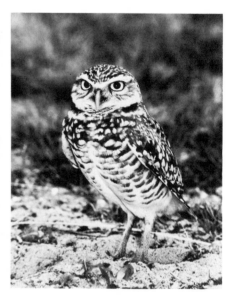

son, some considerations will show up in more than one area of the book, *e.g.,* how can depth-of-field be separated from macro photography, or how can a discussion on wildlife photography be totally devoid of any mention of telephoto lenses? My hope is that each time an old theme reappears, it will do so in a fresh guise and be considered from a slightly different point of view. In the process, it may serve to refresh your memory and act as a review of a meaningful concept.

THE LIGHT WRITERS

Many of you may already be aware of the fact that the word *photography* is derived from the two Greek terms that, when combined, mean to "write with light." If you have invested in this volume, I am going to assume that you are already a *light writer* of some degree and that you would like to develop your present abilities to a higher level. I shall further assume that you presently own a camera of some sort, preferably a 35mm single lens reflex (SLR) camera, and that you are familiar with the basic vocabulary of photography. It is probably reasonable to predict that you use your camera to record the meaningful events in your life, including the way in which you perceive and experience a natural environment. If indeed your interest is to become a more accomplished "light writer," to produce better "light written" poems and essays, histories and novels, that skill will demand that you be more effective in the use of your writing tool (the camera) and its medium (light).

Since light is the more mysterious and the less understood of the two, let us temporarily abandon the physics of light to its puzzling photons and frequencies. Later we shall try to investigate some of the practical aspects of this form of energy that makes photography possible. But for now, let us consider the modern tool that has marvelously harnessed the powers of light with the glass of the lens and the silver of film.

Operating Your Camera

Learning to operate your camera skillfully requires that you become totally familiar with your machine and its adjustable mechanisms. Can you automatically locate the shutter release button

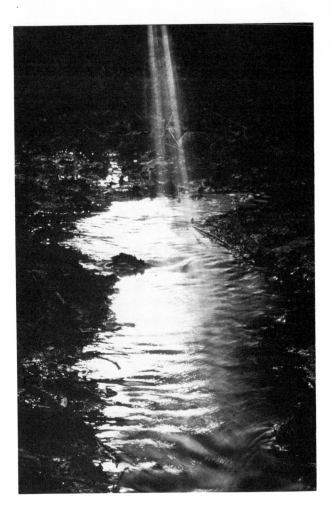

Figure 1.2
The shaft of sunlight transmitted through the lens and onto the film graphically illustrates that the word *photography* means "to write with light."

without looking? Do you know whether your shutter speed dial gives faster speeds by clockwise or counter-clockwise rotation? Can you trust the light meter in your camera body to give correct exposures simply by your centering the needle, or must you underexpose under certain conditions? Rote memorization of the answers to these and other basic questions can reduce the time necessary to capture a fleeting natural moment that you might otherwise miss. This knowledge will also prevent mechanical errors from interfering with your aesthetic intentions and achievements.

Forming an integral unit with your camera body is the lens or, in the case of 35mm SLRs, a wide array of easily interchangeable lenses. One of the major reasons that the 35mm camera has so thoroughly revolutionized and today dominates so much of the world of photography is this unmatched versatility of exceptional optics. On the lens, two rings demand your attention. First, let's center on the focusing ring. Can you focus your lenses quickly and accurately? Do you see when

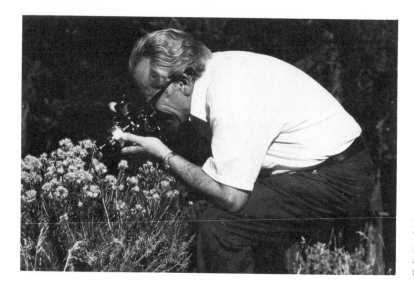

Figure 1.3
The nature photographer at work in the field must be so in touch with camera and lens that operator and machine function as a single cohesive unit.

Figure 1.4
So vast is the assortment of lenses available for today's 35mm systems that the nature photographer can easily carry into the field wide-angles, zooms, macros, and even high-power telephotos.

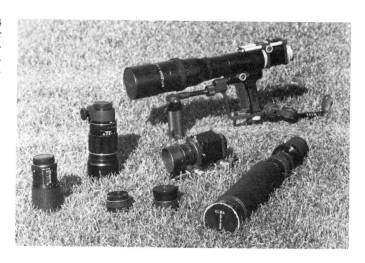

your image is sharp? "Of course," you say. But how many times have I seen beginning photographers hesitantly focus, refocus, and then finally "trifocus" themselves right out of a picture as their animal scampers into the woods or their sun is buried behind massive clouds. As soon as the image appears sharp on the focusing screen, shoot it! If you find that you are having regular problems with focusing, you might seriously consider replacing the screen presently in your camera with another type more suited to your vision. I personally have great difficulty focusing with a split-image screen, so I always order my camera bodies with a microprism focusing screen. Other options are also available; ideally they should be discussed, viewed, and resolved *before* and not after you've bought your camera. In critical focusing situations it will again help if you know whether

your lens rotates to infinity clockwise or counterclockwise. If you're trying to keep up with a subject moving closer to you and you turn the lens barrel even momentarily in the wrong direction, you lose precious seconds that may cost you an even more precious image. Many of nature's most exciting moments can flourish and perish right before your eyes while you fumble with a focusing ring; therefore you must manipulate your focusing mount quickly and accurately.

Secondly, we consider the diaphragm ring. Are you aware of the largest and smallest effective apertures of each lens so that you can utilize the fastest possible shutter speed or obtain maximum depth-of-field as each individual situation demands? Some lenses have click stops on their diaphragms to mark both the full and half *f*-stops. Without looking, do you know how many clicks

from wide open to $f/4$? to $f/11$? to the half stops? Of course, many of today's most sophisticated cameras perform all of these mathematics for you electronically; still more eliminate the mental gymnastics by displaying these numbers for you in the viewfinder. But, as the camera does more and more for you, it is less and less in your understanding and, most importantly, less in your control. For this reason alone (to be discussed in Chapter Four), I would never want any camera over which I could not maintain total functional control. I want to be able to decide what effects *I* want to achieve; I do not want my camera dictating that information to me.

PORTRAIT OF A NATURE PHOTOGRAPHER

As you grow more and more proficient in the use of your camera, I think that you will find yourself more and more frequently capturing on film those elusive moments (see Figure 1.5) that bring great joy to your heart long after the hike in the woods lingers in your emotions only as a pleasant memory.

Nature—Your Subject

I personally feel that there is no subject that offers a broader range of material for the camera buff than the world of nature. I consider this entire spectrum of natural phenomena to be legitimate game for my camera; I hope that you will too. Because of this attitude, nature photographers can be expected to search out everything from a western diamondback rattlesnake crawling across Texas sagebrush to an Arctic tern soaring above the choppy waters of the Atlantic. They might be as likely to point their cameras in the direction of the comical countenance of a green frog as they would to aim them at the handsome profile of a sleek pronghorn antelope.

Personally, I'm a nature photographer who uses color film as a primary medium. Because of this decision I will seek out color that is as flagrantly obvious as the flaming tints that paint the maples each fall or color as delicately subtle as the pastel hues of a rain-moistened camellia blossom on a cloudy, overcast day. I will chase color that is as ephemeral and unpredictable as that moment at dawn when the rising sun may set the eastern horizon dancing to its morning matins, or I will pursue color that is as cyclic and absolutely certain to return as the shades that adorn the spring wildflowers each April.

Figure 1.5
The confident nature photographer must be prepared to endure certain basic indignities, to accept failure, to recognize that not every frame can be as brilliantly executed as my now-legendary photograph of the rare "headless" heron.

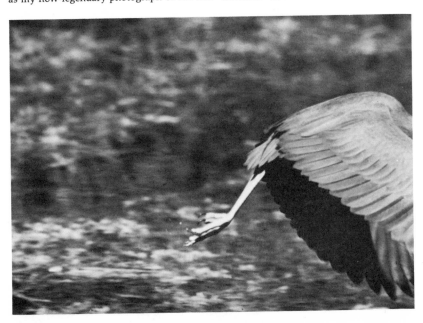

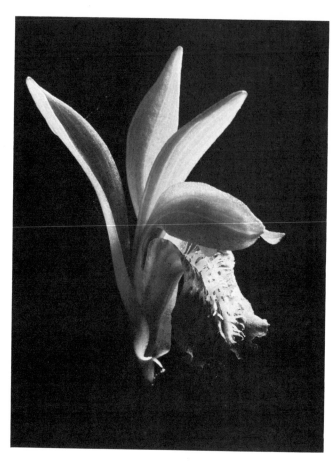

Figures 1.6A, B, C, and D
The boundless variety of subject matter available in nature is merely hinted at in these four photographs, which illustrate plant and macro, animal and scenic possibilities.

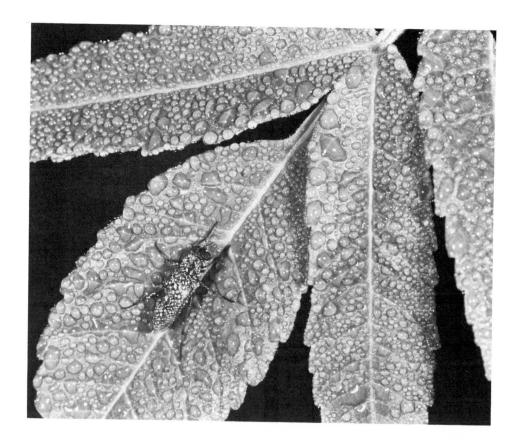

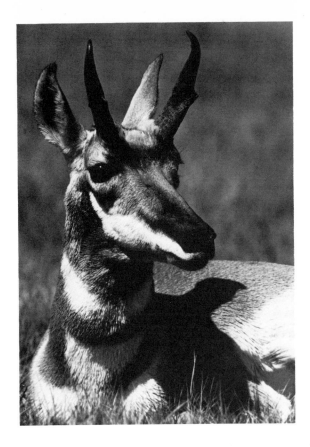

Your Equipment

For me, photography is my profession; for the majority of you reading this, it may not be. And yet, all quality nature photographers share some common characteristics. Have you ever noticed the scratches and dings on a serious nature photographer's equipment? On the other hand, have you noticed that the camera of many a beginner looks as if it could still return to the showroom from which it came two years ago? To the dedicated nature photographer, equipment is a tool, a means to an end; to many novices, however, the camera is treated as a collector's item, a showpiece to be kept in mint condition. No one sets out into the field with the consciously avowed intention of deliberately abusing equipment. Even so, in my case, my cameras are scratched from numerous encounters with branches, they are dented from more than one crash into a boulder, and their once-shiny finishes are chipped and worn thin from constant use. But you will not find so much as a single microscopic mark on the surface of any one of my lenses; there is no dust on my camera body's film pressure plate; there are no scratches or fingerprints on the camera's mirror. In short, the unimportant, cosmetic appearances of a camera may suffer regularly; the functional, working parts never do.

The serious nature photographer's cameras are always on hand, ready for the unexpected moment. The newcomer's camera is too often neatly packed away in a suitcase, awaiting arrival at a predetermined destination where blue skies will magically prevail as they do in the brochure advertising the chosen paradise. The involved photographer has an uncanny anticipation, a real feel for the subject. This photographer is on the spot, whether it be in nature photography or news photography, long before most hobbyists realize there is a spot. Further, the nature photographer who thinks like a professional uses a tripod and is not afraid to set its legs into sand or water. And, a devoted nature photographer is not interested in turning people's heads with fancy equipment. A pro carries along not the latest fashionable paraphernalia but only what is needed to complete the assignment. Of course, there are numerous other differences, but I think the point is well taken.

Nature Photography:
A Profession

Someone noted once that many are called but few are chosen. Nowhere is that statement truer than in the profession of nature photography. When one compares the number of those who make their living in this specialized field with the numbers of all those others who own cameras and take nature pictures as an avocation, one sees that the percentage is a minuscule fraction of those involved. Realistically, the odds of anyone's making a living this way are quite small. Expenses for equipment, materials, and travel mount quickly; the period of apprenticeship can painfully drag on for long years; stiff competition vies for a limited market. Such dissuading words are not set down to discourage your efforts, but rather to reflect the reality of nature photography as a profession. I know; I speak from years of experience with near starvation-level wages.

Should you begin to receive occasional money from slide-show presentations or from print sales at a local art fair, do not be falsely lured on by unrealistic expectations. Should you seriously pursue the career of a professional nature photographer, I would suggest, with few exceptions, that you postpone your occupational shift from the security of a regular paycheck until the income derived from your newly found lifestyle justifies the transfer. Otherwise, I would encourage you to enjoy your nature photography as a hobby, an avocation. If incoming moneys can partly defray the cost of your film, equipment, and travel, consider it all a plus.

Perhaps you could further consider the promising beginnings offered by the philosophy of being the big fish in the little sea. Within the structure of your own social, ethnic, or cultural community, you may very likely rate as the number-one nature photographer, the one whose pictures are sought. Use your pictures within this context to build your reputation—a slide show for a PTA meeting, a print exhibit at a local library, or an adult-education class at a center for lifelong learning.

To accomplish this, recognize that you live within a variety of frameworks in which your photographs can serve an assortment of purposes. Some of your pictures may serve historical functions, such as illustrating the impact of man upon a natural area near you before and after an encroachment. Others may be used for purposes of comparison, such as showing the distinct size differences between the ears of a cottontail rabbit of the east and a black-tailed jackrabbit of western sagebrush. You might use a scenic series to compare the shifting panorama of the four seasons at a favored pond in northern climates.

Some of your images might be employed in education. You may use a pair of them to teach a third-grade science class the differences between a male and female wood duck; an especially prized shot could demonstrate how a heron uncoils its neck when attempting to spear a fish.

Still other photos may act as message carriers. With the special effects of posterization, you could present an endangered species in such an abstract manner as to indicate its dangerous position in the universe. Another print might be used as a photographic warning sign at the head of a trail to alert hikers to the presence of rattlesnakes along the paths on which they're about to trek.

Figure 1.7
One of the many purposes that can be served by your pictures is that of education. This photo of a flattened bark mantid could easily be incorporated into an elementary-school science curriculum to teach the concept of camouflage.

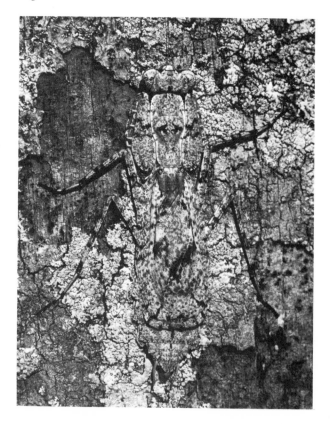

Yet another series of images could be used to involve an audience in active rather than passive participation. For example, you might create two sets of images, one containing pictures of birds sitting on their nests and the other showing only the eggs. You can then engage your viewers by asking them to correctly match the eggs with their corresponding parent.

Another approach might test your audience's critical viewing skills by asking, "What's wrong with this picture?" I have a photograph of a Canada goose standing over her nest, shielding four eggs—and one golf ball. No doubt substituted by some frustrated duffer, this dimpled "egg" goes unnoticed by all until I point it out to them.

For younger audiences, your shots of animals in comical poses can always be used to prod their imaginations in a contest of "What Are They Saying?" Finally, some of your finest images can be used to inspire your audience. In conjunction with an appropriate quote, you provide a "mindscape" for the brain and a landscape for the eyes.

Yes, all of your images can serve a purpose—a purpose dictated only by you and your special needs.

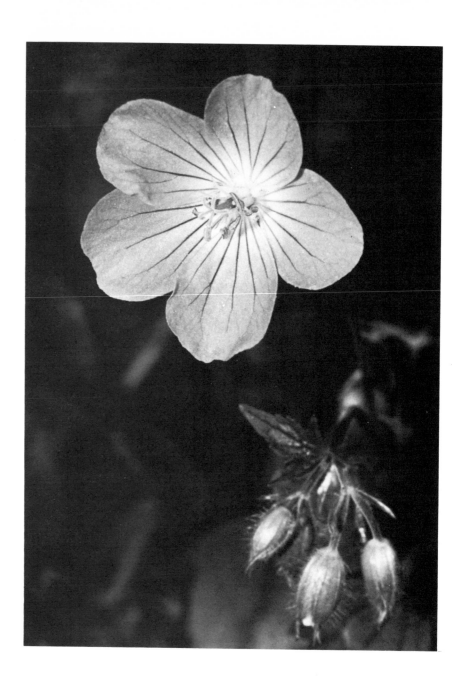

T HE TIME IS A LATE AFTERNOON in December. The place is Mrazek Pond, Everglades National Park.

Come on, Spoonbill! Rapidly the sun is plummeting into the west. Anxiously a friend and I wait for one, just one, of that special bird called a roseate spoonbill. An unlikely creation, this feathered friend: flattened, spatulate bill, greenish-gray head, black legs, and, oh, the incredible pink body with that flagrant splash of carmine on the wings and the salmon on the underfeathers. Truly a nature photographer's delight!

We are not alone, as a host of other prospective cameramen wait here too. Suddenly a spoonbill touches down, a magnificent adult with brilliant plumage. But someone neglected to tell it to land in the one sunny spot left on the pond and not in the dark, shadowed maze of mangrove leaves, branches, and roots. The air is filled with *pssh, pssh, psssh, psssh*. Motor drives??? *Pssh, psssh, psssh, psssh, psssh*. Yes! More motor drives!!! The bird is not front lit, back lit, mood lit, or any lit. *Psssh, psssh, psssh*. In shocked amazement I turn to my companion and ask, *"What* are they shooting?" He shrugs and, over the whirring noises, responds, "Stan, two times zero still equals zero!"

12

CHAPTER TWO

Understanding selectivity

I simply smile and resume the vigil. Although I captured no spoonbill photographs that evening, I did collect something of far greater lasting value, for later the meaning and implication of that apparently simple sentence began to sink into my consciousness. Later still that basic observation would revolutionize much of my entire approach to nature photography. How accurate was my friend's perception! Yes, indeed, two times zero does equal zero; and, if an image is intrinsically valueless, even ten times zero equals zero, and so does a hundred times zero. Perhaps I am being overly critical, but I know from too many frames creased and deposited in the wastebasket that basically you cannot put into a picture something that is not there.

This entire event further impressed upon me how many conditions must all properly come together for a great natural image to be created. Many of these conditions you control, such as focus, exposure, shutter speed, and composition. Many others are out of your control: for example, sunlight, shadows, posture, and the presence of other animals. If you fail to exercise your selectivity wisely and if so much as one factor is missing, your image will somehow fall short. You may

seemingly capture everything perfectly for our spoonbill, but in the background an out-of-focus coot appears to be standing on your subject's neck; your shutter speed may not be adequate to stop the motion of the bobbing head; half of the body is veiled in shadows; and so on. There are endless ways to miss the desired target, just as there is only one trajectory to the bull's eye.

I will add that on the following day, the spoonbill landed on a wide-open perch with an undisturbed watery background behind it. On this day I came to a fuller understanding of the era of the new math, for one bird plus one photographer yielded far more than two images!

3-D, 2-D, AND OTHER VITAL DISTINCTIONS

To effectively translate from what has been perceived by the eye of the heart or the mind to what will be seen by the camera's eye demands an allegiance to and an understanding of what I consider to be the single most important technical concept for any successful photographer. This involves the uncompromising adherence to and the thorough awareness of the transition that takes place from three-dimensional human vision to the two-dimensional world of the film's plane.

You look upon the world with the vision of an animal whose eyes are located on the front of the head. Considered by itself, this uncontroversial statement comes as no surprise to you. You have always known that both of your eyes were on the front of your head. But what you may not have felt or realized is that this amazing ocular arrangement that we share with owls and foxes (but not with rabbits and certain flounders) gives us depth perception. Alas, the camera does not possess such powers. Therefore, one obvious question should occur to you: In this transition, how do I know when a given subject will or will not produce a pleasing image or a dramatic photograph?

The Human Eye vs. the Camera's Eye

Part of the answer lies in altering your own vision to resemble that of your camera. The next time—

in fact, every time—you encounter a questionable subject, eliminate your depth perception by closing one of your eyes before photographing the subject. In that way you see more closely as the camera sees.

How many times have you thought that you had just captured a breathtaking vista when you pressed the shutter button only to be sorely disappointed when the slide died on the screen a month later? Take, for example, your first drive to the top of the Rockies. Here, on the crest of North America, you stand in awe of the scene that unfolds before you. Below you snakes the road you have just ascended; beside it, the river whose horseshoe path the asphalt imitated; in the distance, snow-capped peaks, glaciers, and powerful cloud formations. This is the basis for an obviously stunning photograph, but when the processed film returns, your "stunning" picture has turned to a "stunned" disappointment.

What happened? You already know: The camera reduced your three-dimensional human vision to the limits of photography's two-dimensional world. The result is a flat, depthless slide to accompany your momentarily shaken confidence in your newly purchased $400 camera. This is not to say that you should stop photographing mountain scenes, but rather that you should employ techniques (described in Chapter Five) to photographically heighten the illusion of depth that you realistically experienced.

On the other hand, you may have been surprised occasionally by the elegance of a picture that you took only as a record shot or as a passing whim. You hike to a secluded woodland waterfall cascading over ancient boulders, but the day is cloudy and overcast. As you activate your light meter, you cannot get a reading at 1/250 of a second or even at your familiar 1/125 of a second. Weather conditions force you to shoot at a shutter speed that you didn't even know existed—1/8 of a second. This time when the processed film returns, you're amazed to see the artistic piece you've created. The motion of the water has been permanently captured on the film. The result of the longer exposure displays the milky curtains of soft water veils tumbling over the rocks and creates a surrealistic pattern. You should not have been so surprised. Understanding of yet another technical aspect of the human-eye to camera-eye transition would have enabled you to project the result in your mind long before it registered on the film.

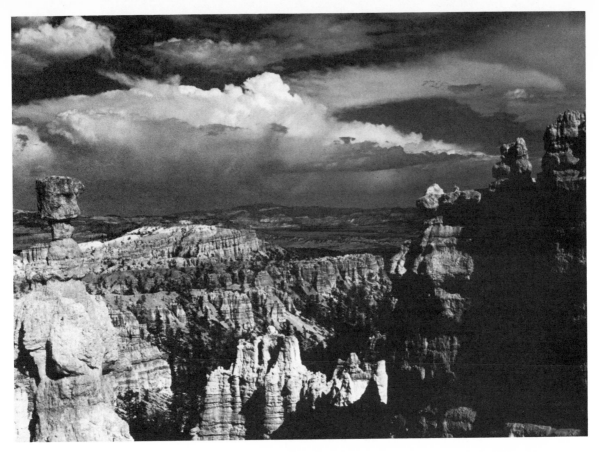

Figure 2.1
Foreground shadows, a sculpted rock fairy-
land as the main point of interest, and lively
cloud formations in the background join
forces with an asymmetrically balanced com-
position to produce an effective scenic photo-
graph.

Figure 2.2
Slow shutter speeds used when photographing
water almost always produce exciting results.

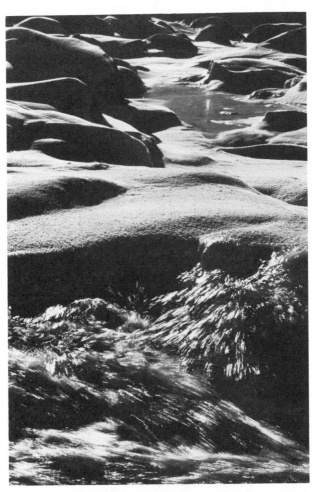

In this regard, many seemingly insignificant features of the natural landscape produce photographs far more spectacular than the most majestic chain of mountains. A spider web hung with the dew produced by the condensation of a cool fall night may look totally unappealing to you, but have you ever looked at the same web under the magnification powers of a bellows unit or a macro lens? Suddenly the camera transforms the thread of a spider's stomach and the vapor of the air into the gleaming strands of a natural pearl necklace. A bird in flight is so common a sight that most people pay it no heed. But they will pay attention to your striking photograph of that same bird if you have used a very fast shutter speed (1/500 of a second or faster) to freeze the perfect pattern of form and the muted shades of color normally only a blur to human vision.

Once again your understanding of the differences between human and camera vision has

Figure 2.3
One of nature's most rewarding subjects—a spider web wet with dew. The droplets in sharp focus become pearls of pewter, while the out-of-focus highlights are transformed into hexagonal jewelry.

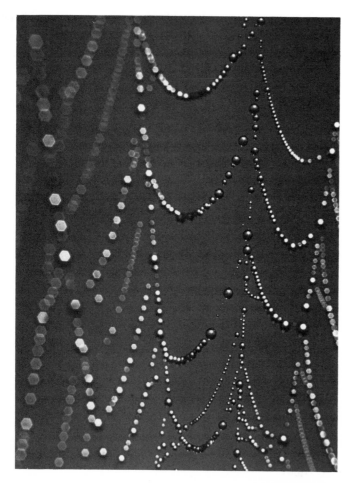

captured on film what we ordinarily cannot see. Photographic techniques such as shutter speed manipulation, macro magnification, and selective depth-of-field may all produce startling results because they present objects too small or processes too fast to be perceived by the unaided human eye. But most of all, with the use of the proper techniques, the camera can show your audiences fresh visions of a world impossible for them to perceive from their perspective. To illustrate my point, examine a collection of Eliot Porter's striking photographs of nesting birds frozen in their approach flight by multiple electronic flashes or Nilsson's truly incredible photomicrographic renderings of the world of protozoans and sections of the human body.

Let us assume that you now understand and assimilate into your photographic philosophy the very real distinction between three-dimensional human vision and two-dimensional camera representation of that vision; furthermore, you accept the validity of camera and lens techniques that allow you to enhance or transcend human vision. In the final analysis, you will now have only one criterion for determining whether or not to shoot. That standard will express itself in the form of a simple question: Does the subject before your eye and lens please you or doesn't it? If it does, shoot it; if it doesn't, avoid it.

TO SHOOT OR NOT TO SHOOT— THE TEMPTATION SITUATION

You find yourself in an ideal natural environment; you are physically equipped with enough appropriate photographic gear to film everything from an eighth-of-an-inch-long aphid to a crater of the moon a quarter of a million miles distant; best of all, you are in a great mental and emotional set, anxious to do the actual photography. But, woe of woes, you see nothing to please your eye. When the light is great, you seem to have no subjects; when subjects abound, the light disappears. The animals seem to constantly have one eye obscured by a branch or a blade of grass; the wind agitates only the flower upon which you've focused; the sky over your landscape is traversed by at least half a dozen jet contrails.

What do you do? To shoot or not to shoot? Undeniably, the overwhelming temptation is to

shoot. You've risen at 5 A.M. for the sunrise, and you're determined to shoot it even if the sun doesn't show up. You're on your first visit to the Everglades and you don't want to miss anything, or you may be on your last day in the Grand Canyon and you still don't have an outstanding frame of sunset at Hopi Point. So you shoot and then you shoot again. In your anxiety, anticipation, and perhaps even some anger, you attempt to force into your image something that is just not there. How well I know that feeling; I've had it enough times myself. On more than a dozen different occasions I have photographed in the Everglades. When I am placed in this, my favorite winter environment, I feel actually compelled to use up some film. I may have 500 slides of an anhinga, but still I want to try for some more. I haven't flown 1500 miles to sit in the sun; no other bird is in sight, so of course I'm going to shoot. But under inappropriate conditions, the unhappy outcome is an ineffective image that results from trying to coerce a photograph.

How difficult it is to learn and then to practice that necessary restraint! Maybe it's a case of " 'tis better to have shot and lost than never to have shot at all." I am much better at restraint than I used to be, but then again I have had a lot of practice at it. Perhaps this trait is acquired only after years of painful experience and rolls of pitiable exposures. Maybe your ears are not ready to hear words such as these; maybe each and every one of us must endure a private, personal ritual of passage. But at least remember that you have been forewarned. "From nothing, nothing comes," admonished the ancients philosophically. It is as true today in the world of photography. When the conditions of atmosphere, equipment, or animal are not conducive to high-quality photography, you would do well to conserve your film for the times when they are. Of course, if you have any doubt at all, shoot now and judge later.

In such a questionable situation the decision on whether or not to shoot might be partially resolved by consideration of the subject's intrinsic interest level. For a variety of reasons, some themes engender far greater responses than others among audiences, judges, and photo editors.

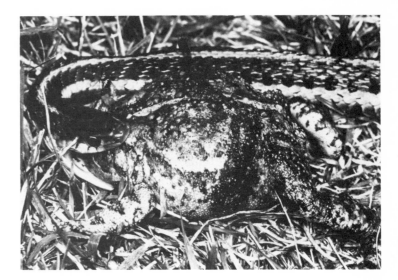

Figure 2.4
Photos of animals in action encourage animated responses from your audiences, and what could be more evocative than the life-and-death moment captured here as a garter snake begins to consume an American toad.

shot of a bald eagle may be more exciting than a fine shot of a robin. Since the opportunities to photograph robins will be more numerous than those to film eagles, you can justifiably be expected to take eagle pictures under less-than-ideal conditions. You can afford to be more critical in your selection of robin images. But even in the case of common animals, there are other factors that might influence your judgment. Perhaps this is your first time to photograph a fox den. The light is not flattering, but will you return tomorrow when the light is more suitable? Better yet, record it now. The fox is not so steadfast as a mountain; you cannot depend on it or any other animal to be there for so much as an hour, let alone an entire day. Just recognize your less-than-ideal shot for what it is—merely a record shot awaiting a better one to replace it in your files. Furthermore, an action shot of any animal will almost invariably demand increased attention. An animated shot of a deer leaping over a log or an egret swallowing a fish will be subject to far less criticism concerning lighting, background, or sharpness than will be a static pose of the same animal.

Wildlife Photography

In the case of wildlife photography, a rare animal is likely to evoke more enthusiastic responses than a common one. On this basis, an acceptable

Scenic Photography

In scenic photography the quality of the lighting will almost invariably determine whether or not you will shoot. Dramatic, moody lighting can

readily transform a mediocre landscape into an aesthetic experience of dynamic impact. In macro photography, you must look for shapes, patterns, and forms to avoid dull close-ups.

In other instances, your subject's intrinsic interest might derive from the arrangement of its lines. The straight telephone-pole shape of the trunk of a lodgepole pine cannot hope to compete for interest with the grotesque, twisted forms of the arms of a Joshua tree. Further interest can be stirred by a subject unknown to your audience: For example, a photograph of a bighorn sheep exhibited to Rocky Mountain residents—who often see the animal—is not likely to motivate the viewers as it will in Miami, where the animal is not part of the natural landscape.

A Final Decision

Of course, vivid colors can always command increased attention too, but as you begin to demand more and more from your pictures, not even a flaming sky will be sufficient reason to shoot unless other conditions are also satisfactory. Finally, your decision on whether or not to shoot may be dictated by your needs. Perhaps you are working to meet a publication deadline; the conditions may not be ideal but you have to shoot. Each individual situation demands your own personal analysis based on your experiences with the subject, present conditions, and future needs.

The corollary of the previous considerations is to shoot a glorious opportunity to its conclusion. You cannot operate on the assumption that you will have another chance tomorrow just because there is one opportunity at hand today. Although on more than one occasion I have been fortunate enough for this to be the case, you must nonetheless treat every situation as if it were the last of its kind. Who can guarantee the same light on your mountains tomorrow? What policy insures the life of your lizard against the hungry patrol of nocturnal predators? Who can promise that torrential overnight rains will not batter the petals from your prized flower?

How well I remember a dead pine in the high desert of southeast Washington. Although the tree provided a great silhouette for the setting sun, I took only three exposures on my first trip there. Recognizing my error, I returned the very next year, only to find that the tree had toppled.

There was also the robin's nest I visited every other day one spring so as to observe and photograph the young. On Thursday I could see by their exercising that the fledglings were almost ready to fly. I debated whether or not to return on Friday, and since it was such a long, out-of-the-way drive, I decided to wait for Saturday. The baby robins didn't.

Do you think three frames of a grand subject sufficient? Shoot a dozen! If I am working on an animal, especially a new one, I am likely to shoot until the animal disappears. For insurance, I will take some record shots from a distance before I try to determine the animal's approach distance and attempt to move closer. In this fashion I have shot more than 100 exposures of a lone coyote hunting in Hayden Valley, more than double that number of trumpeter swans who were molting their flight feathers, and nearly 400 frames of burrowing owls at the edge of a small Florida airport.

Why so many? There are numerous reasons. First, I can capture a wide variety of postures and activities, such as posing, yawning, preening, singing, sleeping, and fighting. Then I can vary lenses and record the animal as part of a habitat or as a portrait. Some of the frames may be flawed in processing; others may be lost in the mail. Some can be submitted to magazines and others to book publishers or a stock photo agency. Still others can be used in slide presentations or to make filmstrips, while the rest are stored as back-up insurance for any contingency. Finally, extra shots made in the camera as originals yield higher quality, less expensive frames than duplicate slides or negatives made at a later time.

Exhaust the moment! As we have seen, trees will topple, clouds will evaporate, and flowers will wither. Under mediocre conditions, take your record shots. Under excellent conditions, shoot extra exposures, change angles, and focus closer. Truly, there is no tomorrow!

THE TEN COMMANDMENTS

Fortunately, I long ago discovered in my evolution as a photographer/naturalist that there are some subjects and events of nature that you photograph

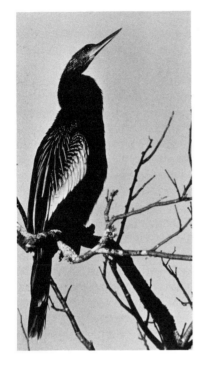
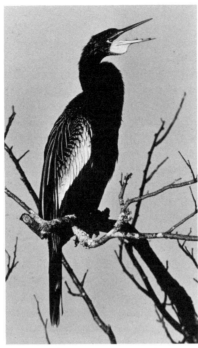
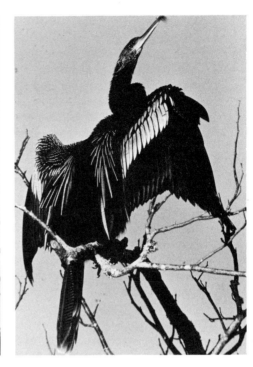
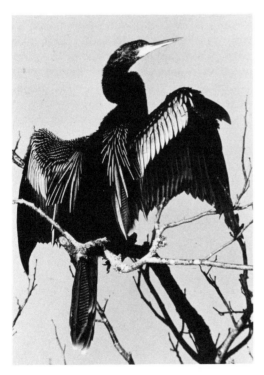
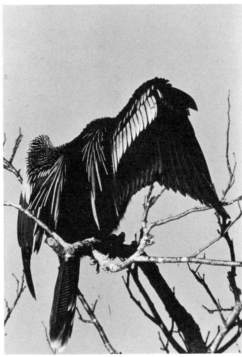

Figures 2.5A, B, C, D, and E
The nature photographer who refuses to invest time in a wildlife subject will reap only a portrait of the creature; the patient hunter, however, can hope to record an assortment of poses such as those seen here of an anhinga calling, preening, drying its wings, and shyly hiding its head.

and others that you simply enjoy. The moments that are photographed delineate an exciting visual record of the natural world; the ones that are witnessed produce fond memories of plants, animals, or vistas that I simply missed on the film or that I understood would not make great photographs. You can blame yourself for missing a splendid opportunity that you are convinced will never return or you can talk more gently to yourself: "I've never seen a painted bunting before; I'm glad I was here," or "I'll never forget the sound of that howling pack of coyotes."

The conceivable photographic disadvantage of "visiting" nature solely to photograph or, even more precisely, to photograph only a desired object, can be the unfortunate result of passing the scene with eyes and heart constrained by invisible blinders. This policy can readily lead to photographic bankruptcy, thus causing a poverty to be created in your life that may never be measured.

One dawn you set out determined to photograph an uncommon flower you've previously located. Along the way you neglect to notice the frosty-winged dragonfly. Got to get to that flower! A pert red squirrel pauses to sip from a seasonal stream, but you're on a mission. Onward! Overhead, in the balcony limbs above, a wood thrush fills the air with his melodious refrains. You don't even hear him. Where is that spot?

In this exaggerated account, can the mere *possibility* of obtaining one image possibly be worth missing all the rest? I personally doubt it. Without digressing any further from the intended path, I should like to point out that nature is the reality, the photograph of nature merely a reflection. By separating these, I have come to establish for myself a set of guidelines that I consider valid reasons for taking a photograph. If the proposed image does not correspond to one (or more) of these categories, then I'm pretty certain to move on down the trail. However, if the image does illustrate one of the norms, I will shoot it.

Perhaps you have other reasons of your own that you can add, but the following are my Ten Commandments of nature photography.

1. *Life.* The most basic common denominator that we humans share with the organisms of nature that span the spectrum from gorgeous orchids to grotesque mantids, from mildewed mushrooms to majestic mountain goats, from lowly sundews to lofty eagles, is life. For me, the life of the being before me is the only reason I need to justify my photograph of it. The longer I hike, the wider the variety of life I experience—the deeper the kinship grows that I feel for the infinite diversity of life forms our own species has so tragically abused. To record them on film may well be my photographic mission to future generations that will never thrill to the sight of an eagle swooping over the Rockies or a redwood towering to the clouds.

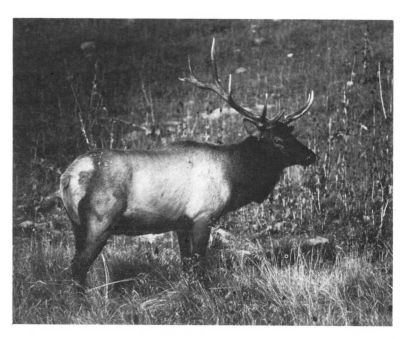

Figure 2.6
The First Commandment: Life. The continuance of life for this bull elk will be temporarily made more challenging until he grows the other antler, which for some reason has not attained its complete size.

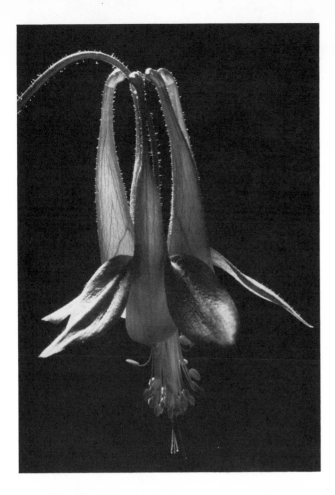

Figure 2.7
The Second Commandment: Light. The use of artificial light has been skillfully employed here to record the fuzzy texture and multiple light values of a pendant columbine. Photograph by Otis Sprow.

2. *Lighting.* As we have previously noted, the word *photography* etymologically means "to write with light." Given this derivation, it seems obvious to me that in at least one very real sense the most effective photographs are those with the most dramatic lighting. It is not nearly so easy to understand what light is as it is to perceive what light does. Look for the unearthly light that occurs during unusual atmospheric conditions such as storms and fog. Look for the glowing light that appears in the early morning shortly after dawn and in the late afternoon just prior to dusk. Attune your eyes to the infinitely subtle variations of light as seen in light in the shadows, light bouncing off rocks, and light diffusing through mist.

3. *Color.* I love colors. It matters not whether they are subtle or flagrant, moody or bright. We humans are one of only a handful of animals who possess eyes capable of interpreting so fully this exciting dimension of vision. There is so much: the maples that blush each autumn with multi-hued make-up, the monochromatic tones that toast both the bull elk and the fall meadows of Yellowstone, the golden coins of sunlight dancing across the water, and the indigo vapors of dusk hovering over the mountains. Enjoy it; photograph it.

4. *Angle.* Learn to see the world from a fresh perspective. Some situations might require a different physical perspective, such as lying on your stomach so that you can look into and not down upon the eyes of a garter snake. If you can afford it, you might want to pursue the optical perspective provided by a fisheye lens. But, most significantly of all, you should develop your own mental and emotional perspective that combines with your knowledge of your camera and your feelings for nature. Disdain the ordinary! Look from *below* the flower, not from *above* it. See from *behind* the waterfall, not from *in front of* it. Look *up* the tree, not *at* the tree. Isolate rather than consolidate. By itself, a single snowflake describes a unique form; clumped together with ten trillion other snowflakes, it loses its identity in an amorphous pile of snow.

5. *Shape/Pattern.* Although in many instances this aspect better suits itself to the medium of black-and-white film, it is as important in the world of color if you use your imagination creatively and the sun's back light effectively. Your mind can look at nature's endlessly varied shapes with the added dimension of perceiving humanly created counterparts. Does the uncurling fiddlehead fern look like a question mark to you? Does

21

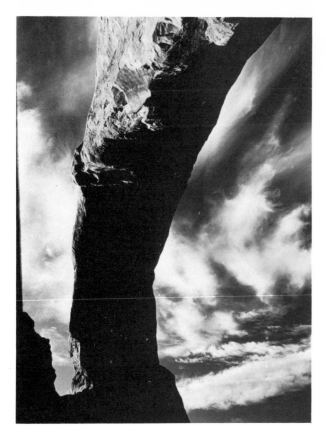

Figure 2.8
The Fourth Commandment: Angle. By lying on your back and pointing the camera skyward, you can often see the world from a fresh perspective, one far more dramatic than that gained by merely holding the camera at eye level.

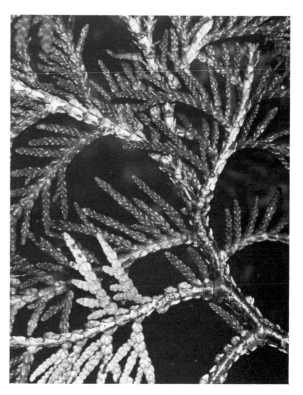

Figure 2.9
The Fifth Commandment: Pattern. To the eye of the perceptive photographer, shapes and patterns, such as those of this cedar bough, abound in the world of nature.

that slowly opening bud resemble the logo of a major American car manufacturer? Shoot them! Can you uncover the shapes of the letters of the alphabet in the features of a forest? The crotch of a birch tree makes an easy *Y*, holes drilled by woodpeckers erase *O* from your list, and a pair of crossed twigs gives you an immediate *X*, but what can you spell with *Y-O-X*? Discerning many of the other letters will not come nearly so easily. Shooting into the sun will silhouette the shape of everything from a kingbird perched on a stump to a thistle bent by the wind. In looking for natural patterns, much of the secret of success will come from the repetition of a uniform feature—the deeply furrowed checkerboard pattern of an alligator juniper's bark, mounds of snow regularly interrupted by their own shadows, the blades of grass bowing in an identical arc, and so on. Other photographs of natural patterns gain stature from

their abstract quality or by their similarity to geometric shapes, such as a parabolic curve or the circumference of a circle.

6. *Texture*. Once again we consider an excellent black-and-white film technique that demands more discrimination to succeed in color. Shooting for texture implies a sense of feeling as well as the sense of sight in your photograph. You know you have done a good job of rendering texture on film when you see your viewers reaching out to touch your print of dramatically lit fruits or when you hear them comment that they can almost feel the fuzz of the sumac in the slide on the screen. You may even strive for the texture of color. In the winter swamp, for example, the interplay of the whites of snow and the golden tans of dormant reeds lends a contradictory feeling of simultaneous warmth and cold.

7. *Story/Sequence.* Unfortunately, too many of us see each individual snap of the shutter as creating a distinct entity totally divorced from every other picture. It is true that some images pack such obvious content that they can tell a story on their own merit. Frequently, though, a single respectable photo grows to a greater stature when combined in sequence with others to tell a cohesive story. In the accompanying series, we see a female killdeer about to settle on her nest (Figure 2.10A) when the photographer's presence is noted. Moving off the nest (Figure 2.10B) to distract the potential predator, she attempts to attract attention to herself and divert it from the nest. Nervously chirping as she feigns a broken wing (Figure 2.10C), she forlornly drags her bedraggled limb across the earth, all the while decoying the human or natural predator farther and farther from the nest. At the precise moment, she leaps into flight and abandons the hunter to test her skills elsewhere. Later she returns to the eggs (Figure 2.10D), to which she has devoted this remarkable sham. Any one image in this sequence would be weaker on its own, especially if the story were unfamiliar. A further advantage during slide presentations comes in the fact that your audience is not nervously fidgeting while looking at a single frame for many minutes while you weave your clever yarn, but rather anxiously awaiting the next slide. Finally, your slide is spared exposure to a high-intensity projection lamp that will slowly desiccate the emulsion and inexorably erode the dyes.

Figures 2.10A, B, C, and D
The Seventh Commandment: Story. The amazing masquerade enacted by a female killdeer in defense of her nest is shown here at four of its strategic points.

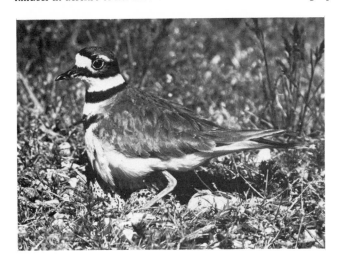

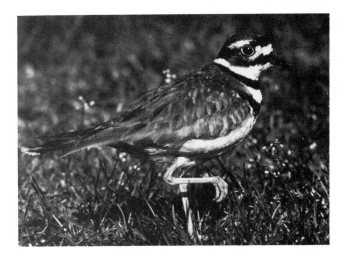

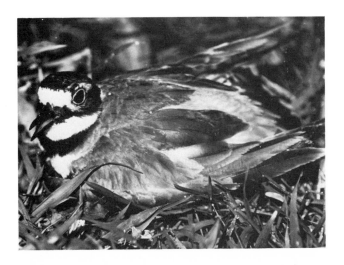

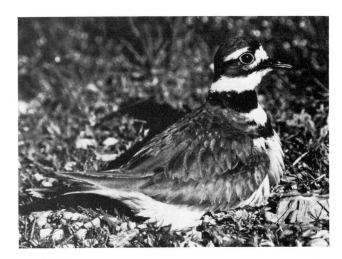

8. *Humor.* Most of us tend to take ourselves and our work far too seriously. Given infinite space and eternal time, it should be obvious that we are little more than infinitesimal particles of cosmic dust. I've often found that the best diet for this weighty realization comes in the form of a good shoulder-shaking, tear-raining laugh. On more than a few occasions, that laugh has derived from the natural world I photograph, such as the American toads seen blissfully (?) engaged in one of the planet's timeless pleasures while oblivious to the bellows unit only twelve inches away. Another personal favorite is a shot of a long-billed pelican photographed head on while wearing a leering expression that invariably provokes a chuckle from my audiences during a slide presentation on the serious environmental crises that confront the Everglades. While you're laughing, I hope that you can laugh at yourself too when a friend's camera captures you in a "natural" moment.

9. *Record.* Not every release of the shutter will yield a photographic masterpiece meriting cover space on well-circulated national publications. Why, even Babe Ruth struck out nearly twice as many times as he hit home runs! Acceptance of

that analogy should help you to realize that some of your photographs will merely be record shots of phenomena that cannot be captured under ideal aesthetic conditions. Such record shots may picture a significant landscape about to fall to the bulldozer, or an animal whose numbers are dwindling to zero. You may record the effect of a year-long drought in the spectacle of a summer fire. The lighting may be less than perfect, the composition less than artistic, and the focus not razor sharp, but at least you have a record. Until a second opportunity presents itself, such images may serve a useful scientific or historic function. This is not to say that you cannot reduce the obvious flaws and maximize the conditions to give your record shots their broadest inherent appeal. Is the sky a bald white? Eliminate most of it by filling the frame more with the main subject or by raising the horizon line in the frame. Is your tripod back at the hotel? Fast shutter speeds can eradicate some of the motion problems now and in other situations where you hand-hold the camera. These and similar, thoughtful techniques can make your record shots at least worth recording until better circumstances allow you another chance at the same theme.

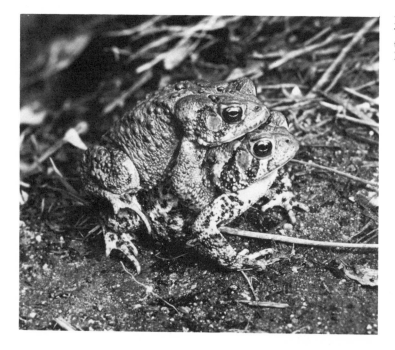

Figure 2.11
The Eighth Commandment: Humor. These toads cannot help but elicit a laugh, or at least a chuckle, from human viewers.

10. *Money*. The great equalizer! The one commandment that by itself can single-handedly balance the other nine combined. Your next-door neighbor wants you to photograph her poodle's hair trim and is willing to pay for your film plus $20. Do it! You can take the money and buy additional film to shoot the blue jay nest that really interests you. The boss wants some shots of his power boat. He offers you film and a day-long ride on the boat that will carry you within range of the osprey nest near his cottage. Great! Do that too. If you want compensation for your efforts, you must start somewhere. If these lowly beginnings will pay for some of your film, buy a few pieces of new equipment, and help to establish your credibility as a quality photographer, why should you complain?

As you peruse The Ten Commandments and then perhaps scrutinize them later in greater detail, you should perceive that they are so broad and all inclusive in their options that they indicate *photographic* justification to shoot in virtually any and all situations that you are likely to encounter. This fact could reasonably suggest to you that there exists yet another yardstick against which to measure your photographs, and that is the purpose for which you have taken them. Once the images have been made, virtually every one of them can serve some useful purpose, as I have outlined earlier. You must be the one to decide where that value lies.

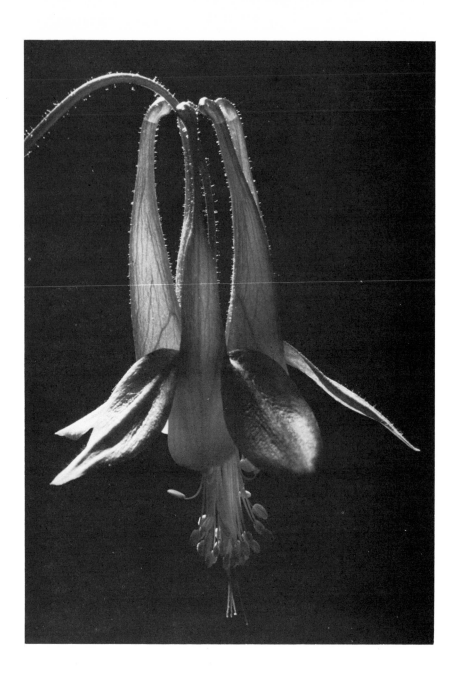

E VERY SPRING, THOUSANDS of little leaguers, high-schoolers, and collegians are diligently instructed by baseball coaches anticipating a winning season from their skilled players. Endless hours are devoted to teaching young arms to throw a curveball and awkward feet to gracefully execute a hook slide. On baseball diamonds across the country, knowledge flows freely and not-so-freely from mentor to recruit. But all the years of experience and all the hours of practice cannot make more than the tiniest fraction of the hopefuls into professional athletes of a major-league quality.

In much the same manner, knowing all there is to know about light cannot automatically make one into a professional photographer. You must be able to *see* light, and experience dictates to me that many people simply lack that critical awareness. Of course, I do not mean to *see* in the commonly used meaning of the word, such as when someone says he *sees* a butterfly, or she *sees* the sunset. No, I mean to be aware of light in a special

CHAPTER THREE

The qualities of light

sense. By this definition to *see* is to perceive in a sense that is both physical and artistic; it is to be aware of light's changing; it is to notice light's creating shadow, color, and form.

THE AGE OF LIGHT

As I hinted at in the previous chapter, it is easier to see the effects of light than it is to understand it. If it is true that many people do not *see* light in the photographic sense of both perceiving it physically and understanding it mentally, then I think we must look for a more efficient way to achieve this end in potential *light writers*. I would suggest that this can be realized not so much by studying the characteristics of light in a textbook as by actually watching light and its effects in the world of nature. I would like to see you spend one full day in an environment where you could watch light from an hour *before* sunrise to an hour *after* sunset. My first choice would be for you to pass that day

in the Grand Canyon, watching any rock formation of your choice. Of course you would take your camera; you would set it on a tripod in a fixed location and then you would take an image every fifteen or every thirty minutes, but certainly no more than one hour apart. This single day's study would probably do more for your appreciation of light than a lifetime in a classroom. If you don't have a Grand Canyon where you live, a mountain lake will do nicely, as will an ocean shoreline or a field of meadow grass touching a forest.

It may validly seem to some among you that I am paying woefully little attention here to this light that is the single most important facet of photography. I defend myself by saying that it is not so for a number of reasons. First, to become esoterically scientific in this area immediately engrosses us in concepts and not in photographs. Secondly, I do not want to divorce the study of light from the associated, more appropriate concepts that we shall consider in later chapters. For how can you disassociate light from discussions of sunrise, exposure, or scenics? Once again I would rather delve into the practical aspects of what light is doing in these situations and what you must do to photographically manage it at those times. Finally, I think that the most important thing to know about light is how to use it, that is, how to use it effectively in technically correct exposures

and how to use it aesthetically in excitingly moody photographs.

Since one cannot separate photography from light, these issues will be considered as the subjects arise in the text. For now, though, this chapter intends to be only a brief introduction to the definitions and applications of the three most basic forms of front, back, and side lighting along with some considerations on natural lighting compared with artificial lighting. In no way should the physical length of this chapter be misconstrued as indicating the relative importance of the subject of light; it will continue to regularly pervade future pages of our investigation.

USING LIGHT: FRONT, BACK, SIDE

In nature photography, you will employ basically three forms of lighting. These lighting techniques are named simply for the direction from which the light strikes the subject in reference to where the camera is located. By this terminology we refer to *front lighting, back lighting,* and *side lighting.*

Front lighting consists of what most of us would label the "normal" lighting condition. The light source shines onto the face of our subject, be

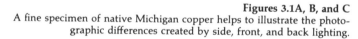

Figures 3.1A, B, and C
A fine specimen of native Michigan copper helps to illustrate the photographic differences created by side, front, and back lighting.

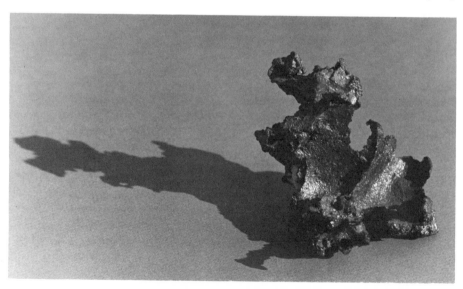

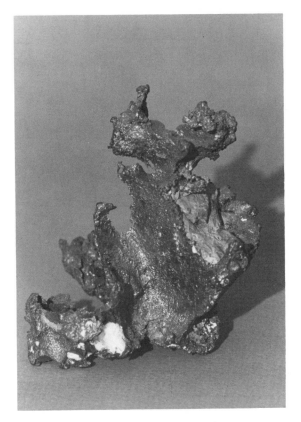

Figure 3.1B

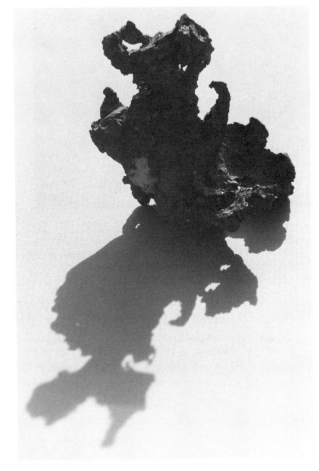

Figure 3.1C

it mountain or mushroom, from approximately the same direction we face it and from which the camera photographs it. This is the old "keep the sun behind your shoulder" trick. In nature photography, front lighting portrays the subject realistically. It reveals the patterns and colors to which our eyes are accustomed, so long as the sun is relatively high in the sky. When the sun appears to hang near the horizon line, colors begin to shift toward the yellows, oranges, and reds that make sunrise and sunset so appealing.

In direct opposition, *back lighting* refers to the times when the light source originates from somewhere behind the subject, facing toward the camera. While the camera points toward the subject, the light flows in the direction of the camera, not unlike a game of monkey-in-the-middle wherein the subject is the monkey, located on an imaginary straight line between camera and light. *Back lighting* enables you to dramatically silhouette the interesting natural shapes of birds and buffaloes, to emphasize the form of a gnarled tree trunk or the pattern of a palm frond and to add a halo to the fuzzy texture of staghorn sumac or cholla cactus.

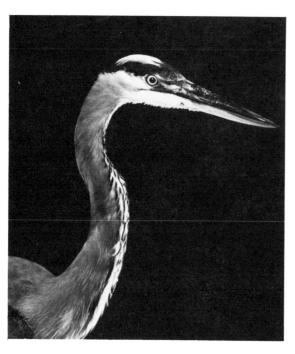

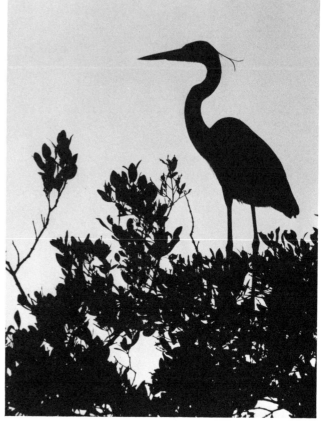

Figures 3.2A and B
In the natural world, front lighting shows us a great blue heron as we expect to "normally" see it, whereas back lighting the bird defines its dignified silhouette.

As you can easily infer, *side lighting* indicates that the light source is located at approximately a 90-degree angle to the camera. When your light source is situated at this perpendicular angle to the camera, you have your best opportunities to create the illusion of three-dimensionality that we discussed previously. When the light is coming across your subject from left or right, there will of course be a cast shadow in the direction opposite the light source. Such conditions are excellent when you wish to lend a feel of texture and solidity to your subject.

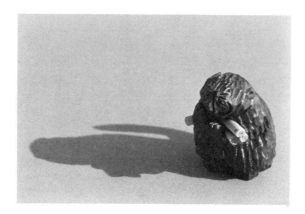

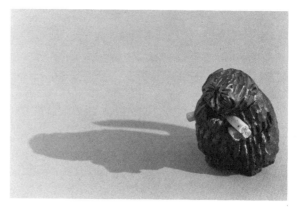

Figures 3.3A and B
When you are employing strong side lighting, you can soften the cast shadows and bounce light into shaded areas by using a highly light-reflective white card, as demonstrated by these two photographs of a stone beaver figurine, one recorded with a reflector, the other without.

NATURAL VERSUS ARTIFICIAL

In nature photography, *natural light* refers to the quantity of light naturally present in whatever environment you choose to shoot. It implies no addition and no manipulation of light by the photographer. In other contexts, *natural light* may also be referred to as *available light, existing light,* or *ambient light.* Essentially, *natural light* speaks of that light that is out of the photographer's control. You cannot move the sun to the left or right, higher or lower, closer or farther, as you could with a floodlight in the studio or an electronic flash on the camera. For me, using natural light is the only "real" way to photograph nature. Natural light is ever changing, spontaneous, constantly altering the face of everything it touches, from larva to lark, from lake to lily. When you work with natural light, your every move must be efficient. You must consume as little time as possible in composing, focusing, and leveling, for the moment is exceedingly brief. You must also be alert, attentive to the continuously shifting nuances that light is always creating. Although you cannot control the life span, the direction, or the mood of natural light, you can, and you must, perceive its effects.

In blatant contrast, the use of artificial lighting means that the photographer is in total control. The photographer can decide how many lights there shall be, how much light each one will emit, and even determine from which direction they shall strike the subject. Philosophically speaking, this sounds like a bargain too good to be true; in practice, it too often turns out to be a bad deal.

Artificial light refers to light that has been introduced by the photographer to implement the existing level of natural light. *Artificial light* implies a source furnished and controlled by the photographer. In a studio situation, a variety of artificial lights, directions, and accessories are employed by the photographer to achieve a multitude of desired effects. For all practical purposes, these devices are useless in the world of outdoor nature photography—unless, of course, you possess an extremely long extension cord! Generally, in nature photography, the term *artificial light* refers to a unit known as an electronic flash, a strobe, or a flash gun. Such a unit is capable of multiple flash discharges so long as the operator replaces or recharges the powering battery pack.

You may think of it as an almost eternal flash cube.

Right off the top of this discussion, I would like to preface all further commentary with the observation that I personally do not like to use artificial light except as a last resort. I understand that flash lighting may not only be necessary but even beneficial in certain circumstances; nonetheless, I find there to be so many variables and so many problems to overcome that I, for one, always prefer natural light if at all possible.

It never ceases to amaze me the nearly supernatural powers imputed to electronic flashes by the uninitiated. Too many beginners stand in virtual awe of the electronic flash; they envision it as their panacea for difficult lighting situations, and in their unqualified judgment they sorely abuse its legitimate capabilities. How many times have I seen tourists pop out of their travel bus, load a flash cube onto their instant cameras, and snap a miniature image of the Grand Canyon. Alas, the entire 217 miles of nature's grandest work will not be magically illuminated by this minuscule *poof!* It is my opinion that *no* beginner and few professionals should commence their photographic careers with a strobe in hand.

Putting aside my reservations toward artificial lighting, I still think that the majority of nature photographers who use strobe lights extensively would agree with the seemingly incongruous statement that the *most* effective flash lighting techniques are the very ones that *least* look as if strobes were used!

Without judicious and skillful use of your strobes, you will create many flaws detracting from your overall image quality. A major problem with a strobe unit is the hot white spot of brightness where the main light strikes an especially shiny or reflective subject. You commonly see this reflection on the glasses of people or off the paneling and mirrors in a home. In nature photography, the same effect can occur when a single strobe illuminates shiny foliage, turtle shells, or wet stones on a beach. The effect can be greatly reduced by altering the angle of the strobe so that it strikes the subject at an oblique, rather than a direct, angle. This necessitates removal of a single strobe from the camera's hot shoe and positioning it elsewhere via an assistant, a clamp, or a bracket. The arrangement of the flash hot shoe on the camera may be great for convenience of operation, but it is lousy for quality of photography.

Figure 3.4
If you were not told so, would you guess that this photograph was made not with natural light but with the artificial light of electronic flashes?
Photograph by Otis Sprow.

Bouncing the strobe light off another surface, called a *reflector*, can also reduce this hot spot to nothing, but it tends to produce a flat, though even, lighting. When you do bounce your light, you must remember to use your electronic flash on its manual mode of operation. Most electronic units manufactured today can perform on both manual and automatic modes of operation. When set on automatic, such a unit employs a sensor that measures the light bounced to it and then automatically shuts off the flash at the correct exposure. Hence you cannot use your strobe on automatic when you wish to bounce your light, because the strobe's sensor will respond to your reflector and properly expose *that* instead of the subject. Finally, when you employ this technique, remember that some of the light will be absorbed by your reflector, and there will be a corresponding decrease in exposure depending on the distance the light travels and how reflective was the surface used to bounce the light onto the subject.

When you employ a single flash, a second possible drawback surfaces in the form of a harsh or undesirable shadow. It is for this reason that my strobe setup contains three small units rather than a single large flash. Next there is the common error of "red eye" when shooting animals. You've all seen this phenomenon in people pictures taken at weddings, birthday parties, or other social gatherings. Because the photographer used a flash unit

held at an axis of the same height as the axis of the lens, the light went out, reflected off the blood in the eyes, and made the partygoers look "smashed" before the festivities even got under way. This phenomenon of the reflection of the light off the blood in the eyes is referred to as *red eye*. If you think it looks weird on people, you should see it on owls and rabbits! The solution is simply to elevate the flash above the axis of the lens or to drop it below that level. Now the light from the strobe is not reflected directly back to the film, the red disappears, and the disease is cured.

A final objection that I have to strobe lighting is that after a while all images produced in this manner tend to take on a boring look of sameness. To me, there is an almost waxen or plastic look to a series of strobe photographs as opposed to natural-light images that continue to vary in their lighting from season to season, even from hour to hour.

In an attempt to balance the scoreboard, though, I do think that there are a number of positive features associated with strobe lighting that should be discussed. The immediately obvious benefit of an electronic flash comes in the fact that you have a continuously dependable source of light that is in your total control. Clouds may conceal the sun; they never obscure a strobe. You place the strobe wherever you want; the sun travels wherever it wants.

In underwater nature photography, the strobe is an indispensable tool. In the world of the sea, the shallow depths introduce you to a world painted in blues and greens. Although natural-light images are possible, without the electronic flash or flash bulbs, an aqua cast will pervade all of your pictures. As you move deeper, the world of blue yields to the kingdom of perpetual darkness where even some of the sea creatures carry their own lanterns. Without an auxiliary light source, photography is impossible. For the snorkeler and the diver, only an artificial source of light can do justice to the stunning colors and textures of the luminous world of angelfish, coral, and anemones. Those keenly interested in the subjects of this liquid realm would do well to consult a book such as *Underwater with the Nikonos and Nikon Systems* by Herb Taylor,* that can better acquaint you with the problems of and the solutions to such relevant areas as underwater housings, exposures, specialized flash units, and so on.

* Herb Taylor, *Underwater with the Nikonos and Nikon Systems* (Garden City, N.Y.: Amphoto, 1977).

In the more highly specialized area of high-speed photography, only the strobe can freeze the beat of a hummingbird's wings or illustrate the uncoiling pattern of a striking rattlesnake. In 35mm photography, the problems of completely freezing motion are magnified because of the arrangement of the focal plane shutter in the camera body. Although the electronic flash may be emitting its powerful light at speeds ranging from 1/1000 to 1/50,000 of a second, the synchronized speed on the camera body is only 1/60 or 1/125 of a second. The result of motion recorded during this longer duration creates a secondary "ghost" image known as "focal plane shutter blur." Once we begin to discuss this situation, we enter a realm of complexly interrelated concepts that involve the ASA of the film, the lightness or darkness of the subject, the difference in levels between the ambient light and the strobe's light output, the exposure latitude of the film, and the power cut-backs available on certain strobes. For most of the instances in which you will be involved, know that this phenomenon frequently stems from the fact that the ambient light level is too high.

Figure 3.5
The submerging electronic flash descends beneath the surface of the liquid world to first surprise and then freeze forever the prized catch of a squirrelfish with its dorsal fin erect.
Photograph by Nancy Ormond.

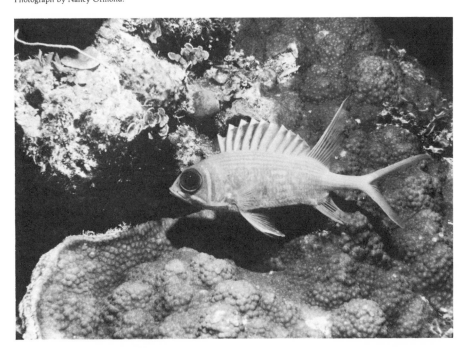

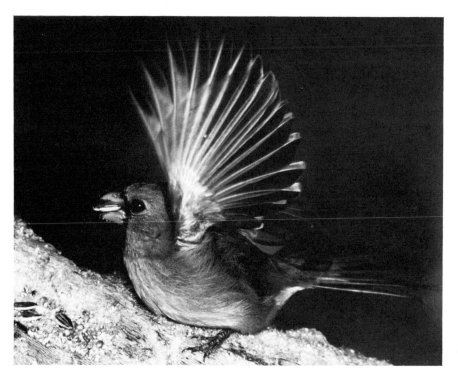

Figure 3.6
Normal shutter speeds could never have stopped the madly
pulsating wing beats of an almost airborne cardinal as did the elec-
tronic flashes used to make this picture possible.

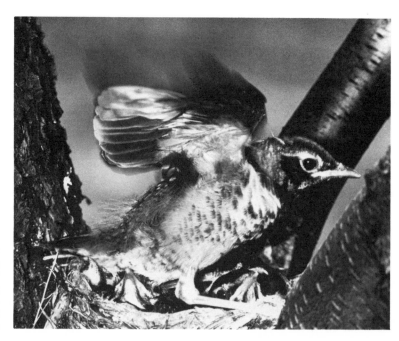

Figures 3.7
The flexing of a young robin's wings
here creates "focal plane shutter blur,"
motion recorded during the 1/60 of a
second that the camera shutter opened
for the synchronization time of the
electronic flash.

For all forms of photography, strobes gain another victory because they go off at such fast shutter speeds (up to 1/50,000 of a second and more) that they negate the problem of camera motion. Then, too, you have the capacity to photograph plants that bloom only in deep shade and animals that are active mostly or only at night. Owls, raccoons, opossums, and many other animals common to suburban and even urban neighborhoods begin their day after dusk. Without a flash, these always interesting, often humorous creatures remain inaccessible even though they rummage through your garbage cans or hole up in the eaves of your garage. Since these animals move about readily in the nocturnal world alien to your eyes, you will find it imperative to have a strobe that works on an automatic mode of operation. This will eliminate the need for time-consuming calculations necessary for the manual mode of operation. While you're busy dividing guide numbers and footage, the animal is busily disappearing. If, however, you are not stalking, if

instead you are waiting at a den or nest, the manual mode will be acceptable because distance calculations will have been established beforehand. In considering distances, remember that your flash will not provide effective lighting for any distance much beyond twenty feet or so, even with a good-sized unit. Another light that you will almost certainly need is a small penlight attached to your camera strap so that you can direct an inoffensive amount of light toward the subject for focusing.

Yet another advantage of strobes, offensive to some, but often pleasing to me, is the black background produced by operating your strobe on its manual mode of operation. The output of light is calculated in relation to the distance of the subject. Very quickly beyond that distance the light's falloff is almost immediate. This produces the almost uniform black background in slightly more distant materials receiving insufficient exposure. In wildflower photography this can be a particularly useful technique. Although it is un-

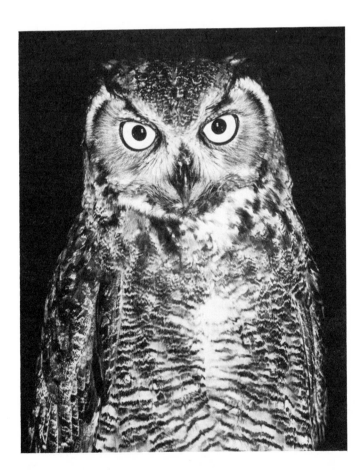

Figure 3.8
Electronic flashes open your door to the world of darkness and permit you to acquaint yourself and your camera with nocturnal creatures, such as this great horned owl.

Figure 3.9
The uncluttered black background, created by the use of a strobe on its manual mode of operation, contrasts effectively with the stems of a dormant cattail shivering with hoarfrost.

questionably not desirable when shooting a dark purple flower such as a violet that will merge right into this background, I find it a very effective contrast when employed behind a pink orchid, a red and yellow columbine, or a creamy winter cattail bound in hoarfrost. Since this technique does severely underexpose more distant material, it can render inoffensive a potentially distracting background.

Electronic flashes gain a final edge when you employ a *slave*, a sensing unit that instantaneously

responds to the sudden burst of light emitted from a main strobe. By positioning a second, slave-equipped strobe out of the frame and behind your subject, and a main strobe at the camera, you can beautifully accentuate vegetation or other subjects with a halo of back lighting. So long as no light from the second unit is striking the front of your subject, there will be no change in exposure.

One final warning: On all those occasions when you will be using electronic flash lighting, I would consistently be aware of the fact that the

Figure 3.10
The small button-like apparatus plugged into the electronic flash is popularly known as a *slave*—a sensor responding to the light output of a master unit.

power output of most units is overrated. There-fore, to follow the dials on the unit that match footage to aperture for correct exposure, especially on the manual mode of operation, will in fact yield an underexposed image outdoors. Most strobes are tested indoors, where light-reflective walls missing from natural environments add to the apparent light output of the unit. Because of this, I have measured the true output of my units against a strobe meter, which is simply a type of light meter that registers the power of electronic flashes. Now I can be far more certain of correct exposures in the field with slight (½ stop) compensations made for subjects lighter or darker than the average value determined by the meter.

Yet another reliable method to determine the true power of your unit on both modes of operation is to perform your own test. Take a normal gray card (available at most any photo store) and focus on its gray side from a distance of ten feet. Most flash units are given a guide number, such as 80, that is used to establish an exposure chart for your unit. You take the guide number (80) and divide it by the number of feet from the subject (10), and the answer (8) will tell you what f/stop to set on the lens diaphragm for proper exposure. By setting the lens at various f/stops during your test, you will at some point obtain a properly exposed image. Let us say that your test results show that a proper exposure was obtained at f/5.6. You now take that number (5.6), multiply it by the number of feet (10), and you see that the true guide number for your unit is not 80, but rather 56 (5.6 × 10). If your unit has been overrated, your images will be underexposed on the manual mode of operation. By doing this simple twenty-minute indoor exercise now, you can save a lot of outdoor heartaches later.

W HEN I FIRST ENTERED PHOTOGRAPHY, I was positively fascinated by all the pieces of equipment, "goodies," as my friends and I would longingly label them. I was hooked; I immediately became a gadgeteer, an accessory junkie. I wanted one of everything and two of most of them. At a maddening pace I set out to purchase each and every one. The lens caps of new arrivals grew steadily larger in diameter, and gadget bags had to be continually upgraded in size in order to accommodate the growing collections of "goodies."

It had to stop somewhere, and fortunately it

did. As my field experience increased, so did my awareness of the absurdity of not only all the paraphernalia I owned but also all that I *couldn't* take with me. I finally sat down and examined my photos to see what lenses, cameras, and so on I really used. Once that was determined, I sold my dead weight, consolidated my working pieces, and settled on an appropriate field setup. Now I carry less weight, but I can cover more of the kind of situations I photograph. This chapter should help you to avoid my mistake and to create a personal attitude toward equipment that will work for you.

CHAPTER FOUR

Equipment: guidelines to some basics

THE RIGHT TOOLS

During the course of classroom judgings of student material, I find that my partner and I often assess not abilities, but rather equipment. We may say, "You should have been closer to your subject," or "You needed a flash to add some light," or "A longer lens would have given this image greater impact."

From the student point of view, the response might be: "I don't have a macro lens," or "I don't

understand how a flash works," or "I can't afford a good long lens."

Although I may understand the objections, especially the financial ones, I still must answer that the job of a photographer is a profession not unlike that of a plumber or a carpenter. Just as these professions require the snake lines and hammers of their skill, so the photographer needs the basic tools of the trade.

If, for example, you find yourself attracted to close-up photography, then *you must have the tools to get the job done.* Maybe you cannot afford the

Figure 4.1
My present field setup is both comfortable to carry
on my shoulder and quick to respond to a variety of
photographic opportunities.
Photograph by Gio Chiaramonti.

top-of-the-line approach to your macro photogra-
phy, so a good automatic bellows unit is out of the
question, as is a 100mm macro lens. But other
roads lead to the kingdom. Certain sets of exten-
sion rings can be purchased for less than $30.
Diopters, filterlike glass attachments that screw
onto the front of the lens, will also allow you to
photograph more closely, depending on their
powers. Although these secondary choices do not
allow the flexibility of the first two, they do work
and they do permit you to improve in your chosen
area.

You must bear in mind that photo editors
and art directors generally are not interested in an
amusing personal story of how you or I obtained a
photo of a rare wildflower that is only a speck in
the frame when a detailed close-up is required.
The editors concern themselves only with the
quality of the finished product. Another's frame-
filling image of the identical flower taken at a local
conservatory is far more valuable, even without
any clever story to accompany it. It is simply a fact
of photographic life that once you know the di-
rection in which you wish to head, you must have

certain basic equipment with which to expedite
that trip. So let us now take the first step on that
journey.

Cameras

So you want to buy a camera? A 35mm SLR, you
say? What a job confronts you! Never before has
the camera marketplace been sated with such a
variety of bewildering options! The choices seem
to present as many selections as a cluster of paint
chips on a color swatch. There are compacts and
sub-compacts; automatics and semi-automatics;
manuals and automatics with manual overrides;
and so on. One manufacturer claims its version to
be smaller than another's; a third advertises the
lightest weight; a fourth the greatest variety of ac-
cessories; a fifth the brightest viewfinder; each
company has a claim. The average buyer is left in
a state of total disarray. What can you do? I hope
that the following information and advice may
help you out of your quandary.

First, it should be clear that all cameras, re-

gardless of cost, chrome, or complexity, are basically alike in the functions they serve and the jobs they perform. Essentially your camera is no more than a box designed to hold your film flat, with a button that allows you to open the box for a measured period of time that will correctly expose the film. Many of today's cameras automatically perform that job for you in one of two ways. Aided by the wizardry of modern electronics, some cameras locate this automatic control on the diaphragm of the lens. In such cameras, it is called a *shutter speed preferred* or *shutter speed priority* system: You set a shutter speed and the camera automatically picks the "correct" lens aperture to yield an accurate exposure. Other cameras locate the automatic function on the shutter speed dial. They are called *aperture preferred* or *aperture priority* cameras because you pick the desired lens opening and the camera electronically selects a corresponding shutter speed. A few models are even designed to permit both systems to work on a single camera. This allows more flexibility for a variety of photographic situations. Some of the automatics are also equipped with a manual system wherein you pick both the shutter speed and the lens aperture. In all cases, the automatic cameras allow you to override that function by as much as two full *f*/stops when you want to intentionally underexpose, overexpose, or compensate for special conditions.

Random sampling of processed and printed film reveals a statistical exposure accuracy of some 80 percent for such cameras. Still, I would not buy one of the fully automatic cameras for myself, nor would I recommend one for you, because such systems basically take control of the photograph away from the photographer. Such cameras are great for someone who wants to quickly snap pictures of a baby crawling around the house or special moments at a lively party. In my photography, though, I want control; I want to interpret each situation. If you are so involved as to be reading this book, then I think you do too. Furthermore, automatic cameras seldom, if ever, allow you to understand what you are doing, either rightly or wrongly. You just press a button and out comes a picture. Hence, I use only cameras that are fully manual. *I* set shutter speed and diaphragm; *I* interpret the light meter's information; *I* am in control.

Whatever type of camera you settle on, I suggest that you hold off on your purchase until you can afford one of the best. By that I mean one that will give years, if not a lifetime, of dependable, quality service. Don't buy cheaper models with the hope of steadily upgrading them; you will continually lose money on your trade-ins and may well be disappointed in their performance results either by acts of omission or commission. A camera spending more time in a repair shop than in your hands is no camera at all. If you can't afford a new camera, check photography magazines or reputable local stores for used bodies that frequently look and operate as good as new. A thorough inspection by you or a knowledgeable expert-friend will guarantee the camera's functioning parts, and the price reduction will assure substantial dollars left over for other purchases.

The Camera Body

What do you look for in a camera body? The ideal comfort and convenience of controls varies from person to person, so you must decide which arrangement feels and works best for you. Beyond that, many beginners want a camera with a built-in light meter and a hot shoe for a flash; that's easy, for most of today's 35mm SLRs satisfy both of those requirements. More importantly though, I think you should look for the following three features:

1. *Self-timer.* By cocking this clocklike device, you engage a time mechanism that delays the release of the shutter for a number of seconds. Not only will this allow you to include yourself in some of your images, but it will also permit you to release your shutter with greatly reduced motion when you've lost or forgotten your cable release or tripod.

2. *Fast flash synchronization.* Because of the focal plane shutter, most 35mm cameras at first synchronized the flash unit at 1/60 of a second. Today's improved models now synchronize at 1/125 of a second. This is a great advantage in reducing the "ghost" shadows of motion that we discussed earlier.

3. *Mirror lockup.* The capacity to lockup the camera's mirror during exposure is perhaps the most important characteristic to seek, for it prevents the greatest source of motion from reducing your image sharpness. Although the flapping mirror has been interiorly baffled and cushioned, it still creates a smack upon its opening to admit

light to the film. To lockup the mirror is to negate that slapping; to lockup the mirror is to create far sharper images when conditions permit. Obviously you cannot lockup the mirror while attempting to focus on a moving animal. Many of today's newest camera models do not have a mirror lockup; manufacturers may state or advertise that they have so totally resolved the problem that it is not necessary. From comparative test results I have seen myself, I just as totally disagree, especially when the camera is used at slower shutter speeds. *One warning:* When shooting directly into the sun, be *very* careful not to leave the mirror locked up for any extended period of time, or else the light passing through the lens may permanently damage the camera's shutter curtain.

One final suggestion on purchasing your new camera: Do not be misled by the arguments supporting the belief that smaller is better. Smaller is only smaller. Since the camera must still contain the same size cassette of film, that means other parts must be made smaller, thinner, and therefore generally subject to much earlier wear. Furthermore, how much of a difference can a few ounces lighter and a few millimeters shorter body make when it is mounted on a five-pound, twenty-inch-long lens? Wise selection of a camera body will give you year after year of trouble-free performance in the field and on the film.

Color Film

If I were to try to identify a single flaw in the photographic equipment of beginners, I think I would most often point to the type of film they have loaded into their cameras. It is such a basic consideration from both the technical and aesthetic standpoints that I find it hard to believe that most novices will thoroughly investigate the types of cameras they might want but then will indiscriminately purchase whatever film is available or whatever happens to be the best advertised, highest speed new film on the market at the time.

It seems to me that at least as much care should be exercised in the selection of the film as was employed in the choice of the camera. A craftsman in fine furniture does not use precision tools to carve from just any random piece of wood; a concert pianist does not attempt to play a complicated Beethoven piece with hands encased

in boxing gloves. Neither can the photographer who uses inferior materials ever reasonably expect to achieve superior results.

As stated in Chapter One, the emphasis of this book is one of color transparency techniques, so the following consideration of film will almost exclusively be limited to that specific realm. Once I have settled on color film, the reasons for selecting transparencies rather than color negatives are numerous:

1. When producing color separations, magazines, books, and other publications work almost exclusively from transparencies, not negatives.

2. The results are apparent to the eye's normal vision. Can you read a color negative? I can't. I see only an orange and purple maze that somehow will become green, white, and so on.

3. The cost is less. To purchase, process, and print at index-card size, a roll of negative film costs some 70 percent more than merely to purchase and process an identical size roll of slide film. Instead of gathering a printed collection of all your bad shots at a reduced size, as you do with negative film, slides allow you to pick out the best and then have those enlarged to an enjoyable desk or wall size.

4. When the process must be reversed, the chemistry involved to convert slides into negatives is far more successful than the converse. Although I have seen orange slides, slides that are too contrasty, and slides that are not sharp, I have yet to see a decent, high-quality slide made from a negative. By comparison, every day I see excellent internegatives made from slides.

5. No 35mm color negative film even approaches the quality of the slide film I am about to recommend.

With that brief justification of my philosophy completed, let me clearly state that I represent no film company. I work for no film manufacturer. I use only those materials that will give me the optimum results demanded by my job's needs. Finally, I think you should know that what is about to follow represents my own personal philosophy, gleaned from years of experience, but in no way does it represent the endorsement of my publisher or anyone else.

Given that introduction, if you are shooting for your own pleasure, load whatever film you please into your camera. If you are not, if you are

shooting to be a serious professional and you are not using Kodachrome 25 film, you are so badly stacking the deck against yourself that you are not achieving anywhere near the results of which you and your lenses are capable! Was I too subtle? If you think that statement brash, how about this one: I personally know of *no* professional nature photographer in 35mm who is making a living with anything other than Kodachrome 25 film. I have experimented with all the other higher-speed films and with the films of the other manufacturers. Today, nothing but Kodachrome 25 film ever passes through my cameras. Without degrading other products and examining their negative aspects, I would far rather dwell upon the excellent qualities of this superb product.

There are so many reasons why I choose Kodachrome 25 film that it is hard to know where to begin, but here's a start:

1. The film's construction and its slow speed (ASA 25) make it virtually grainless. When the time comes to go to publication or to make large prints, it is easy to see that it is far and away the finest 35mm film made. Magazine, book, and calendar publishers need the crispest original possible to create high-quality plates for reproduction. Kodachrome 25 film gives it to them in abundance. With the advent of direct positive printing processes in which you make your print directly from your slide with no internegative step required, even larger size prints with greater quality are readily available from Kodachrome 25 film. I have forty-inch prints from this film that gallery viewers contend had to come from 4 × 5-inch film size.

Many beginners unjustifiably object to the slow speed of K-25, and they base most of their reasons for not using it on this premise. But if they would think the argument out to its conclusion, I think that their objections would dissipate. In these days of high-speed lenses, K-25 is always usable, especially on a tripod. The exposure balance for this film on a sunny day equals 1/125 of a second at *f*/8, an exposure equivalent of 1/250 at *f*/5.6, 1/500 at *f*/4, or 1/1000 at *f*/2.8. Many shorter lenses are as fast as or faster than *f*/2.8, and most lenses up to 300mm are at least as fast as *f*/4. If, in these sunlit cases, you are underexposing for saturation, as will be expanded upon later, you can add another *f*/stop and you would now be shooting at 1/1000 at *f*/4. You are now at the *fastest*

shutter speed on most cameras! You can go no further; why then would you possibly want to concede the superb quality considered here and following when there is absolutely no need to do so?

2. K-25 most naturally reproduces nature's colors. Although there are definitely a few conditions it does not handle admirably or to my satisfaction, it reproduces all the others so well that this inconvenience can be readily accepted, especially when the more imperfect alternatives are considered. Some people would have you believe that color is a subjective matter of taste, a personal judgment of the individual. I refuse to accept that argument. The *perception* of color may be subjective; whether you like or dislike one color or another certainly seems to be subjective. But color itself is a physically measurable phenomenon, just as is the length of a football field or the weight of a car. Color can be measured by the frequency of its wavelengths. In fact, color is so precise that astrophysicists, working with ultra-sophisticated machinery, can create a staggeringly precise biography of the age, direction, and composition of stars light years away merely from analysis of the color of the spectrum emitted. Although neither you nor I have access to the elaborate technology to measure the color frequency of a field of wildflowers and a slide of that same field, others do. Once conversion formulae are applied to equalize the differences in light temperature between sun and projection lamp, it becomes a simple matter of either equalling or not equalling frequencies. Although color-balanced somewhat warm, K-25 does this best.

3. K-25 gives you vibrant contrast.

4. K-25 provides an excellent exposure latitude. For a slide film it gives surprising room for exposure error and still acceptable results, especially in underexposure.

5. K-25 gives superb shadow detail. Unlike other films I have used, it maintains shadow detail better and does not allow these areas to go black. With correct exposure of light levels within the film's latitude, you can see into K-25's shadows.

Can you fathom a Rolls Royce automobile costing less than a Volkswagen automobile? Well, in one of the ironies of filmdom, that is exactly what happens. Kodachrome 25 film, commonly regarded by illustrative photographers as the best film, is also the cheapest of Kodak's slide films.

But please, do not blindly believe me; buy a twenty-exposure roll of three or four different types of film that interest you and conduct your own controlled test. For a minimum investment, you will convince yourself what is best for you. Make sure to keep accurate records as you shoot simultaneous pictures of a number of variables:

1. Shoot the primary colors of red, green, and blue.
2. Shoot black and white and flesh.
3. Shoot the above colors in sun and in open shade.

When the processing returns, compare the results. There are obviously many films to serve many purposes. High-speed films greatly reduce contrast and, because of their grain structure, enable you to achieve special effects in printing. Other films are balanced toward one particular color or favoring one end of the spectrum. This will allow you to emphasize a warm or cold feeling of a given subject. But if you are shooting nature to render it as you see it in the magazines, I feel that you must be loading your camera with Kodachrome 25 film.

In the final analysis, I fine that most beginners will not listen to this or any other argument. When students comment to me that their slides don't display the colors that they see in mine, I now feel that there is only one response: "If your slides don't have that color and if you want them to, then you've just got to switch films."

Black-and-White Film

Should you choose to load your camera with black-and-white film, you will find three basic technical options. The general types of black-and-white film are categorized according to the speed of each, *i.e.*, their sensitivity to light (ASA). First are the fast-speed films, commonly considered to be those with an ASA of 400 or higher. Secondly, we have medium-speed films whose ASA range loosely extends from 64 to 200. The last are the slow-speed films with an ASA of 50 or less. The differences in the films lie essentially in the relative size of their grain and contrast. Higher-speed films have much more noticeable grain structure, slower films far less; on the other hand, the faster films have greater abilities to

handle more contrast levels. Because the slower films lack this capacity, your exposure control is far more critical when you use them. Both fast- and medium-speed black-and-white films offer the photographer a far greater exposure latitude than the color slide film discussed previously. In practice, this translates into the fact that a poor exposure on color slide film that might have to be discarded can readily be saved on these black and white print films.

You should be aware of the fact that distribution for black-and-white nature photographs may offer a greatly restricted market, sometimes limited to the pictorial galleries that require grand enlargements of scenics taken with a large format camera (4 × 5 inches in size and larger). By comparison, 35mm film cannot compete with the results obtainable from the negative of the same type of film that originated in the camera some ten to fifty times larger. Although the bulk of 35mm photojournalism is still black-and-white–film oriented, as are publications such as this book, many of nature photography's most exciting and most colorful subjects are crimped by the use of black-and-white film. Sunrise, sunset, fall foliage, brightly plumed birds, and gaily decorated butterflies are but a few of the numerous themes whose black-and-white print is likely to suffer in comparison with a color presentation.

Although I personally do not like black-and-white film as a medium for nature photography, the rising costs of color film and color plate making may substantially increase the use of this film in future nature photography markets. Even today, nature magazines such as *Audubon, Natural History,* and *National Wildlife* make use of black-and-white photographs.

Regardless of what film or films you eventually select, you must treat your film with the attention it deserves. In its unprocessed state, one of film's major enemies is heat, for it accelerates the chemical processes of change. Before use, your film can be stored at home in the refrigerator to keep it cool and thereby retard these chemical reactions. Before shooting, though, make sure that you remove the film for at least a couple of hours to allow it to warm to room temperature, or else condensation spots may form on the film.

When you're shooting in the field, especially on a two-week or longer vacation or assignment, I suggest that you keep your film inside the plastic container with the lid on. This will greatly help in thwarting the admission of moisture, an even

greater foe of film. Secondly, store it in a cool spot of the car, certainly not in the glove compartment or on the floor near a hot muffler. I always store my film, in its original container, in a white box wrapped in layers of white sheets, and then stow the package in the car's coolest place, usually on the back seat on the side away from the sun. If possible, I always park the car in shade when out on extended hikes.

In conclusion, as soon as you've exposed the film, send it on its way for immediate processing so that the chemicals can be stabilized. If you use Kodak film, note that there are a number of processing laboratories strategically scattered across the country. Mail your film to the location nearest where you are shooting; do not send it to the one closest to your home. The film's greater danger period is before, not after, it is processed. When you start your film on its way, do not indiscriminately deposit the mailer in any mailbox near Phoenix at 6 o'clock on a Saturday night. The next pick-up may not be till noon on Monday and your film will swelter in an oven of your own creation. Instead, take your film to a post office. Even the smallest towns have indoor locations that will afford better waiting conditions for your valued exposures. Having taken such basic precautions to safeguard your film, you should have alleviated any doubts concerning those matters that are in your control.

Lenses: From Wide-Angles to Telephotos

After settling on the type of film you wish to load into your camera, the next question you will have to answer is: "What kind of pictures do I want to take?" Once that issue has been resolved, you will be able to decide which lens will most effectively serve your purposes both technically and aesthetically. For our purposes here we shall omit macro lenses (which we'll investigate in Chapter Five) and look at three broad categories—standard, wide angle, and telephoto—along with a brief excursion to the land of zooms and mirror lenses.

For many of you the answer to the original question posed above will be: scenics. You will use your camera to record the picturesque places you visit for your two or three weeks of vacation time. Although the standard 50 to 55mm lenses that accompany a camera body are probably the most useless of all lenses for nature photography,

they will nonetheless handle admirably a majority of the scenic situations you will want to photograph. Lenses of this general focal length look out at the world and record its varied subject matter with much the same size perspective as that seen by the human eye. For this reason, 50mm lenses issue a naturally pleasant and realistically sized image. From canyons to mountains, from ponds to oceans, this optic is versatile enough to feel at home in most normal scenic locations.

If the only subject matter in nature to attract your photographic attention is scenics, a 50mm lens is certainly acceptable. However, if you anticipate that your interest is not just a passing whim and if you express an interest in a variety of natural subjects, I would heartily suggest *not* buying such a lens at the time you purchase your camera body. Rather, try to estimate as best you can the direction of your interests and buy a more specialized lens suitable for close-ups, whether frogs or flowers, panoramas or wildlife in action. Even in scenic photography you will sooner or later recognize that many situations are far from normal. One day you may discover that you cannot capture all of the billowing clouds scudding above the sawgrass of the Everglades with your normal lens. On another day, positioned against the rim of the Grand Canyon, you just can't take another step back to frame the glowing rocks with the silhouette of a gnarled tree.

What can be done? Realizing that their 50mm lens does possess some very real physical limitations, many advancing photographers will choose to augment their collection with the purchase of a wide-angle lens. This lens, shorter than the standard lens, does exactly what its name indicates: it looks out at the world with a wider angle of view. As the focal length of a wide-angle lens decreases, its angle of view increases; hence, a 24mm lens, shorter than a 35mm lens, will see a larger angle of view than the latter. Lenses of this type will allow you to include an entire panorama of autumn farmland or to capture the breadth of a wind-swept day along a frozen lake. But the very feature that is the greatest asset of a wide-angle lens can frequently become its biggest impediment. It simply sees too much, as it did for me on the day pictured in Figure 4.2A, taken in Arches National Park. As I waited for the sun to rise, the abundance of scattered clouds convinced me that the whole eastern sky would soon be aflame with color. So I set up with my 35mm wide-angle lens and recorded the moment. As the sun neared the

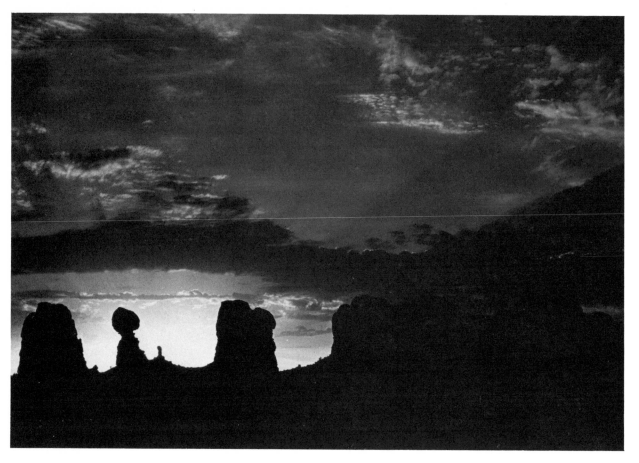

Figure 4.2A and B
Whereas a wide-angle lens often sees too much unwanted subject matter
(above), the telephoto can narrow in on only the finest material (opposite).

horizon, I saw that my imagined magnificence was not going to be. So I quickly switched to a 300mm telephoto and aimed only at the brightest section of sky—that portion surrounding the second-from-the-left rock formation. The result, as you can see in Figure 4.2B, was a dramatic improvement in composition and, for me, an image with far greater visual impact.

Because of this dual personality of wide-angle lenses, I personally find them to be the most difficult to use effectively. Not only do they reduce the size of distant subject matter to less than that to which our eyes are accustomed, but they also give the appearance of remoteness, thereby

making it difficult to fill the frame of the already tiny piece of 35mm film. This fact in turn leads to a reduction of *impact*—a key word for any scenic photograph.

But, because of the arrangement of internal lens elements, the wide-angle lens can effectively be employed to distort foreground perspective. Try using your 28mm or 24mm lens tilted straight up against the trunk of a fall tree turned to gold. Make certain to choose the vertical format and you can't help but feel the illusion of heighth given to your tree. A second comparison shot, taken with your 50mm lens, will dramatize the difference.

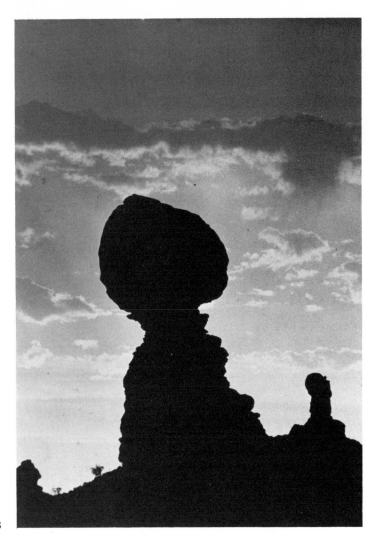

Figure 4.2B

Recognition of these characteristics will permit you to emphasize the pluses and negate the minuses of the wide-angle lenses. Use a wide-angle lens when:

1. you want to distort foreground subject matter or create unusual perspective,
2. you desire to create the illusion of vastness of space and distance,
3. you cannot include wanted material with your standard lens,
4. you are working under physical conditions that restrain your locomotion to compose as desired, and

5. you require the maximum depth-of-field possible.

Even for scenic photography, I generally prefer telephotos (of the shorter focal lengths) for at least two reasons. First, the telephoto's angle of view acts exactly the opposite of the wide-angle's. Whereas a 35mm wide-angle lens may see an angle of some 62 degrees, a 150mm telephoto will view only 17 degrees from the same spot. Why shoot an entire mountain range when the alpen glow of sunset is striking only one peak? Your 35mm lens will see all of the unlit peaks and reduce the size of your one glorious mountain to an

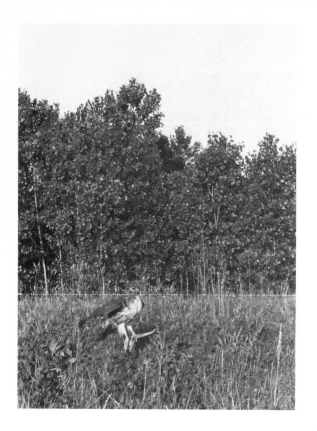
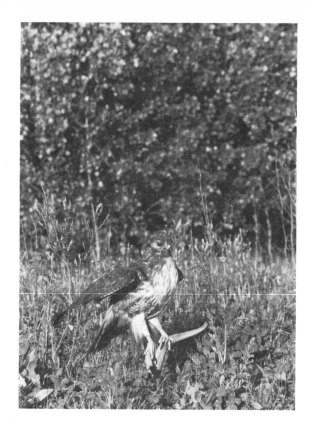
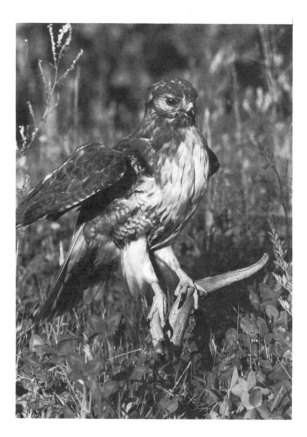
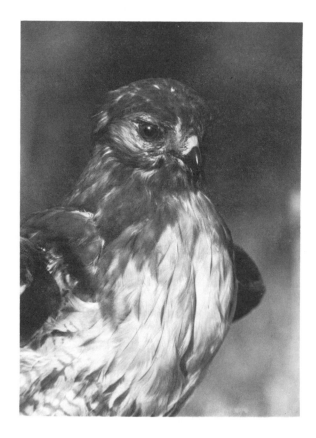

Figures 4.3A, B, C, and D
The steadily decreasing angle of view and regularly increasing size magnification of telephotos is shown by these four shots of a taxidermy specimen taken, in order, with 50-, 100-, 200-, and 400mm lenses.

almost unnoticed molehill filling only a fraction of the frame. In contrast, telephoto lenses in the range of 85 to 200mm will never see all of those dull mountains and instead will accentuate your special peak through increased size to dominate the frame. Figure 4.4 was recorded under the monkey bars, over the merry-go-round, above the fence line, and between the chimneys of the houses that line the playground of the elementary school where I once taught. But because it was taken through the eye of my 640mm lens, all of that extraneous material was eliminated and the film registered only the skeletal outline of a splendid cottonwood that flourished on our playground and the glowing sky beyond.

The second reason I rate telephotos as my favorite photographic optics concerns the compression effects they achieve with foreground-to-background distances. In Figure 4.5, the anhinga in the foreground actually is resting some twenty-five safe feet from the alligator in the background. But because I shot her through the compressing eye of my 500mm lens and because I composed the alligator's massive jaw against her (the anhinga's) slender neck and waited for her to pose somewhat nervously, she now appears to be rather anxious about her reptilian visitor.

Yet another benefit of the very long focal length telephotos is their extremely narrow depth-of-field. Although calling this a benefit may sound contradictory to some people, consider the fact that the human eye is attracted to sharpness and repelled by its absence. Do you remember how your eyes watered when you tried on the glasses of a friend whose prescription didn't coincide with yours? If you have photographed a

Figure 4.4
The narrow angle of view seen by a long lens.

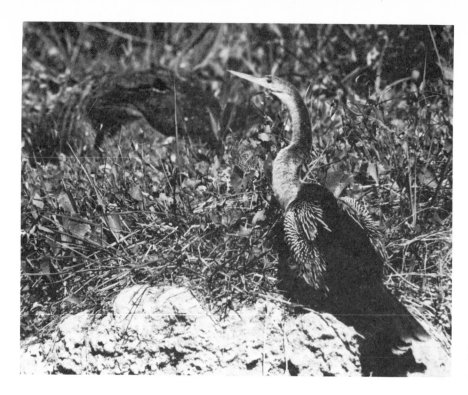

Figure 4.5
The compression effect
of a long lens.

pronghorn on the grassy prairie of South Dakota in such a manner that every neighboring blade of grass is as crisp as the pronghorn, you may be in trouble. If your audience is looking at the grass rather than at the pronghorn, you're definitely in trouble. The preferred option in some situations such as this may be to use a long focal length lens and a large aperture that will blur the grassy en-

vironment into a pleasant background and force the viewer's eye to the sharp focus on the pronghorn's eye. Occasionally you can even position a sharply focused animal between an inoffensively out-of-focus foreground plane and a substantially blurred background plane to produce a more dimensional image with the effect of a diorama.

Figure 4.6
The use of a long lens at a large aperture creates an out-of-focus background
and forces the viewer's eye to the sharpness of the subject—a pronghorn.

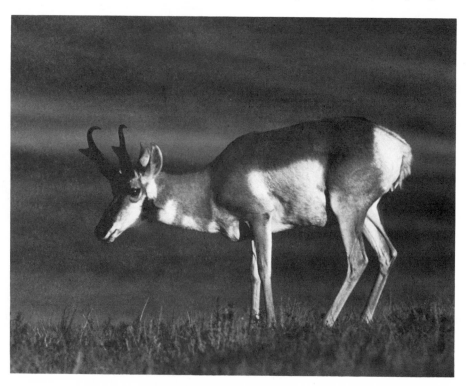

To summarize, use your telephoto when you want to:

1. eliminate unwanted subject matter,
2. compress foreground-to-background distances,
3. bring distant subjects optically closer,
4. flatten perspective,
5. emphasize one sharp element, and
6. minimize depth-of-field.

In conclusion, the judicious selection of lens type will go a long way in enhancing on film for your audience the feeling you experienced at the moment you decided to release your camera's shutter.

More on Lenses: Zooms and Mirrors

For years, I remained staunchly (and perhaps stubbornly) opposed to the use of zoom lenses. How, I argued metaphysically, can a lens designed to perform 126 optical tasks possibly do any one of them as well as a fixed-focal-length lens designed solely for one purpose? In the early days of zoom lenses, my philosophic objections concerning their shortcomings were photographically substantiated by optical results notably inferior in sharpness and contrast, especially when the lens was used at maximum aperture. As the years passed, my objections neither changed nor improved, but zoom lenses did. New optical coatings and formulae improved all lenses; zooms further benefited from the more efficient arrangement and movement of internal zooming parts. Finally, at the suggestion of my brother, who was working as a technical representative for one of the manufacturers, I was persuaded to accept and test one of the company's demo models. That week I experimented with a 100–200mm zoom lens on the antics of my brother's four terriers. As a thank you, I made a 16 × 20-inch print for him. I was convinced; the enlargement was sharp, even to my critical standards. That same week I purchased the lens for my system; shortly thereafter I added a second zoom lens to suit my needs. Today, they are both valued members of my lens arsenal that I would not care to do without.

The two zooms I employ are a 45–125mm and a 100–200mm continuous focus, macro zoom.

The two of them have greatly simplified the problem of carrying in the field. With the pair mounted on my double tripod head, I have 156 lenses covering 45 to 200mm and possessing macro capabilities. One of the great advantages they provide is instant, on-the-spot cropping for scenics, for close-ups, for anything. If 61mm is too small, simply zoom to 94; if 173 is too large, maybe 109 will yield a better composition.

The first optic gives me a variety of lenses that stretches from just a small wide angle to nearly three-power telephoto. I find this lens especially useful at sunrise because of the flexibility it provides for a sky colored widely or slightly; in the same way, it is useful for scenics. The second lens is also used at dawn, even more extensively, not only for its four-power magnification at 200mm, but also because of its macro capacity. Should I discover a dew-laden butterfly only three feet away while I am shooting the rising sun at infinity, I can instantly move to my new subject with no lens switching, no extension-ring additions, in fact no adjustments except to refocus. Because of its continuous zoom feature, this lens is particularly valuable to me at close-up distances. Some macro zooms have macro capability only at their shorter-millimeter lengths. I have selected this lens because it focuses as closely at 200mm as it does at 100mm. This near-focusing capacity, combined with the length of the zoom, not only allows me to stay as far away as possible from an animate subject that might be scared off, but it is also powerful enough to reach into places where I cannot walk. If I happen upon a small moth, I may need all 200mm, but at least I don't have to sit on the insect's wings; for a larger dragonfly that replaces the moth on the branch I may require only 171mm, but that's okay, for I merely need to zoom down. Should a yet larger toad pass beneath the plant, I can stay right where I am and zoom down to maybe 126mm. This is all very convenient for reduced motion, as it means less chance of frightening off the animals.

Although my feelings toward zoom lenses have altered over the years, my attitudes toward mirror lenses have not. Many newcomers though are smitten by these cata-dioptrics, commonly called *mirror* or *reflex lenses*. Such optics entice by their compact size and incredible near-focusing distances. Mirror lenses are commonly less than half the length of their telephoto counterparts and normally weigh much less. In addition, mirror lenses in many instances more than halve the near

focusing distance of traditional telephotos, although some of the new models are rapidly narrowing this gap. Where my manufacturer's 1000mm telephoto lens can focus only to one hundred feet without any extensions, its 1000mm reflex lens focuses to twenty-six feet! A substantial advantage, no doubt about it.

However, I would never recommend a mirror lens to the serious nature photographer, because the apparent advantages are outweighed by simply too many more manifested disadvantages. Although the newest-model reflexes coming out at about the time of this publication are said to reduce or resolve many of the drawbacks, there are still flaws inherent in the design of the lens itself. The most insurmountable obstacle of any mirror lens is the fact that you have *no* adjustable diaphragm to vary your aperture or to manipulate your depth-of-field. The negative influence of this characteristic alone is almost overwhelming for depth-of-field, which is the *only* artistic control you possess on your lens, and you immediately concede it forever. If the lens is an $f/8$ optic, in one sense it will always be an $f/8$. The lens may have a rotating filter disk; among the filters there may be a neutral density filter that reduces your lens from an $f/8$ to an $f/11$, but that filter only blocks light, it does not alter depth-of-field. Secondly, you cannot shoot into the sun when it is at any elevation in the sky without getting a donut ring around it. Thirdly, there is the problem of out-of-focus highlight materials that are doubled because of the bouncing of the light by the mirrors. This results in distracting circles of confusion and other environmental features such as twigs and foliage that are out of the plane of focus. Although this doubling presents no problem for clear backgrounds such as calm water or smooth rock, most of the wildlife you are likely to want to picture with such a lens is not found under those conditions. Fourthly, with many models, you cannot shoot into a blue sky without obtaining a prominent circle of overexposed film in the center of your frame because of the concentration of light reflected off the core mirror. Finally, these mirror lenses are generally more subject to impact damage than telephotos. Such shock can cause displacement of optical elements that in turn can adversely affect image sharpness. Mirror lenses can ill afford further reduction in sharpness, or the appearance of what we see, because they already yield less contrast (acutance) that, together with resolution and granularity, is one of three pre-

cisely measurable factors used to define the imprecise term *sharpness*. In conclusion, therefore, I find that mirror lenses, though useful in a handful of highly isolated situations and under skillful control capable of some interesting effects, normally do not come up to critical standards.

Automatic Lenses

The final consideration in our discussion of lenses deals with a feature that I think you should always look for in any lens, *i.e.*, an automatic function. Not to be confused with automatic cameras, which take control away from you, automatic lenses give you far greater control, along with speed of operation and ease of focus. Such optics contain a pin or flange that, a fraction of an instant before exposure, activates the lens diaphragm to a previously set $f/$stop while allowing you to focus with the lens wide open. Let's posit an automatic 300mm–$f/4$ lens that you have chosen to photograph a swan. Your independent light meter indicates an exposure of 1/250 of a second at $f/11$. With an automatic lens, you can immediately set your diaphragm at $f/11$ and yet still be focusing with the brightness of $f/4$, the maximum wide-open aperture of your lens. Since $f/11$ is a much smaller aperture, admitting much less light, it also makes the image much dimmer and therefore much more difficult to focus. If you were using a manual or a preset lens in this case, you would be placed at one of two distinct disadvantages.

First, you could set the lens at $f/11$, but then you would be looking through such a dark viewfinder that you might not be able to focus with any speed or confidence. Secondly, you could leave your lens open at $f/4$, focus and then stop the diaphragm down to $f/11$, but by then you would have lost time, probably some of your composition, and possibly the swan. The automatic feature on any lens eliminates this dilemma; in every type of nature photography, from macro to telephoto, it qualifies as a valuable teammate. Wherever you align your diaphragm, you are still able to focus at the brightest light-transmitting capacity of the lens. For lenses up to 300mm in length, I would buy nothing else but an automatic lens. Beyond 300mm, the complexities of maintaining a manageable size and weight plus an effectively usable diaphragm speed and near-focusing distance so magnify the problems (including the cost) that only a handful of manufacturers market them.

Tripods

Over many years of teaching many hundreds of students, it has been my experience that the hardest good habit for them to develop and put into constant practice is the use of a solid tripod.

After viewing my instructional slide show that kicks off our full-day workshop together, one or more of the students is almost certain to pass along one of the three comments I most frequently hear: "Boy, I've never seen slides as sharp as that; you must have really good cameras!" Of course I have good cameras; but many class members have more expensive models than I. What I do have and what I do *use* is a good tripod. I am no miracle worker, but I *am* an adamant tripod advocate. Even if I am shooting with a 28mm lens set at *f*/8 with a shutter speed of 1/1000 of a second, my camera still sits on a tripod.

I am impressed with both the number and diversity of inventive excuses that students can find to avoid this one discipline that will probably make the single biggest difference in raising scores of their photographs from the realm of mediocrity to the kingdom of excellence.

> "I've got really steady hands, so I don't need one."
> "I'm allergic to aluminum."
> "I read an article that showed how carrying a tripod can cause shoulder cancer."
> "I'm shooting at a fast shutter speed."

I don't care how *fast* you are shooting or how steady you *think* you are. Blood runs in your veins and air courses through your lungs. As you hike with your equipment, the muscles in hands and arms, shoulders and legs contract and expand, tense and relax—causing further imbalance in the human biped. You can find all the excuses you want, but if you are at all serious about improving your photography and *if there is sufficient time to shoot*, there is no alibi good enough for not using a sturdy tripod. If you are going to use only a spindly-legged tripod, it is not much of an exaggeration to say that you may as well not have one at all.

Figures 4.7A and B
This is a tripod (left): The camera is based solidly on a sturdy *three*-legged system of support. This is a unipod (right): The camera is not-so-solidly supported on a *one*-legged column that happens to be standing on a tripod.

In addition to providing your images with far greater crispness and clarity, the tripod will become your biggest ally in forcing you to really look at and "see" your photographs. Is the composition pleasing to the eye? When you hand-hold your camera, you probably look at your subject and then take the camera away from your eye to make proper mechanical adjustments before re-elevating it to eye level and then snapping. What do you think the odds are of relocating that camera in the exact position maintained only seconds before? You needn't be Jimmy the Greek to figure that they are almost nonexistent. On the other hand, a tripod will allow you to position and *hold* the camera *exactly* where you want it. You will have time to look over your frame from top to bottom, from edge to edge. You can comfortably wait for the wind to stop blowing on your flower; you can outlast the sun as it hides behind passing clouds. Are there hot spots in the background? Change your angle! Does a tiny twig almost imperceptibly stick a finger into one of the corners? Move closer! Straighten the horizon line. Slow the shutter speed. Check your depth-of-field preview. Add a polarizer to the lens. Your camera isn't going anywhere in the world, but with your improved photographs, you might be going somewhere in the world of photography. Did you get a sharp image today? Did you capture a special composition? Thank a tripod!

Does it appear as if I am raising the issue of sharpness to the level of an obsession? Perhaps I am. But I also understand, appreciate, and even employ the use of softening techniques. I accept softness or lack of sharpness when they represent the *conscious* efforts of the photographer to achieve a desired artistic effect; I do not accept them when they are a cop-out, an alibi for laziness, or the failure to use a tripod. Furthermore, if you didn't dearly value sharpness too, why did you go out and spend all that money on first-rate optics? You could easily obtain fuzziness with the use of cheap lenses. Using your top-quality lens without a tripod may be considered analogous to driving an Indy 500 car in Chicago's rush-hour traffic. Neither lens nor car can reach its full potential.

Light Meters

If we were to liken our finished photograph to a finished bakery product such as a loaf of bread or a coffee cake, we would see each one as the result of a certain recipe containing perhaps flour, cinnamon, and yeast; or light, time, and a polarizer. Just as the baker employs measuring cups, spoons, and so on to ration the proper ingredients, so the photographer must have a device to measure the photograph's most important ingredient—light. The importance of this measuring cup for light, a light meter, cannot be overemphasized. A wide variety of light meters temptingly vies for your purchase dollar. There are incident light meters, those that measure light shining onto the subject; there are reflected light meters, those that operate by measuring the light bounced off the subject. Today's 35mm SLRs almost invariably contain a light meter of their own in the body. Brandishing meters advertised as selenium, cadmium disulfide, or silicon blue, they are all very impressive, as well as very confusing.

So remember: regardless of a light meter's simplicity or complexity, they are *all* alike in that *every one* of them measures 18 percent gray or the *middle* of the light scale between maximum white reflectiveness and minimum black reflectiveness. Therefore, I have settled simply on a one-degree spotmeter. I first used a spotmeter by accident years ago. At the time, I owned two camera bodies, but the light meters in both were nonfunctional. Two days later I was leaving for the Everglades. With no time to have the body meters repaired, I walked into a professional dealership and bought a one-degree meter. To this day I have never once regretted it; I would not be without it. It is hard to pick a most valuable tool, but if this meter weren't on the top, it would be awfully close.

Because of the type and/or location of their cells, the meters in camera bodies can all be tricked to a greater or lesser extent by certain lighting situations. But I have never found my spotmeter to be incompetent. Spotmeters resemble stubby pistols; they see the world with an eye sensitive to only one degree of light, a degree that is indicated by the tiny circle in the viewfinder. So critical are these tools that a bird with white, pink, and red feathers might yield a different reading for each of its colors. These meters allow the photographer to critically expose for the value of greatest interest. In color slide photography, this is an absolute necessity for at least two reasons: first, the comparatively narrow latitude (five stops for K-25) of the film's ability to handle a range of light values, and second, the basic absence of the zone system of exposure that works for black-

and-white film. In many lighting conditions, color slide film cannot simultaneously render both the high and the low light levels indicated by the meter. For reasons to be discussed in Chapter Six, you must commonly expose for the highest light value. What is of importance here is the fact that the one-degree spotmeter provides you with unrivalled flexibility to pick out this value (or any other value) better than any averaging or integrated metering system. All spotmeters are equipped with both high and low light levels so that you can obtain readings even under very dim conditions. Some even give you a digital readout for your exposure. They all give you what you must have most: critical exposure control.

Filter vs. the Atmosphere

Except for a polarizer, I use *no* filters at all, for a number of reasons. First, I believe that to shoot *natural* images *unnaturally* amounts to almost contradictory terminology. Imagine this: an audience sees one of my photographs with a haunting yellow glow. Later one of the viewers asks, "Did you use a yellow filter?" If I answer in the affirmative, my natural image is rendered unnatural and, far worse, all future images with unusual color or lighting become implicitly suspect. Flaming red waters appear on the screen and the audience does not even bother to question me but instead collectively whispers, "He used a red filter," *ad infinitum.* I do not wish that; instead, I prefer to use the greatest filter ever conceived—the earth's atmosphere.

When passed through layers of fog, mist, and haze, the sun's light strikes the earth's varied subjects in an infinitely variable manner. An orange filter used on color film will simply make everything oranger, but light filtered through the atmosphere will create not only many hues of orange, but also tangerines, cinnamons, and apricots as it illuminates the crevices and crystals of rocks, the bark of trees, and the feathers of birds. But if you pursue scenic photography seriously, I would urge the immediate purchase of a polarizer, a rotating filter that effectively blocks all wavelengths of the spectrum except for blue. The benefits are many. The obvious first one is saturation of your blue sky color and concomitantly a greater separation for cloud structure along with a reduction of atmospheric layers of haze. While enriching the blues, your polarizer will not shift other colors

but will actually improve them by taking out the specular reflections of the sun. The sun's light is pure white. When it strikes a shiny surface, it creates a white spot or a specular (mirror) reflection. Without a polarizer, your rich fall foliage looks pale, your glowing rocks weak. With the polarizer, you take out the specular reflections and your leaves turn red again while your rocks glow anew. When used properly, the polarizer can also take the reflections out of water and windows. The polarizer reaches its maximum effectiveness when used at any angle of 90 degrees to the light source. As the angle decreases, so does the effect of the polarizer. Another benefit is that the polarizer's influence can be controlled, unlike other filters, which are either on or off, all or nothing. The polarizer allows you to determine how much power you want it to exercise by rotating it through the entire 360-degree arc of its circle and stopping at the point you desire.

The one disadvantage many nonusers point out is the reduction of light reaching the film. This is true; at maximum polarization you will lose some two full f/stops of light. But remember: If you are serious about your photography, your camera is going to be locked firmly on a tripod and therefore the loss of light normally will not matter. In fact, this apparent disadvantage can readily be turned to a substantial advantage. Since the polarizer is blocking the light, you will be able to use slower and slower shutter speeds to record rushing water and transform it into sensuous veils tumbling over rigid rock. You will also be able to shoot into the sun without exceeding the chemistry of certain fast films. One valid drawback is that the thickness of some polarizers, when used on wide-angle lenses, may be seen by the eye of the optic and therefore cause vignetting in the corners of your pictures.

For black-and-white–film users, other filters may be deemed an absolute necessity in many instances. Yellow, orange, and red filters, for example, will steadily dramatize the clouds in your scenics. Many photographers employ the skylight filter (a pale pink) for both color and black-and-white photography not only to slightly warm cool shadow areas but also to protect their valuable lens glass. Indeed, it is true that, if you're going to bump against a rock, it's better to scratch a $20 filter than a $200 lens. However, I would suggest that instead, you protect your lens with the lens cap or at least remove the filter before shooting. The filter's effect on the shadows is negligible, but

Figures 4.8A and B
The dramatic effect of a polarizing filter can be seen by comparing these two photographs of a cloud structure—the first taken with a polarizer, the second without.

its reduction of image sharpness is more apparent. The curvature of your fine lens has been designed for maximum correction of optical flaws; with the filter you place nothing but a flat piece of glass in front of this computer-perfected optic. To me and many others that makes no sense at all.

Motor Drives and Auto Winders

One of the great technological advancements of recent years to aid and abet still nature photography, especially in the area of wildlife photography, has been the arrival and improvement of motor drives and auto winders, two types of automatic film advances that can speed the emulsion through your camera on a continuous mode of operation that will evaporate your 36-exposure roll of film in less than ten seconds or on the more conservative basis of a single frame at a time. By comparison, the hands and reflexes of the photographer are almost primitive. Today's most so-

phisticated, specially-adapted motor drives reel off as many as ten frames per second or nearly half as many as a movie camera.

I personally do not like the haphazard use of motor drives. I find that many photographers operate them on the principle exemplified by the saying "Even a clock that has stopped tells the correct time twice a day!" Such photographers carelessly bang away, apparently feeling that out of sheer statistical probability, something good is bound to be recorded. I far prefer to be more selective and to limit my use of motor drives to those times when they profitably negate the reflex time needed to advance the film during critical moments of action that I would otherwise miss. So, when the frost is on the meadows and the necks of the Yellowstone elk are swollen with the hormones of the mating season, you can rest assured that my motor drive will be on the camera to capture the posture of their bugling, the condensation of their breath upon the refrigerated dawn air and, most of all, the head-shattering clashes of their antlers when locked in battle. The motor

drive will also be there when a flock of Canada geese on a local river is preparing to take its evening flight, when the alligators of the Everglades prehistorically rise from the sloughs, or when rowdy blue jays converge upon winter bird feeders.

Some people object that the noise of motor drive units scares away the animals. I have almost never found this to be a problem; but if the first few frames advanced by the motor do seem to alert the animal or cause it some concern,

I may wait a while or I may periodically release identical frames to accustom the animal to the sound before attempting a closer approach to record the special, frame-filling moment I'm seeking.

Auto winders are not so noisy and they do not yield so many frames-per-second, but then again they are more compact in size and they cost nowhere near as much money either. More on these valuable aids will follow in our section on wildlife photography (Chapter Five).

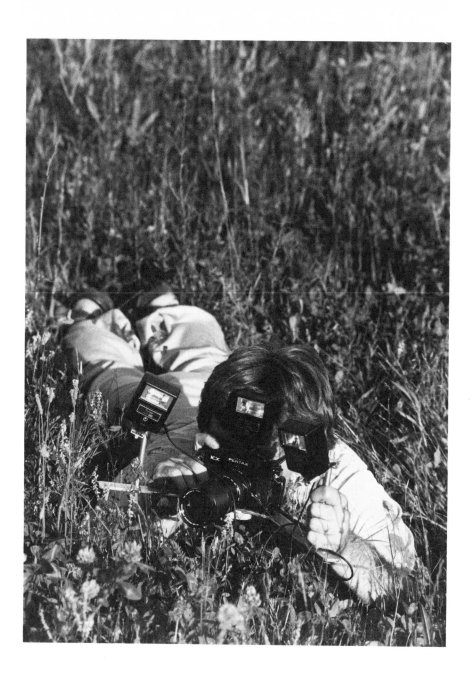

A MONG SEVERAL APPEALING GENRES of photography, you have opted for nature photography. Although the term appears to be rather self-defining, I do think that there are some distinctions to be made and some issues to be clarified. In camera-club competition, an image of nature is defined as one in which there is no evidence of the hand of man. As a definition to serve categorical differences, that description is fine by me. Whether man is or is not "natural" is a question that can presently be left for another discussion. But at this point I do think we need to define and

recognize the differences between *biological* photography and *nature* photography.

To me, nature photography is wading the edge of a swampy pond in search of spring peepers; nature photography is fighting off hordes of mosquitoes on your way to a Calypso orchid; nature photography is sitting in a blindingly oppressive sun for eight hours with nothing to eat as you wait for the eagle's repeated visits to her nest. Nature photography can also be the sunset photographed from your back porch, the mockingbird pictured on your front lawn, or a view of the

CHAPTER FIVE

The nature of photography; the photography of nature

sea taken from your vacation retreat. In essence, however, both are field photography—field photography as opposed to biological photography, which photographs natural subject matter in a controlled studio environment.

Such photography serves many useful scientific purposes, such as revealing the intricate changes that occur when a moth emerges from its cocoon or a bud opens into a flower. The future spin-off from such efforts may someday result in the long-sought cure of a disease, the biological control of an insect pest, or a new form of art. I do,

however, believe that the makers of such controlled photographs have an obligation to exhibit these pictures as such and not allow them to pass as "natural" in competitions or in the minds of those newcomers who would quickly grow discouraged at their inability to "find" such moments on their own outdoor safaris. Beyond that, it seems reasonable to state that biological photography need not conflict with nature photography, and, in fact, that one can probably enhance the other in many applications.

If you are a photographer accustomed to

working in a controlled studio environment, your first experience in field photography will unquestionably jolt you into an appreciation of the vast differences here and the capabilities of those who perform in this uncontrolled, unregulated studio that we call planet earth. The sun, the bearer of light, passes into and out of clouds at its own whim, capriciously casting favorable or offensive shadows wherever they may fall. Your models may still go by soft-sounding feminine appellations such as Holly, Dawn, or Robin, but they toss their heads at will and shift their profiles, not in response to your directions, but to a host of environmental factors. Twigs, litter, and leaves on the natural set in many cases cannot be removed by an assistant without permanently scaring the subject into retreat. No, this is a studio controlled by the models. You do not decide when, where, and how they shall pose. Rather, when they do, you must react as quickly as possible, for the posture is seldom maintained for more than a few seconds before your light has shifted, before your props have changed, before your model is gone, moved off to keep a more urgent appointment on a far more pressing set.

SCENERY: FROM POSTCARDS TO AESTHETICS

We momentarily touched on scenic photography during our discussion on lens selection, but such a popular theme deserves far more attention, especially in the consideration of the technique of framing and the magic of lighting. A *scenic photograph* may be popularly defined as a landscape picture in which the camera's focus is set on infinity. When most beginners hear the term *scenic*, their mind conjures up pictures of mountains and oceans and canyons. Given such spectacular natural subject matter, it is unfortunate that most beginners so carelessly record them. Scenics tend to be taken as the result of a voice from a speeding car saying, "Wow! That's neat!" Car slows; car stops at roadside rest; occupant pops out with camera; occupant snaps camera one time; occupant returns to car; car resumes speeding! Only the incredibly high inherent interest level of such subjects keeps them from being total failures.

Framing

How does one begin to move beyond postcard "snapshots" and advance to aesthetic landscapes? A good place to start is with that technique known as *framing*. You know that this method of improving your scenics indicates exactly what the word implies. You try to find some object to frame or provide closure for your main subject matter. Too frequently starting photographers become overly enamored of this technique once they have discovered it. The result is a swarm of chaotic images wherein the viewer cannot possibly determine whether to look at the frame or the subject. Hills whose faces are madly freckled with cherry blossoms and lakes whose waters are scratched by branches with octopus fingers are common flaws in our classroom reviews. I find a generally effective rule for framing to be: *If the frame enhances the feeling of the main subject matter, include it; if it doesn't, eliminate it.* A distant landscape wearing an ermine robe of snow might be artistically framed by fleece-dusted branches in the foreground to amplify the wintry feeling. Silhouettes of natural features such as trees or rocks or animals can provide not only a black shape to contrast with lighter colors of distant subjects but also an interesting pattern. Vegetation of the landscape, such as foreground flowers or overhanging foliage, can photographically enhance the seasonal scenics of spring and fall. Instead of indiscriminately framing every image simply because you've read somewhere that this makes your pictures better, I would suggest that you learn by practice when and how framing is beneficial or detrimental. I have indicated earlier when I personally find it unnecessary, distracting, and simply confusing. There are times and ways I believe framing to be an enhancing addition to your scenic photographs.

To begin, when your selected frame material is unlit, you produce a dramatic silhouette that forces your viewer's eye to a lit main subject in the distance, as in Figure 5.2, where the last rays of the sun strike the peak of massive Mt. Rainier. Such a technique is one of only a handful of ways that I know to elevate photography from its essentially two-dimensional realm to the illusion of three-dimensionality. Another related way to frame effectively is by the use of shadows. Again, they are excellent for leading your viewer's eye—from a foreground shadow to a background of light and

Figure 5.1
A massive column of ice fronting Tahquamenon Falls is used here as a frame to add to the wintry mood of the entire scene.

Figure 5.2
Mt. Rainier: the dominant feature of the Pacific Northwest, framed by the branches of but a few of the trees that shade its snow-capped slopes.

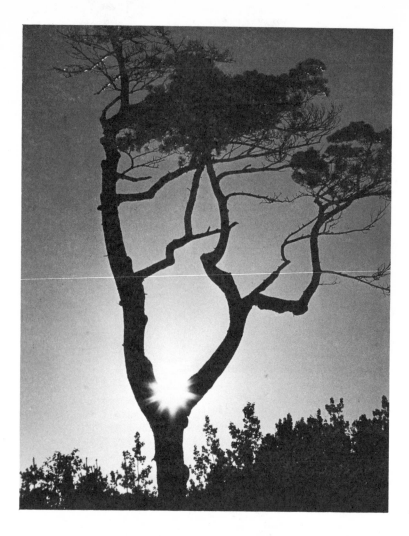

Figure 5.3
Dead trees can become powerful aesthetic allies when back lighting emphasizes their shapes and causes a star-patterned sun to burst from their forms.

color. Yet a third means of framing is by the introduction of a strong front element, particularly dead trees. Not only do their gnarled, twisted silhouettes add character to your images, but they also serve a useful technical purpose. On backlit scenes they can effectively block the sun, thereby avoiding the unbearable hot white spot of the sun burning out your picture. In the process they prevent the sun from so artificially inflating your light meter's reading that your image will be no more than a blackened piece of charcoal-like film. Finally, by directing the sun through the crook of a tree trunk or branch, or a rock crevice, you create a pinhole effect. The passing of the sun's light through such a small opening invariably produces the starburst so popular in many photos.

When none of the elements discussed above is present, you can achieve the basic principle by including a human figure in some of your pictures. If you are the only one around, a camera with a self-timer will be appreciated, for it will allow you a time delay to include yourself in your own image. People can add perspective to your

photographs; they represent a known measuring stick against which to estimate the height of a giant Saguaro cactus or a milepost to distant mountains. In addition, if your model wears a bright red jacket, you can, without overdoing it, add a touch of color to an image that might otherwise lack such vividness. But I personally feel that the occasional use of humans in your nature scenics takes a giant philosophical stride beyond its commonly accepted photographic benefits. I believe that people in slides give your audiences someone with whom they can identify; viewers can thereby more readily feel a part of the natural systems they are sharing; no longer are they passive entities totally divorced from the scenes being witnessed.

Many beginners think that a wide-angle lens is a requirement for framing, but this often is just not the case. You can use your 50mm lens for the same purposes if you'll just take some steps backward. In addition, this standard optic has the advantage of not reducing the size of distant subject matter, as would the wide-angle.

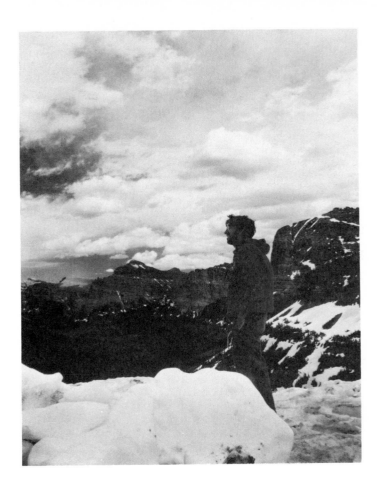

Figure 5.4
Most audiences will relate favorably to the occasional appearance of a human figure in some of your scenic photographs.

Although the employment of the framing considerations above can add a technical expertise to landscape photos, for me the real merit of any scenic photograph derives from its lighting. The finest light comes only in the first hour after sunrise and the last hour before sunset. Because of the slant of the earth's axis, certain wavelengths of the spectrum are blocked and our planet is bathed in a warm glow of yellow, orange, and red. An easy way to illustrate this phenomenon is to take comparative images of the same scene. Take one at high noon. Although there may be nothing technically wrong with the composition, you may find yourself asking instead, "What's *right* with this?" Your answer may be, "Nothing," especially when you contrast it with the same landscape recorded only minutes before the sun sets. If the sun has happened to be particularly favorable that night, you will surely notice that your lighting has created a texture and a mood, a drama and a feeling that approaches the territory of a painting.

As a significant footnote in regard to scenic lighting, we cannot possibly omit consideration of another powerful form of lighting, that of *side lighting.* Also available only in the early hours of dawn and the last hours before dusk, side lighting is unequalled when you want to emphasize texture, whether it be in sand dunes, tree bark, or snow banks. In conjunction with the long shadows cast at this time of day, side lighting gives you yet another way to produce a powerful scenic.

In the final analysis, the ultimate test for any scenic photo is how to carry it from the category of a postcard depicting blue sky with white fluffy clouds and convey it to the realm of an aesthetic experience. To do that, I think it is an absolute necessity that you be responsive to the weather and its many moods. I urge you to revel in the snows that fall upon the mountains in late August when there is still the visible greenery of vegetation to provide contrast and color. I encourage you to rise with a family of mallards on a misty morning at your local lake and follow them about their early morning routine as the parents educate the ducklings in the business of duckdom. Finally, I ask you to rejoice in the dramatic storms that brew

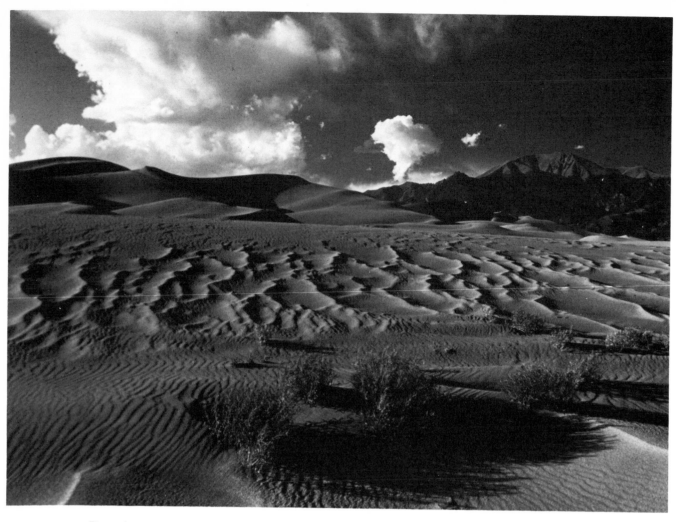

Figure 5.5
Great Sand Dunes National Monument in Colorado provides a grand location in which to practice your side-lighting techniques.

over the desert in mid-July when ground temperatures surge toward 200 degrees but also when bolts of lightning crackle beneath double rainbows. In short, I guess I am trying to tell you that good scenic photographs can be taken at any time, but great ones are captured only under unusual atmospheric conditions, whether close to home or a thousand vacation miles away.

Sunrise and Sunset: Minus the Sun

Of all the scenic photographs, unquestionably the most popular are those of sunrise and sunset. Not only are they generally the most colorful, but they are also among the easiest and the most forgiving when it comes to exposure determination. Unfortunately, many beginners (and lots of pros, too) so carelessly record the break of day and the arrival of night that their images too often become commonplace, trite, or meaningless. If you find that these adjectives apply to your images of sunrise and sunset, perhaps you should stop for just a moment and ask yourself, "Why am I shooting this?" or "What do I expect from this image?" If you answer with honesty, I think that you will find yourself becoming more selective and more frequently obtaining pleasing results.

For many, a major flaw derives from the fact that they are shooting with only a 50mm lens. It simply sees too much of a sky that is drab, colorless, or uninteresting. Your mind's eye might be seeing only the bright glow of color about the setting sun, while your camera's eye is seeing not only that but also the rest of an unappealing sky. The worst part is that the colorful section may fill not more than 1/50 of the picture, hardly enough to make any impact on an audience. The obvious solution is to resort to a telephoto, at least 200mm worth and preferably from 300mm to 500mm. With its steadily decreasing angle of view, the

telephoto will eliminate the bland sky and focus upon the brilliant hues around the sun. With its powers of magnification, it will greatly enlarge the flaming ball to a commanding central point of interest.

Some of the not-so-obvious solutions include the following:

1. Shoot off the exact point of the sun's rise and set; here a haunting, otherworldly glow commonly accompanies the commencement and the conclusion of day.

2. Shoot directly *across* from the sun, especially in places such as the Grand Canyon, where the nearly totally flat horizon line makes an uninteresting silhouette but where the interplay of shadows, color, and light upon the facing rocks is absorbingly compelling.

3. Find an interesting silhouette of a smaller object, such as a plant or an animal, and use the color as a backdrop to sharply accentuate and silhouette the comical posture of a puffin or the geometric shape of a seedhead.

Believe it or not, a second flaw in these pictures comes in exposures, particularly in frames where the sun is totally above the horizon line. The sun is so much brighter than anything around it that one of two mistakes occurs depending on how the photographer judged the exposure. If the photographer failed to include the sun in the area of the camera meter's reading or allow for its increased intensity, the sun becomes a very hot white ball. By comparison, if the photographer does include the undiffused sun in the metered area, it so inflates the reading that nothing else is visible in the picture because of the severe underexposure. Personally, I always expose for the brightest area *off* the sun so that color is saturated and detail is maintained in different exposure values within the latitude of the film. I do not include the sun in the frame once it is more than a *palm's width* above the horizon. I do make an exception if it is diffused by fog or other atmospheric protection. Looking into the sun for any extended period can damage the camera shutter and, far more importantly, your eyesight. When the sun burns from a clear sky, I look to other possibilities.

You can further improve your pictures of sunrise and sunset by avoiding the flat horizons of lakes, prairies, and so on unless you have stunning color or uncommon cloud formations that will override this negative influence. Remember: A straight line is a dead line. Shun the tacky, banal framing approaches that are in fact framing nothing. Instead, haul out your macro equipment. Look up; experiment. Stay after sunset and overexpose; arrive well before sunrise and overexpose. What happens?

On many occasions you have certainly found yourself in the company of a great sky, but with nothing to silhouette before it; other nights, no doubt, you have been confronted by intriguing shapes with no color beyond. Some photographers would choose to take the best of both worlds and combine them later in what is referred to as a *sandwich,* that is, the two pieces of film (one of color, one of shape) *sandwiched* together like slices of lunchmeat in a new mount. When you are consciously planning this approach, remember not to give full exposure to each slide or else, when they are combined, they will be underexposed. Rather, give increased exposure to each individual slide and then the resultant sandwich will be more correctly exposed.

MACRO PHOTOGRAPHY: LITTLE THINGS MEAN A LOT

Over years of observation, I have found that people involved in macro photography are genuinely characterized by a heightened awareness of the thousands of miracles that daily take place right in front of their eyes and right before their lenses. Macro photographers quickly learn not to disdain the apparently commonplace subjects. They find many of their most spectacular images in what are seemingly the most unspectacular of places. On a hike through the woods, macro photographers know that the most important facet of the journey is not how far you walk but rather how close you see. The incorporation of that philosophy into your macro photography will go a long way toward ensuring your success therein. Competent macro photographers are those who best perceive the intricate patterns of nature. There are patterns of form, such as the web in Figure 5.6C, spun and frosted by a master craftsman. There are patterns of color, such as a cedar bough highlighted by late-afternoon sunlight or a clump of banana-shaped iceplant displaying the traditional red and green colors of Christmas.

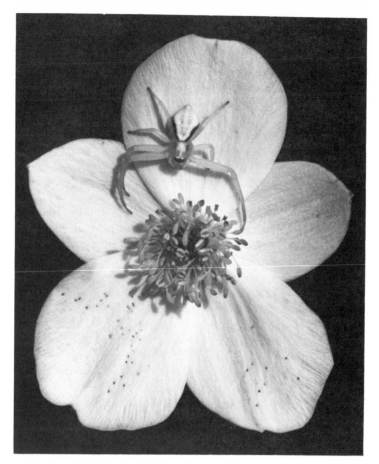

Figure 5.6A

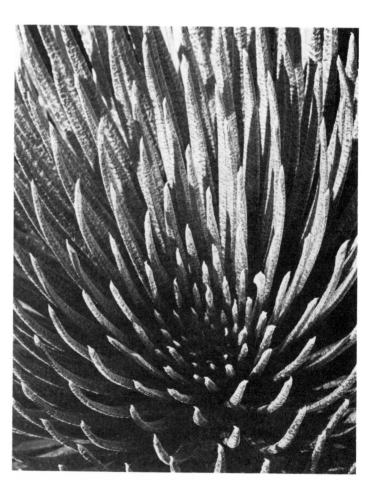

Figures 5.6A and B
The usual subjects regularly produce unusual
pictures when photographed at macro
distances because they extend human vision
to a realm beyond our ken.

66

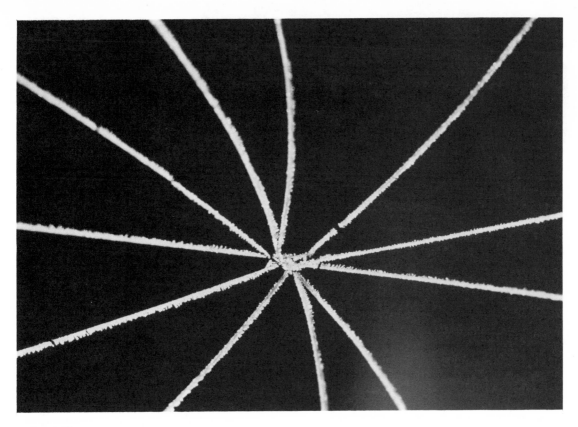

Figure 5.6C
The radial, spokelike pattern of a spider's web—revealed only by the macro photograph.

Plant Photography

For many photographers, the phrase *macro photography* means plant photography, and for them plant photography may mean nothing more than the photography of their favorite wildflowers. Although flowers may indeed represent the most popular plant subject, they do not hold exclusive rights to your botanical pictures. Mushrooms, ferns, and trees can all provide interesting subject matter; the individual parts of leaves, berries, and reproductive stamens or pistils produce further close-up possibilities. As a rule, successful plant photographs result from the isolation of subject matter. A close-up of a single perfect flower makes a more effective visual than a shot of a field full of the same blossoms whose detail and intricacy cannot be perceived from that distance; one cluster of berries will normally be more powerful than a whole bush of the same.

If you wish to pursue wildflower photography, you must know when and where they bloom. A good field guide, such as Peterson's,* will direct

* Roger Tory Peterson and Margaret McKenny, *A Field Guide to Wildflowers of Northeastern and North Central America* (Boston: Houghton Mifflin Company, 1968).

you to the correct environment at the proper time of the year. Further success in wildflower photography will be achieved by recognition of the fact that certain colors photograph better under varying conditions. Many spring wildflowers are white. To photograph them in bright sunshine is not a wise practice; a cloudy, bright day, when the white spot of the sun can be detected behind the cloud cover, yields optimum results. On the other hand, richer colors will often be better rendered in sunny conditions. Frequently the common photograph of an ordinary flower can be aesthetically enhanced when the blossom is visited by a pollinator, such as a bee or a moth. New dimensions can also be derived from the same subject when the bloom is wet with dew or even lightly sprinkled with frost. You can further create interesting patterns and uncommon photographs by shooting the flower after it has gone to seed or even after it has withered and died.

Achieving technical perfection in any type of plant photography depends on a number of considerations that are discussed elsewhere. Rather than repeat them here, I would like to direct your attention to those sections of the book where you will find discussions of appropriate

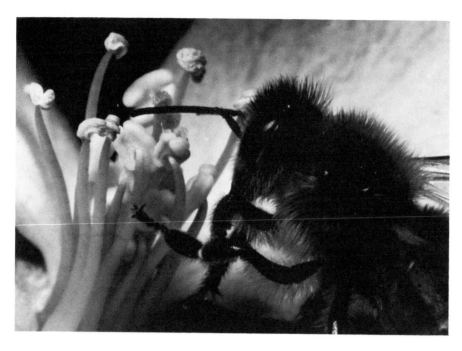

Figure 5.7
Flower and insect combined in the same frame often create a more effective picture than either one separately.

concepts such as background control (pages 103 and 144–45) and depth-of-field (pages 99–103).

Macro Equipment

Whether it is plants or other types of macro photography that interest you, this specialized field clearly demands some equally specialized equipment to portray it. I personally feel that the most versatile and most effective close-up system is a two-track, auto bellows unit with a short-mount lens. The bellows is simply the lightproof tunnel that allows you to extend and contract the distance of the lens from the camera. A short-mount lens is one that contains no focusing barrel of its own. All of its focusing is accomplished by the forward or backward movement of the bellows. The advantage of such a lens is that when the bellows is completely collapsed, your lens will still focus to infinity even as extending it will permit you to render an image close up at even larger than life-size reproduction. In contrast, a lens with its own focusing ring, when placed in front of a bellows, will *not* be able to focus to infinity. The two-track bellows also makes focusing much easier at extremely close distances. As you get closer to a macro subject, focusing becomes so increasingly difficult that the subject may always look totally out-of-focus or it may appear at no point to ever lose its focus. With the two-track bellows unit, you can extend your bellows to its

desired length on the first track and then on the second rail easily move the entire camera body and lens unit into sharp focus.

For some beginners, the bellows unit introduces the seemingly monstrous mathematical problem of exposure calculation. As you extend the bellows, you are forcing light to travel farther to the film plane and thereby diminishing its intensity. I personally feel that too many instructors magnify the problem to a greater degree than the bellows magnifies its subject. To begin, if you own a camera with a through-the-lens metering system, the camera will compensate and measure the light for you. If you use an independent light meter, there is still no need to carry slide rules or pocket calculators to figure your exposure. I have managed to avoid any exposure problems by following one simple rule that guarantees success for anyone who can divide. Simply divide the length of your bellows extension by the length of your lens. Your answer will tell you how many *f*/stops you must *open* your lens for correct exposure.

Example 1: Let us assume that your bellows is extended 100mm and you are using a 100mm lens on the end of the bellows. 100 ÷ 100 = 1, so you must open up your lens one full stop from your independent meter's reading to ensure correct exposure. If your hand-held meter indicated that *f*/8 was the correct exposure, you must open your lens one stop to *f*/5.6.

Example 2: Again the bellows is extended 100mm (you find this marked on the rail or somewhere similar); but this time you have a 50mm lens on the front of the bellows. Because 100 ÷ 50 = 2, this time you must open your lens two *f*/stops, or from *f*/8, past *f*/5.6 and then on to *f*/4.

Example 3: Let us still maintain our 100mm bellows extension, but in this final case let us put a 25mm wide-angle lens on the front. Because 100 ÷ 25 = 4, in this instance we must open our lens four full *f*/stops, or the equivalent of going from our original *f*/8 all the way to *f*/2.

From these three examples it becomes obvious that the influence of a bellows *increases* as the length of the lens *decreases*. Because of this light-reduction problem inherent in bellows photography, many nature photographers introduce artificial lights to provide pocket sunshine that will give them the greater depth-of-field so often required at close distances. More on this topic will follow later (Chapter Six). With longer-length telephotos the effect of even a drastic bellows extension is virtually nonexistent. Let us suppose that we are using a 600mm telephoto on a bellows extended 150mm. Because 150 (bellows extension) ÷ 600 (lens length) = ¼ (exposure increase), we see that we must open our lens one fourth of an *f*/stop, which is so negligible, particularly with long lenses, that it may for all practical purposes be ignored.

Next to a bellows, my second choice for close-up photography would be a macro lens.

When macro lenses first appeared on the market, most were of the 50mm length. Today the popular length seems to be 100mm. I consider this a giant step forward for a number of reasons. First, the 50mm macro forces you to approach many subjects very closely before you see a frame-filling image. In the case of inanimate subjects or even with plant life, this is not so great a handicap as it is when photographing living creatures such as nervous butterflies, skittish lizards, flitting bees, and thumbnail-sized tree frogs. Such organisms are commonly frightened away by your nearness or are otherwise scared off by the changing light of your body's shadow falling upon them. With the 100mm lens you can remain twice as far away and still obtain the same size reproduction, which is a substantial advantage. Another pair of pluses for the 100mm macro lens is that it allows you to reach twice as far into places, heights, or environments that you cannot navigate and it prevents you from disturbing or destroying with your limbs or gear such delicate features as spider webs hung with dew or branches draped with powdery snow. Finally, the 50mm lens sees too large an angle of view and therefore may include too much distracting background material. In contrast, the 100mm macro is in effect a small telephoto that sees a narrower angle of view and may therefore eliminate from your background those hot spots of the sun, distracting natural litter, or even another, but unwanted, animal.

After the bellows unit and the 100mm macro lens, the choices swiftly lose appeal for me. At the

Figure 5.8
A two-track auto-bellows unit —to my mind the premier approach to non-mobile macro-photography subjects.

head of this list of second options I would place extension rings, hollow tubes that, when placed between any lens and the camera body, permit the lens to focus closer than its normal near-focusing distance. The drawback is that in the process they cause the lens to lose its infinity focus as long as one or more of the tubes are in position. This is no major catastrophe, for you obviously inserted the tube because you found suitable close-up subject matter. However, it can be rather inconvenient if a deer should wander to within ten feet of you while you are picturing a tiny mushroom. As you slowly turn to focus on the deer, you suddenly notice that you can't. By the time you remove the extension tube to restore the continuous focus of the lens, your deer may have left. With both the bellows/short mount lens combination and the macro lens (whether 50 or 100mm), this problem would not occur.

Extension rings normally travel together in a matched set of three tubes marked 1, 2, and 3. The higher the number on the ring, the closer you can focus; also, the higher the number, the less the range of focusing distance from near to far points. Each ring may of course be used independently or in conjunction with any number of others. As you continue to combine the rings and increase your close-up capacity, a major problem will occur with increasing focusing difficulty. You should make sure that you purchase *automatic* extension rings, or else your automatic lens will lose that highly desirable function and, as you stop down to f/16, for example, to achieve greater depth-of-field, viewing and focusing will be almost impossible.

Another extension ring that I own, and consider more valuable, is the variable extension ring. Unlike other fixed-length rings, this ingenious

Figures 5.9A and B
The variable extension ring —collapsed (left) and partially extended (below).

device increases or decreases its length by your rotating its helicoid mount as you would in focusing a lens. You can think of this highly useful and practical accessory as the "zoom" of extension rings. The obvious benefit, especially in wildlife photography, is that it allows you to alter the near focusing distance of a lens without continually adding or removing rings. Let's imagine that you have a 500mm lens that focuses to thirty feet. As you sit at a bird feeder, a red squirrel wanders to within twenty-three feet of you. Since you can't focus on it, you remove your camera and insert a plus one ring. Just as you see the image grow sharp, the squirrel bounds closer. Now it's only twelve feet away, and again you can't focus on it. Off comes the camera, out goes the plus one ring, on goes the plus three ring. Now you can focus once more, but the squirrel has in the meantime backed off to twenty-eight feet. Get the idea? With the variable extension ring you can in many cases resolve this problem. In addition, the variable extension ring gives two points of focus control. Not only can you rotate the extension ring, but you can also rotate the lens barrel. In effect you have a very short bellows unit that extends your flexibility in close focusing situations.

My last choice for macro photography would be the diopters that screw onto the front of a lens in the same manner as filters. I like this method least because you are passing light through more and more layers of glass, thereby causing more and more possibility for reflection, refraction, and diffusion of light, which in turn cause a steady reduction in sharpness.

Earlier, I briefly alluded to the use of artificial lighting in close-up photography. As I mentioned previously, I am not particularly fond of the use of continuous strobe lighting, but I understand that in many instances it is an absolute necessity. Without it, I found myself losing too many valuable photographs when the wind blew across my plants, when patchy light crisscrossed my mushroom, and most especially when insects flew away as I attempted to set up for them on a tripod. As a result, I devised an aluminum bracket to hold two small electronic flashes, one at a 45-degree angle to the film's plane, the other at a 30-degree angle; a third strobe occupies the camera's hot shoe. I then equipped my camera with a 100–200mm macro zoom lens, and suddenly I found myself catching those plants and animals that I had previously been missing. The zoom lens allows me to change image size without having to change flash distances and then juggle mathematical computations. The three strobes provide sufficient light for ample depth-of-field ($f/16$ at minimum focus for any length of the lens), and they eliminate virtually all shadows. In addition, because the strobes are going off at such a fast speed, I can in these instances hand-hold my camera without fear of movement causing a blurred photo.

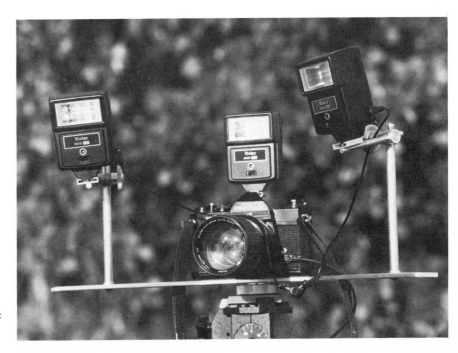

Figure 5.10
My father made the custom aluminum bracket pictured here. The bracket is intended for expedient use upon mobile subjects in the field.

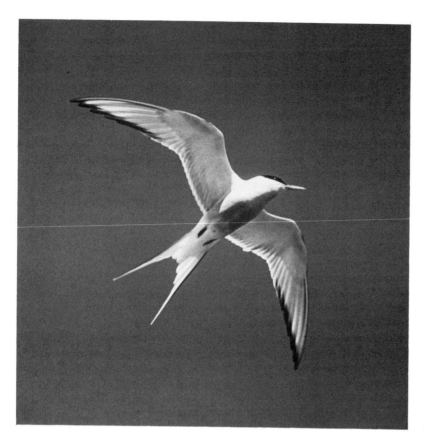

Figure 5.11
The activities of wild animals present a never-ending source of exciting nature photographs.

WILDLIFE:
THE ULTIMATE HUNT

After delving into the world of macro photography, another logical direction for you might be to reach out and attempt to bring the world of animals closer to you. For me, the photography of wildlife is both the most challenging and the most rewarding aspect of nature photography. Part of the reason no doubt stems from the fact that wild animals constantly involve themselves in an endless array of activities for pictures. It may be a solitary gull touching down on its favorite rocky outcropping in the middle of Lake Superior, or a rare canvasback taking off from a turquoise river in northern Florida. It could be two young pronghorns paired off in the ritualistic sparrings that initiate the mating season, or it could be a cow elk tenderly attending to her confused calf.

Failures are numerous. Clouds may obscure the sun as you snap; animals may move their heads; your focus may be slightly off; an unno-

ticed blade of grass may cross the animal's snout and extend over the eyes; long lenses employed to increase subject size may also magnify errors of motion.

Successes are cherished. The male eagle joins his mate on the sun-drenched pine bough as you sit stiller than you ever thought possible only a hundred feet away. A Ctenucha moth, gorgeous beyond belief even with the preposterous color combinations of a head of orange and an abdomen of iridescent blue, doesn't even move an antenna as your strobes light it up forever. An American bittern, hidden recluse of the marsh, carries the fish it has just speared to within ten feet of you, lays it at your feet and icepicks it into submission right before your waiting camera.

Unlike the human animal, the wild animals of the woods and waters neither ham nor freeze before the camera. They may be recorded in their most frivolous or their most sublime moments; as humorous or solemn; as almost human or virtually supernatural; unaware or ready to charge. I often like to shoot my animals in the way I might

shoot a human portrait, including the head and shoulders only. But I can assure you that if it's a 600-pound bull elk, as in Figure 5.12A, that's one portrait that will be shot with at least 500mm or more. Common sense should indicate the frequent necessity of using a telephoto lens of appropriate length, if for no other reason than your own safety. You might legitimately object, "Well, that's fine for him, but I don't have a 500mm lens." That may be a valid equipment objection, but it's certainly not much of a photographic objection. In Figure 5.12B we have another bull elk, even photographed in the same valley of Yellowstone, but this time using only a 100mm lens on a splendid fall morning when a gibbous moon was setting over Swan Lake Flats. Now, instead of a portrait, we have a pictorial, a story-telling slide that depicts the animal's habitat, portrays its feeding habits, or tells something else of its life-style.

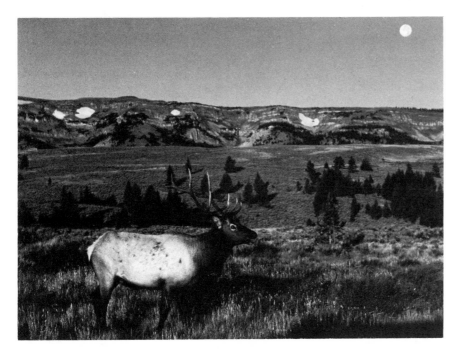

Figure 5.12A
Elk pictorial.

Figure 5.12B
Elk portrait.

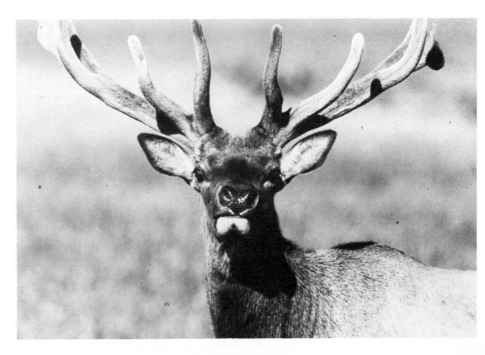

The fashion in which you portray your animals will go a long way toward demonstrating your unconscious attitudes toward them. Do you respect them? fear them? laugh with them? Your photographs will reveal it. Although your emotional reactions toward animals are your own personal concern, you can take some physical precautions to ensure that you capture the animal on film to your advantage. Just as the portrait photographer, who may be repelled by the personality of the bank president before the camera, must picture this subject in a favorable light, so also you, who may be repulsed merely by the thought of a baboon, might have to illustrate the animal in a respectful posture. If you look at the animal from its own height (or close to it), you will help to achieve this effect. Often, looking down on an animal physically emotes a photographic aura of looking down on it psychologically as well. If you do not wish to demean your animal, meet it on its own level. Bend your knees; shorten the tripod legs; lie on your stomach. Experiment with different perspectives. Looking up at a very tall animal, such as a giraffe at the zoo, will help to accentuate

its height; looking straight down onto the back of a crocodile may reveal an interesting pattern. Rules can always be broken effectively, but before you break them, you must understand them.

Many of your successes in animal photography, and in all other aspects of nature photography, will derive from behavior on your part that intrinsically has nothing at all to do with photography. Part of your scientific approach must take into consideration the types of clothes you wear and the motions you make, the scents you sprinkle on your skin, and the time you get out of bed. They may all have more bearing on your pictures than the type of film in your camera or the length of the lens in front of it. Shirts or jackets of solid colors should be avoided because the animal's eyes see them as a disturbingly uninterrupted mass of shape that is both large and unfamiliar. Instead, outer clothing with checked or striped patterns may be far more acceptable. This is even the way in which many of nature's creatures, such as the zebras and antelopes, camouflage themselves on the African savannas. Some photographers even resort to the camouflage outfits more

Figures 5.13A and B
Photographing a burrowing owl from its own level creates a more pleasing perspective than that gained by looking down on the animal from above.

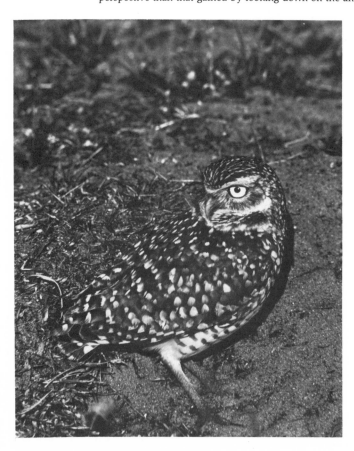 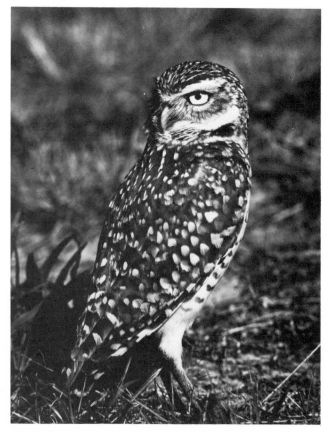

normally associated with soldiers during time of war. I own a camouflage jacket; I've used it a number of times while stalking photographs in the northern woods and, so far, not a single tree has run away from my approach! We humans pamper our bodies with an incredible array of cosmetics such as colognes, perfumes, soaps, and deodorants to make ourselves socially attractive. Wearing them into the woods will also make you more attractive—especially to the hordes of mosquitoes, flies, and bees that survive by their scent of smell. They'll love you so much they won't let you alone! Some bird watchers attempt to alter their body's natural odor by taking yeast tablets or Vitamin B capsules, both of which, when taken regularly over an extended period, are reputed to produce an aroma repulsive to mosquitoes (and maybe to humans as well). Before subscribing to this regimen, I would recommend the advice of a doctor. While on this subject, I should mention a second consideration: your own normal body scent. Essentially unnoticed by you who lives with it, this scent is readily detectable by many wild animals. Staying downwind of deer, mountain goats, and moose is a valid technique employed regularly by the hunter with bow and arrow and one that can be profitably imitated by the hunter with camera. In regard to your motions, you must remember that many wild animals certainly do not see the way we do and most probably do not respond to harmless activity in the way we would like to believe they do. For example, insects such as dragonflies have as many as 20,000 multidirectional facets in each of their huge compound eyes. Although they do not see sharply, they record the slightest fast motions with astonishing accuracy. This is the reason that your fast swipe with a rolled-up newspaper at a common housefly on the screen door invariably seems to meet with failure. In addition, insects may benefit from tiny hairs called cilia that detect the motion of air against their bodies. Of course the animal does not know that a sensitive nature photographer such as you intends no harm; rather, to it, you represent a potential predator about to devour dinner. For the insect, 'tis better to waste some energy on the short flight from you than to remain and possibly wind up dead in the stomach of some bird. I'm sure you've witnessed even semi-tame animals such as the geese or swans in metropolitan park ponds sent momentarily scurrying into retreat by the erratic motions of young children offering food. These are animals generally accus-

tomed to the presence of people, and yet they still react with a trace of fright. Imagine how much more so it will be in a wilderness animal that may never have seen a single human or whose only knowledge of mankind is the death-dealing smell of gunpowder. In the animal's world, quick, startling movements may be associated with these same actions of predators who pounce from thick bushes, strike from decaying leaves, or streak from the empty sky. Naturally, the animals have evolved a fear of them. You must respect that fact, even if only for the very selfish motive of getting your picture. Finally, the vast majority of wild animals do not punch a time card in accordance with the 9-to-5 workaday world of people. Most are crepuscular (active at dusk) or nocturnal. Are you willing to stalk them on their conditions? Are you willing to stir out of bed well before sunrise so you'll be out there to pursue the numerous birds who are active around dawn when the insects they feed upon are immobilized by the cool temperatures? If the answer to these questions is no, then you can expect more often than not to come home photographically empty-handed. But if your answer is yes, you will be amply rewarded—but something's lost that something's gained. To record nature's grandest creations, you must give up sleep and warmth; but you will get your photograph and the nicest payment is that, while the price of freezing fingers or soaking toes has to be paid but once, the reward is yours to enjoy for the rest of your life.

Knowledge of habits and habitat will also be invaluable in obtaining the pictures you want. If you journey to southern Michigan in May to photograph the migration of a pod of whales, you are going to be sorely disappointed. If you feel that your lack of knowledge of nature causes your approach to nature photography to be decidedly helter-skelter, you might find some time well spent in perusing any of a number of popular natural-history publications that will not only increase your awareness but also the success ratio of your picture-taking excursions. Try an issue of *National Wildlife* or *Audubon* magazines. Look into *Ranger Rick's Nature Magazine* if you're the parent of a child who occasionally tags along on the hikes into the forest. I spent ten years of my life teaching third-graders; after leading these eight- and nine-year-olds on numerous field trips, I am convinced that, because they are physically closer to the ground, these youngsters frequently see what we will miss. Encyclopaedia articles, field guides,

local conservation clubs, and television shows can all provide you with valuable insights into where you can find exciting natural subject matter within a single tank of gas of your home. Once you have accumulated some general information, you will find that the pursuit of a cherished photograph will be greatly abetted by specific knowledge of animal behavior. When does a robin nest? Where do the gulls feed? What forests harbor damsel-flies? Who preys upon the abundant insects of summer? The answers to questions such as these and an endless list of others will bestow a substantial advantage upon the human animal with camera.

When you can't go to the animals, you can lure a number of them to you by erecting some basic feeding stations to attract their attention. Certainly wayside cafeterias are most populated during those times of year, most notably winter, when natural foods are in scarce supply, but they can be effective during any month of the year. Many purists would object that the animal is not in its natural habitat. That obstacle is readily overcome by using a natural artifact and then hiding or camouflaging the food in some crack or crevice of a branch or stump. You can also provide

an accessible resting perch where birds may land before arriving at the exact food location. By placing this twig out of the food area, the camera (and the audience) will never know that your evening grosbeak portrait wasn't taken in the heart of northern wilderness. After a period of observation, you will soon learn the favorite landing places of your regular customers. By your focusing on that place and making sure there are no telephone wires, cars, or other human artifacts in the background, your patio might one day qualify for designation as a bird sanctuary. Furthermore, when many different species of animals gather at the feeder, you may have an opportunity to record a unique, humorous pose of a spritely chipmunk or a quarrelsome encounter between a blue jay and a sparrow. Another alternative offered at feeders is to deliberately make apparent the fact that the animal *is* part of a manmade environment. Such images are far from valueless. They can record animals that might otherwise be unapproachable, and they can become an integral part of your audio/visual presentations to illustrate man/nature interrelationships. But whatever types of photographs you expect from your feeder, you must remember as a matter of con-

Figure 5.14
The Stump: My natural bird feeder may have to share the patio with a barbecue grill, but that does not prevent it from attracting some forty species of birds, although it rests less than two miles north of Detroit's city limits.

Figure 5.15
Dried ears of corn skewered into tree trunks can draw many animals, such as this red squirrel, to your feeding station.

science to keep it stocked with food. Word spreads quickly amongst the wildlife community that your little restaurant is open and serving. The animals who have grown dependent upon it could starve in as little as three or four days in harsh winter weather if you fail to provide for them.

Although we have already discussed certain aspects of telephoto lenses, their significance in wildlife photography is of such great importance that we cannot neglect to probe further considerations here. Since your relationship with this piece of equipment begins with your purchase, research into the qualities you seek will be your first task. The first characteristic most buyers investigate is lens length. We measure telephoto lenses in terms of the length of the standard 50mm lens. In this system, a 500mm lens is ten times longer than a 50mm lens. The result is that it will yield on film an image ten times greater in size from the same distance. Another way to consider its effect is to think of that same lens as reducing geographic separation from the subject by ten times. Hence, if

you are a hundred feet away, the ten-power 500mm lens will give a picture that looks as if you were only ten feet away with the 50mm lens.

Although lens length is obviously a significant consideration, in my judgment it is not the primary value, since the outcome of this decision will be based on relatively personal preferences dictated by your methodology. In other words, just because the lens is longer does not mean it is better. A 135mm lens will serve just fine for a bird photographer who intends to record nesting birds from only eight to ten feet away in a blind. A second photographer, stalking the very same birds off the nest as they search for food, may find 500mm inadequate. I feel that the more important characteristics to seek out include: the automatic function that we described earlier, the close focusing distance of the lens, and the speed of the lens.

No matter how many millimeters you tote into the field, each and every one of them is virtually useless unless the lens allows you to focus

closely enough to take advantage of them. My 400mm lens focuses to an exceptionally close five feet or so; in stark contrast, the closest focusing distance of my 1000mm lens is ninety-eight feet. To reproduce the same size image at its minimum focus as my 400mm lens does at its minimum focus, this two-and-a-half-times-as-long lens would have to focus not to its real ninety-eight feet, but to less than a fantasied thirteen feet! A second important feature to look for is lens speed. Many 500mm mirror lenses have a speed of $f/8$. By comparison, my 500mm lens opens to $f/4.5$— an optic transmitting some 150 percent more light, a fact that translates into one more full shutter speed and another one-half stop depth-of-field. Ideally, I (and everyone else) would like to see a 500mm-$f/2.8$ lens that focuses to ten feet. Somewhere there exists for you a happy compromise of lens length, speed, and near-focusing distance. You must decide what you will give for whatever you will get.

After settling on your particular piece (or pieces) of glass, remember that each one will be chosen in the field for how well it matches the given situation. If you can only approach to within seventy feet of a foot-tall shorebird, you will obviously select your 400mm lens over your 135mm lens for size reproduction. If you get lucky enough to approach within ten feet of a deer, your 50mm lens will be physically enough, but because of its comparatively large angle of view, it may not be the proper choice, especially if the deer has wandered into the vicinity of a human creation such as a parking lot. We have repeatedly touched on the difficulty of moving toward wild animals, but as in Figure 5.16, you are too close because of the tell-tale environment. You may find it wiser to back up and use a 135mm lens whose smaller angle of view may eliminate the parking lot's pavement and still provide you with a frame-filling animal; or, you may wish to stay at the close distance and still use the longer lens to go for a more impressive close-up instead of a full body shot.

As we've mentioned earlier, the longer lens will flatten perspective and compress distances from front to back. In many instances, this will be

Figure 5.16
Although I photographed this doe by the side of the road in Yosemite Valley, no one need ever know, because the 400mm lens used to capture her portrait also eliminated the pavement, people, and passing vehicles.

a highly desirable asset. A herd of bison plodding along the side of a park road will look far more massive, impressive, and congested if the members are compressed together with a long lens. On the other hand, a shorter lens will spread the herd out more if you wish to show wide open spaces. Because of its larger angle of view, it will also include more of the surrounding environment and thereby help to locate the animals in their habitats of mountains, desert, or woodland. Also to be considered is the fact that the shorter lenses tend to be much faster, lighter, and easier to focus. These features may allow you to hand-hold the camera to capture a fleeting moment readily missed if you're working on a tripod with a slower, heavier telephoto. Shooting at 1/500 of a second with a ten-ounce $f/1.9$ lens may capture a shot that a four-pound $f/6.8$ lens at 1/60 will only blur.

In the following chapter we will devote a great amount of space to the topic of depth-of-field. In the case of telephotos, as the length of the lens steadily increases, we eventually reach a point where it is virtually nonexistent. Although this presents one drawback, it also permits (or forces) you to take advantage of your maximum lens aperture. Stopping down a 600mm-$f/5.6$ lens to $f/8$ will so negligibly increase your depth-of-field that I would far prefer to see you shoot at 1/250 of a second rather than 1/125 so that you

can further negate the substantial problem of motion. In many respects, motion rates as the single greatest enemy of telephoto photography, so whatever precautions can be taken to offset its negative influence should be employed. Fast shutter speeds help greatly; so does locking-up the mirror, although that is often inadvisable and even impossible when shooting moving animals. Some photographers go so far as to weight their tripods with sandbags. A more traditional way to stifle vibrations has been the use of a cable release. I almost always use this motion-reducing accessory with my shorter lenses, but in the case of the much longer lenses (300mm and up) whose length is centered on a tripod head, I challenge the theory of the cable release. Whatever troubling motion exists is not arising solely (or even mostly) from the lens, which is firmly supported on the tripod. Although it is unquestionably true that lightweight telephotos can be affected by strong winds, most of the vibrations derive from the camera. It is the camera that floats unsupported in the air; it is the camera that contains the mirror that flaps up and down. Therefore, I try to stop motion at the camera by releasing the shutter with my hand. I may occasionally use a handkerchief or a small sponge to absorb vibrations. If time permits, I always create a little tension on the lens by pressing up or down on the lens *at* the tripod socket. Remember, a lens with a ten-power magnification

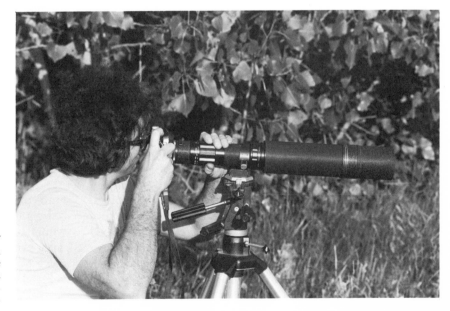

Figure 5.17
For me, hand releasing of the shutter when using long lenses works more smoothly, more rapidly, and, I feel, with fewer vibrations than releasing the shutter with a cable release.
Photograph by Gio Chiaramonti.

not only enlarges image size by that amount, but it also enlarges motion equally.

The beginner's awestruck fascination with long-length telephotos can extend so far as to endow them with almost supernatural powers. When students first set eyes on my high-power telephotos, you can almost hear their thoughts: "If I had lenses like that, I sure could get super shots." Alas, this judgment is basically inaccurate, not unlike saying that one would become a great baseball hitter simply by putting the best bat made in one's hands. Telephotos do not represent a photographic panacea for the problems of wildlife photography. Although I definitely would not want to attempt my job without them in most every circumstance, it is equally true that they present many obstacles to overcome, such as the motion we have discussed along with carrying in the field and speed of operation. Many beginners feel that just because a lens is long, it automatically guarantees a frame-filling portrait of a five-inch songbird from a hundred feet. But that viewpoint simply does not stand up under more careful scrutiny. Did you realize that a 200mm lens from twenty feet away will yield an image size *twice* as big as a 1000mm lens from two hundred feet away? To obtain the same size reproduction with the longer lens, you would have to photograph from a distance of one hundred feet. From this brief observation it should become obvious that the key to the success of telephoto photography is not the length of a lens *per se* but rather a combination of its length and the closeness to the subject. Of course, one of the advantages of the longer lenses is that you don't have to approach so closely. But considered solely from the aspect of size reproduction (without any reference to how close you are able to approach your subject), a 300mm lens at twenty-five feet will give you a bigger bird in the frame than will a 600mm lens at sixty feet. The problem is: Can you get as close as twenty-five feet?

This interface of lens length and distance to subject carries us to the consideration of how close the photographer should move toward an animal before it may be considered effectively captured on film. In the case of smaller songbirds, such as warblers, robins, and jays, many successful nature photographers feel that you need 25 millimeters of lens for every foot of distance away from the subject. By this formula, you would require a 500mm lens if you were twenty feet away, but only a 200mm lens if you were eight feet distant. Obviously, larger animals such as raccoons or deer would demand less glass to achieve the same size reproduction. However, I do not like using such rigid equations to predetermine my selection of what is or is not suitable. I prefer using a less structured system that advises me that I am close enough to shoot as soon as I can clearly make out the animal's eye. Without the eye, there is nothing. As with humans, the animal's eye captures its spirit. If I cannot see the eye, I know nothing at all of the animal. Is it angry? afraid? alert? sleepy? Only the eye will tell me. Because of this, I *always* focus on the animal's eye, *regardless* of what else I must sacrifice in depth-of-field. If indeed the eye is the shining diamond in the photograph of an animal, then the diamond's sparkle is the highlight in the eye. Also called a *catchlight*, it is this white highlight from the light source that frequently separates the dynamic wildlife photograph from the ordinary animal picture.

Many wildlife photographers eschew the use of long telephotos and achieve their success with the use of a "blind." Basically a blind is no more than a hutlike room, just large enough to contain the photographer and the needed equipment. No matter how sophisticated or how primitive in structure, all blinds are designed for the sole purpose of concealing the photographer from wary subjects. The blind may be a wooden edifice covered with natural vegetation or it may consist of a bare frame stretched over with tent canvas bearing some camouflage pattern. Openings in the tent create vents for the lens to peer out and for air to squeeze in. As legs begin to teeter, as eyes commence to weaken and as muscles start to atrophy, my octogenarian years may find me a foremost proponent of the blind system of nature photography. Until those desolate days, though, I prefer the excitement of the stalk. In essence, my method is one of saying to the animals: "Here I am. I'm not going to hurt you. I'm going to follow you until you leave or until I'm able to get the shots I want."

However, there is one blind I do employ on more than one occasion—my car. For some obscure (to me) reason, many wild animals that would be frightened away by human presence afoot will acknowledge your existence with no more than a passing nod if you remain in your vehicle. I can vividly remember one fall day in

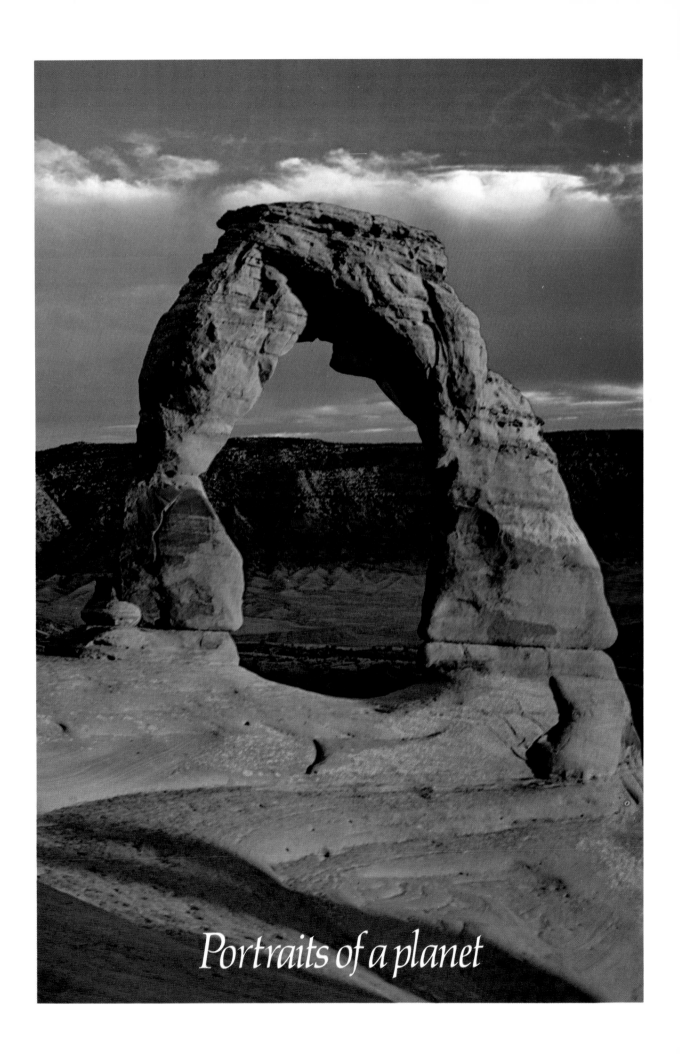

Portraits of a planet

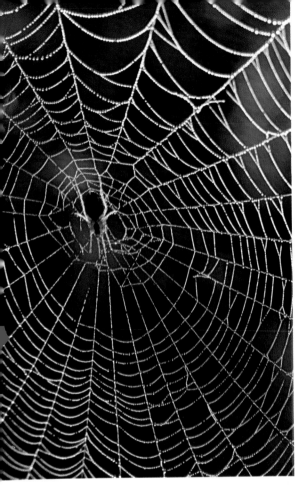

(above) The back light of the sun creates
a prismatic rainbow in the dew-laden structure
of a spider, while at the same time accentuating
the amber architect.

*100mm short-mount lens on bellows; exposure established
by one-degree spotmeter reading dew.*

(right, top) Reflections . . . alligator . . . Everglades
National Park.

*500mm lens; exposure established by one-degree
spotmeter reading water reflections.*

(right, bottom) Keeper of the castle
. . . coral toadfish . . . Paradise Reef off Cozumel,
Mexico.
Photograph by Nancy Ormond.

*55mm micro lens on 35mm camera in underwater
housing, one electronic flash at depth of forty feet.*

PREVIOUS PAGE
At sunset, a sanguine sun transforms the tower
of rock known as Delicate Arch into a fiery
spectacle of sandstone.
45–125mm zoom lens with polarizer.

OPPOSITE PAGE
(top left) The storm builds; the sky darkens;
the saguaro endures.
*45–125mm zoom lens; exposure established by one-degree
spotmeter reading cactus trunk.*

(top right) The sun breaks; the rainbow
shimmers; the saguaro glows.
50mm lens with polarizer to emphasize rainbow.

(bottom) Fogbound . . . mallards . . . Michigan.
*500mm lens; exposure established by one-degree spotmeter
reading fog around birds.*

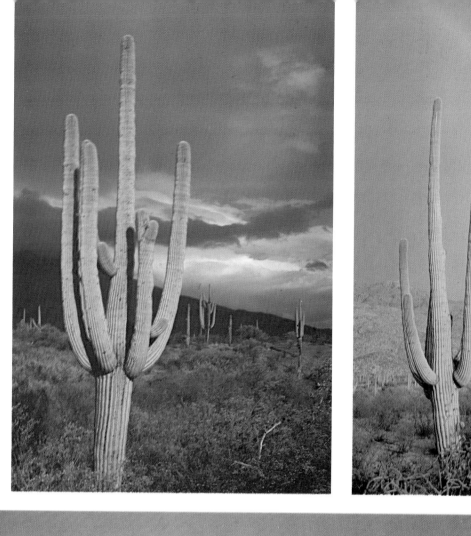

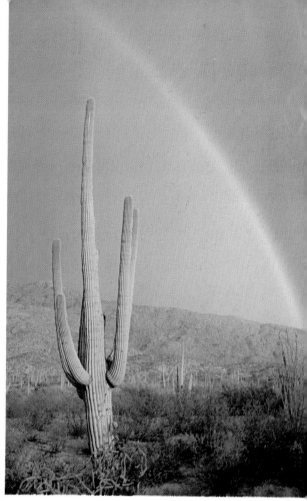

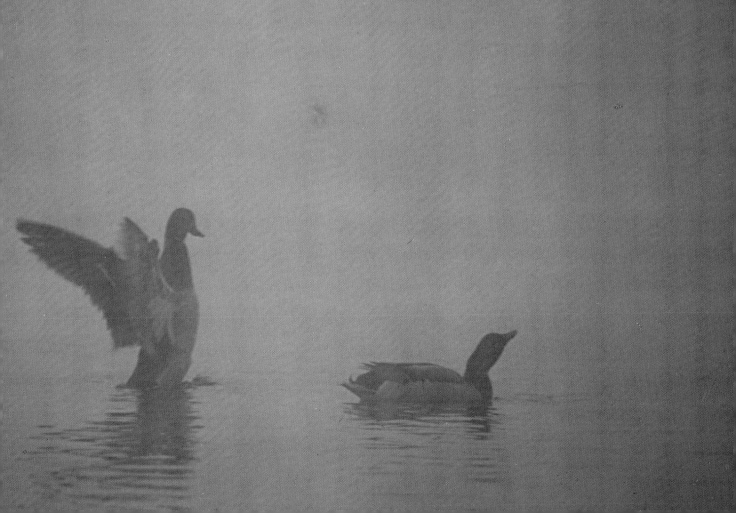

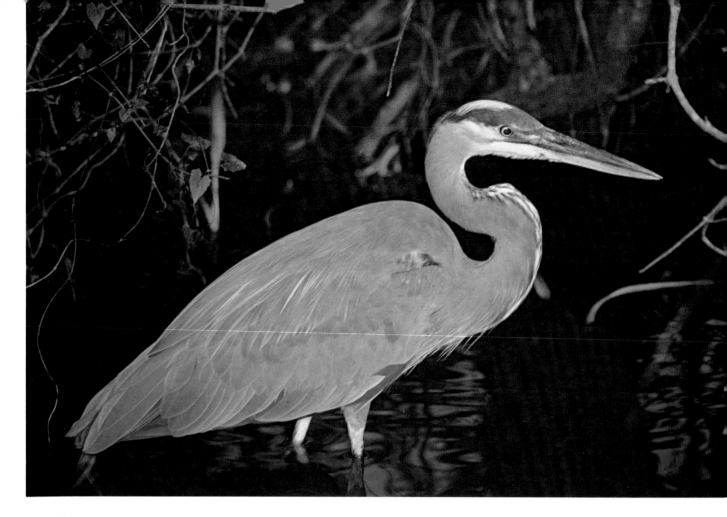

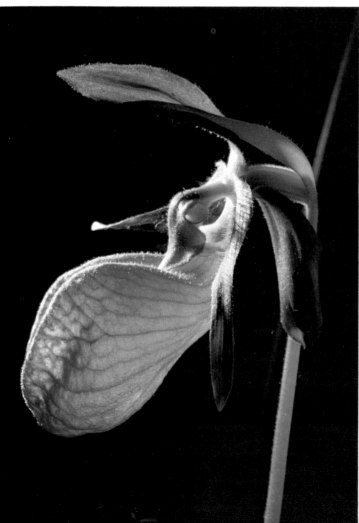

(above) Wading hunter . . . great blue heron . . . Everglades National Park.

100–200mm macro zoom lens; three electronic flashes used on manual mode of operation; exposure calculated for strobe-to-subject distance.

(left) Excellent artificial-light techniques have been employed here to render a pink moccasin flower as a lovely orchid of subtle color and delicate venation.

Photograph by Otis Sprow.

50mm macro lens, one electronic flash, one reflector card.

OPPOSITE PAGE

(top left) The scarlet leaf: light collector, color changer, picture maker.

100mm short-mount lens on bellows; note out-of-focus highlights that have acquired the star shape of the diaphragm of this special lens.

(top right) The richness of vegetation and the softness of water provide the necessary raw ingredients to enhance the technique of using a slow shutter speed.

50mm lens, two polarizers, twelve-second exposure.

(bottom) The monarch . . . bison . . . Yellowstone National Park.

100–200mm zoom lens; exposure established by one-degree spotmeter reading brightest fog area around animal.

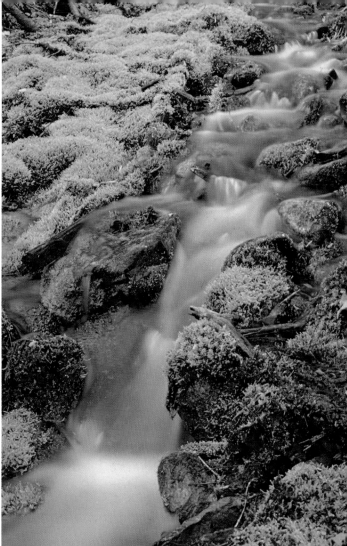

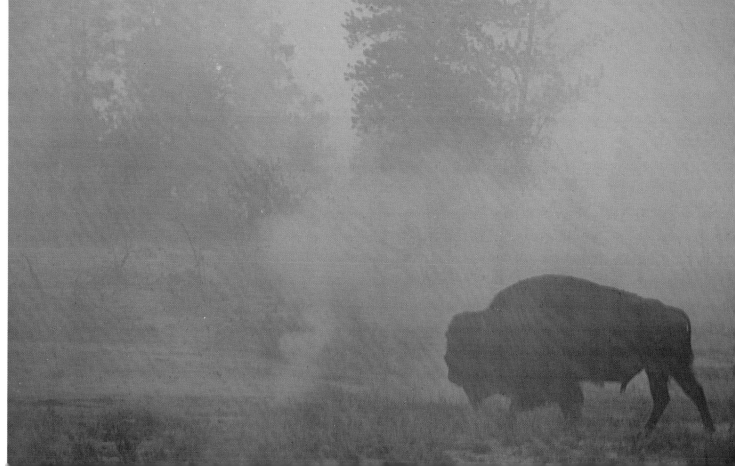

(top) An acrobatic caterpillar displays the muscular skills of a trapeze artist as it dangles in mid-air to extend its tireless mouth parts toward yet another defenseless flower.

100–200mm macro zoom lens with three electronic flashes.

(bottom) A rippled ocean of yellow waves emerges from the petals of a prickly pear cactus blossom.

100mm short-mount lens on bellows; shutter speed of 1/1000 of a second used to achieve narrow depth-of-field.

OPPOSITE PAGE
This sentry oak has undoubtedly witnessed the brilliance of many dawns like this one in its southern Michigan home.

135mm lens; exposure established by one-degree spotmeter reading red area of sky.

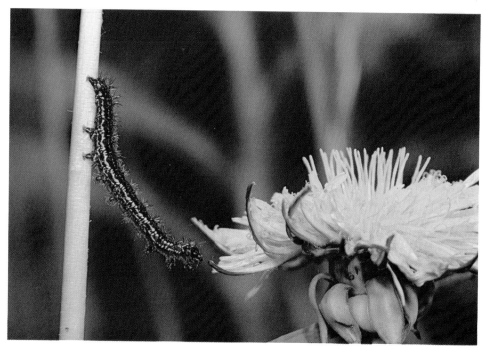

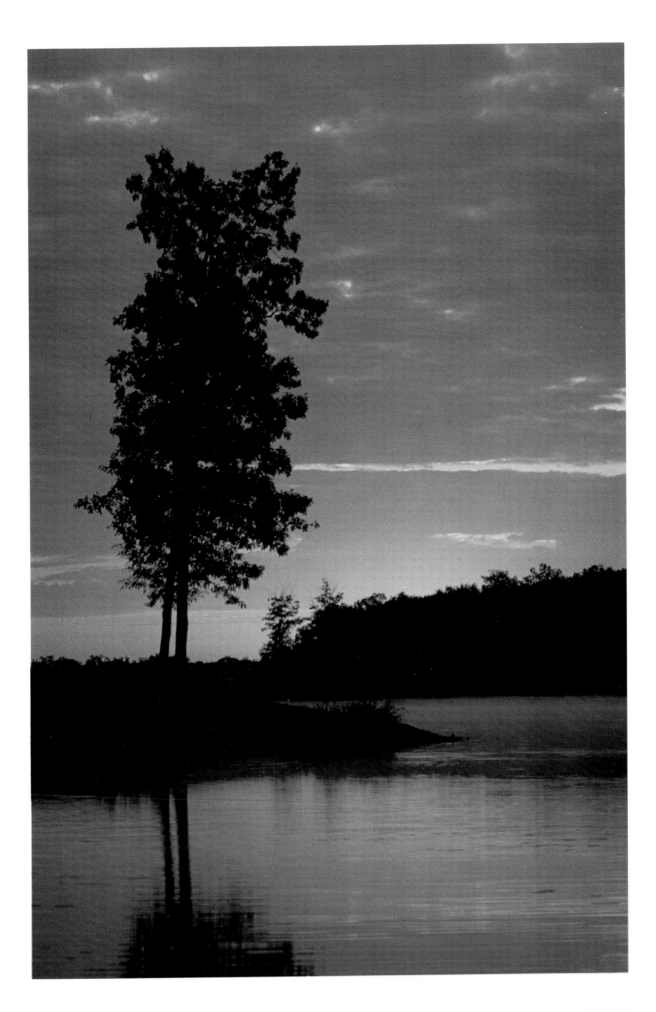

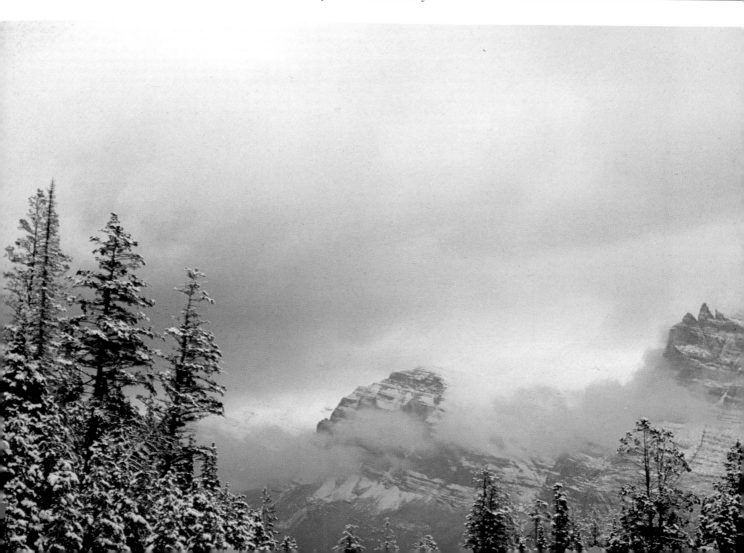

(right) The light of the dawn sky radiates spectral colors—no need for any photographic filters—on those days when the sun lights up the earth from behind a veil of fog and mist.

45–125mm zoom lens; exposure established by one-degree spotmeter reading light at tip of sun's rays.

(below) Although the calendar indicated only early September, the first snowfall upon the mountains of Montana intimates that winter will arrive early in the high elevations.

35mm wide-angle lens; exposure established by meter in camera body.

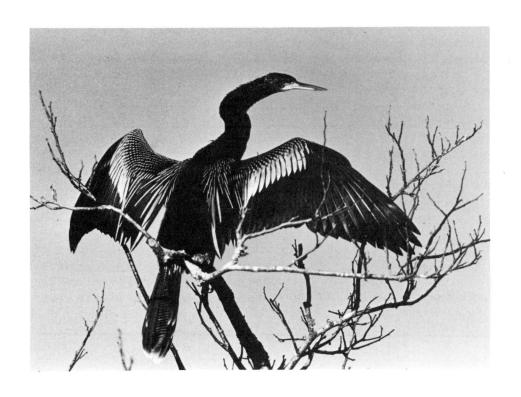

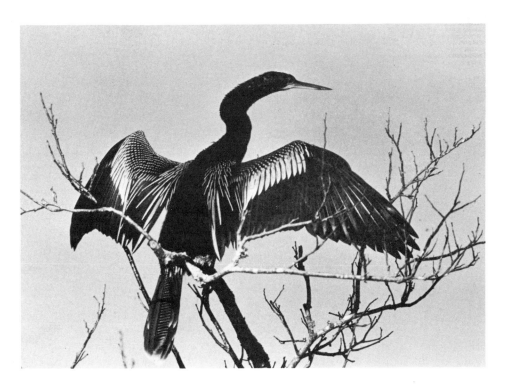

Figures 5.18A and B
Note the difference in this pair of anhinga photographs, one registering the
animal with a highlight in the eye, the other without.

Yellowstone. As I drove the park road through Hayden Valley, I came upon a coyote hunting rodents by the roadside. My first attempt outside the car sent the animal scurrying a hundred yards or so toward the river. Dejectedly I found each repeated effort met with the same behavior. Finally, I decided to try it from the car window. The beautifully furred wild dog wandered to within thirty feet of my doors. I used my Bushnell window tripod mount and my 500mm lens to race through five rolls of film before the hunter killed a rabbit and ambled into the distant woods to feed in peace. In this same fashion, I have photographed immature bald eagles in the Everglades, nursing bighorns in the Rockies, and nesting red-winged blackbirds in the swamp regions of Lake Ontario.

There are a number of precautions that should be taken to ensure your success. Drive slowly. Have all of your equipment set up and your exposure calculations predetermined before your final approach. Once you have brought the car to a halt, allow the engine to run until you have focused and composed. Obviously you must shut the engine to stop vibrations before you shoot, but this should be done at the last instant, for the change in sound falling upon the animal's ears may cause it to disappear. This is especially true for the sensitive ears of the many birds who perch the wires, poles, and trees along many roads. If the animal stays once you have shut down your motor, shoot immediately. If the animal remains for that first shot, you may find yourself in for an enjoyable session of photographing the creature in a variety of poses. For your own safety and for that of other visitors to park environments, you should be considerate enough to keep your car in parking areas or safely off the road on shoulder zones, but certainly not in the mainstream blocking the traffic.

Figures 5.19A and B
Your car can be an effective photographic blind. All you need do is purchase a window-mountable tripod head or produce on your own a similar system of sturdy support.

After you have recorded the standard poses and common frames of the available wildlife, you will no doubt find yourself dissatisfied with more of the same. In your boredom you will seek more action, more unusual moments from the same creatures. In this regard, one should consider what biologists call the "fight or flight" situation. When you confront a wild animal, you represent a large, alien form of life in its environment. The creature has one of two unlikely choices of what to do. First, it may stay and fight you. That is not appealing, for you are much larger than virtually all of the birds and reptiles plus most of the mammals you encounter. The second choice is to take to flight. That also represents a bad option because millions of years of evolution have programmed into the bird or beast a behavior mechanism that urges it to guard the home, protect the territory, or defend the young. This is the fight or flight situation. The animal's inability to resolve the dilemma results in what is called *displacement* activity. Birds may preen their feathers or bob their heads; prairie dogs may chatter or wag their tails.

What does all this have to do with photography? Simple: your recognition of this seemingly innocuous behavior should provide the unmistakable clue that you are approaching the animal's invisible territorial boundary. Prepare your camera for that magic moment when the bird will soar into flight or the prairie dog will pop onto its hind

legs. Know which way the animal is heading, for it is most likely to make its initial move in that same direction. If you have an auto winder or a motor drive unit (or even if you don't), compose the subject so that it will be moving into rather than out of the frame. This will give you the opportunity to get more than one shot. If the animal is facing from your left to right, place it in the lower left quadrant of the film, pan with the motion, and, if possible, try to keep the subject parallel to and in the same plane as your camera back. This will help to negate the depth-of-field problem created by the use of a long lens and will allow you to use a fast shutter speed to freeze the motion. As you pan when you follow the animal, you will blur the stationary background and, perhaps, when your processing returns, you will be able to see at least one reward of the subject that was hidden by a flapping mirror.

In attempting to photograph this special action moment of a bird in flight or a predator attacking its prey or whatever else, I would like to unqualifiedly recommend a Novoflex Follow Focus lens set-up. As far as I am concerned, there is no other method available that even comes close to the versatility, speed, and quality offered by this unique series of lenses. Some of you may already know of Novoflex's patented focusing systems. Unlike traditional lenses, which focus by rotation of a barrel mount, a Novoflex lens focuses by the squeezing of a trigger. As you practice with

Figure 5.20
The Novoflex system of trigger focusing—a delight for the wildlife photographer. Here used on a tripod, the method is both mobile and sturdy.
Photograph by Otis Sprow.

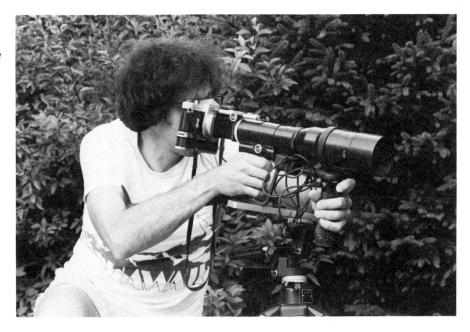

the grip, focusing becomes as easy to control as the pressure on the gas pedal of your car. It is unequalled when you want to pan with any moving animal in any situation. A most desirable option that I have included on both of my Novoflex lenses is a bellows unit that permits continuous focusing on my 400mm lens from infinity to approximately five feet. Another option I purchased was the shoulder mount; it acts like a gun stock and permits comfortable, adjustable hand holding. But you know my aversion to that policy; rather, the years of experience have taught me to use the gun stock even more effectively by mounting the lens on the tripod and then loosening the locking handles just enough to allow my tripod head to move up and down, left to right, like a ball-head socket would do. The battery pack from my motor drive balances the front of the unit and provides the point of shutter release with my left hand; the center of the lens is locked on the tripod; the right hand focuses the trigger and the rear of the entire unit is supported against my body by the shoulder mount. In this way I obtain the very best of three worlds: Novoflex flexibility, tripod stability, and continued use of Kodachrome 25 film. I would not trade this arrangement for any other system available on the market today.

Photo essay: the birds

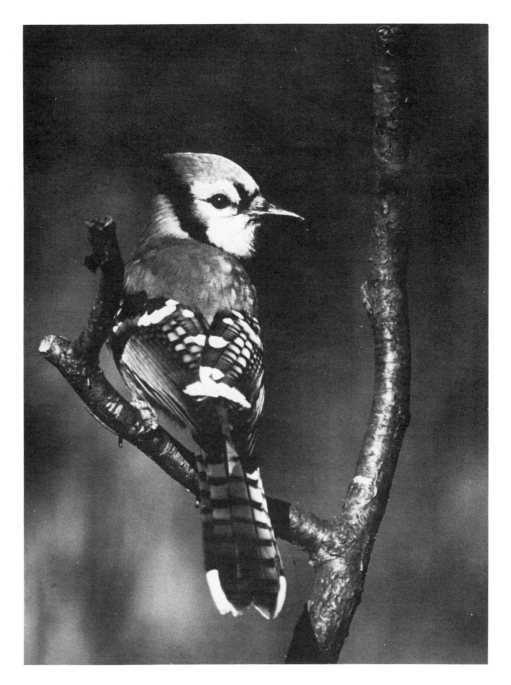

Unquestionably the most popular form of wildlife to photograph and probably the most readily accessible is the birds. They cavort as aerial acrobats; they sport vibrant colors; they chortle with cheerful chirps. Little wonder that these feathered creatures command so much of our photographic attention. The following photographs therefore pay them tribute—tribute to their music and their flight, tribute to their beauty, and mostly to their enrichment of our lives, for, as Hal Borland has stated, "Without birds where would we have learned that there can be music in the heart?"

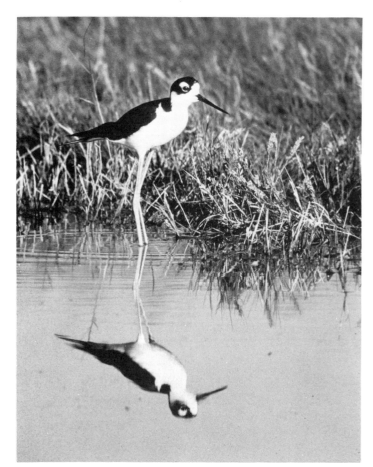

Characterized by the unifying feature of their feathers, the birds have nonetheless developed into a number of diverse families.

(left) Black-necked Stilt, family Recurvirostridae: This sleek, fragile-looking bird roams the shallows of swamps and marshes on slender legs of brilliant pink.

(below) Red-shouldered Hawk, family Accipitridae: With the keenest eyes in nature, hawks and other raptores scour their landscapes for smaller prey.

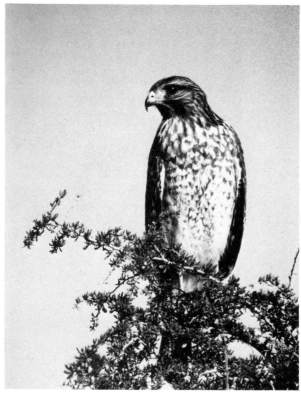

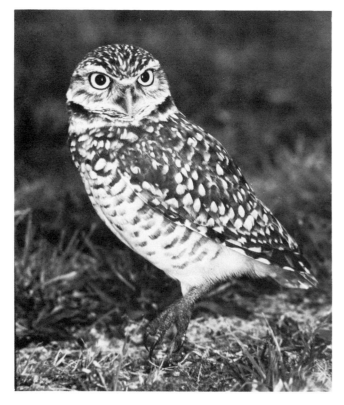

Burrowing Owl, family Strigidae: These tiny (9–11″) predators spend many of their daylight hours—uncharacteristically of owls—standing in the open at the mouths of the earthen burrows they call home.

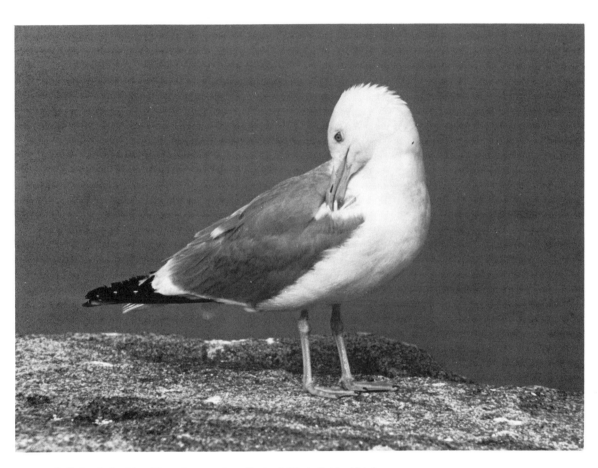

Herring Gull, family Laridae: The calm preening efforts of this individual bird belie the raucous gull lifestyle that readily adapts these birds for life with man as well as for the wilderness.

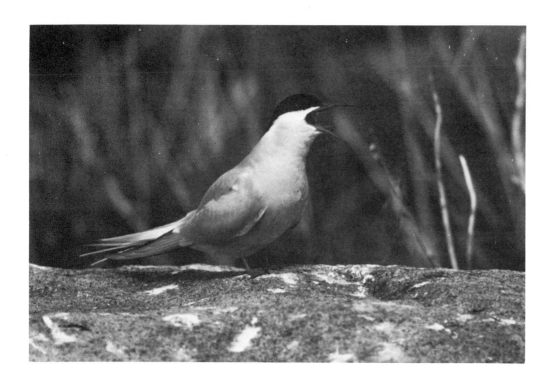

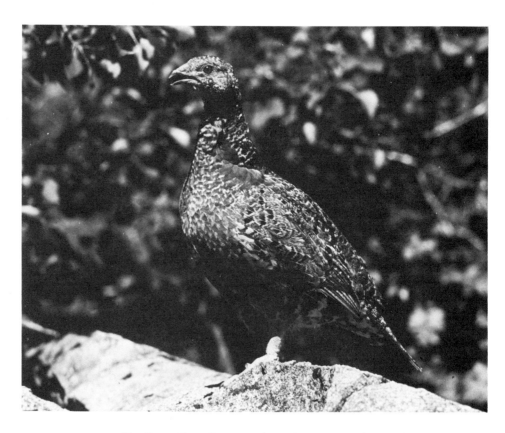

THE GIFT OF SONG. Romantics have often interpreted the exuberance of singing birds as a joyous expression of the celebration of life. Biologists tell us that these songs are actually bellicose chants of aggression, admonishing others of the species to stay away from the staked-out territory and thereby avoid hostilities. Whatever the explanation, who among us would wish to hike in a world devoid of the birds' music? To silence the shrieking of an Arctic tern, to smother the peeping of a blue grouse, would be to suffocate the flow of life itself.

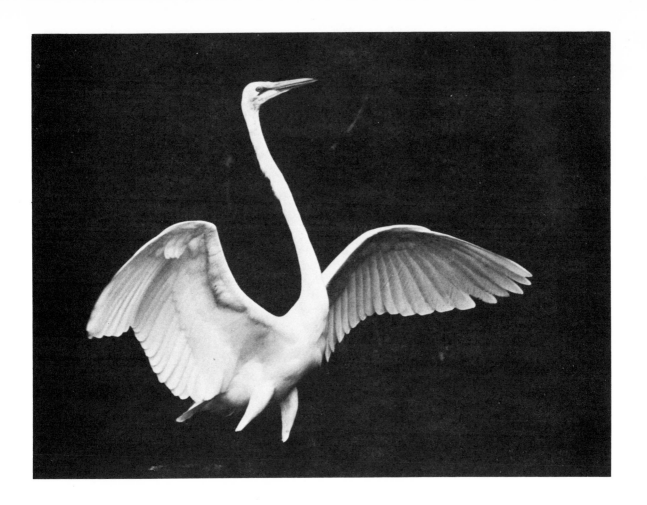

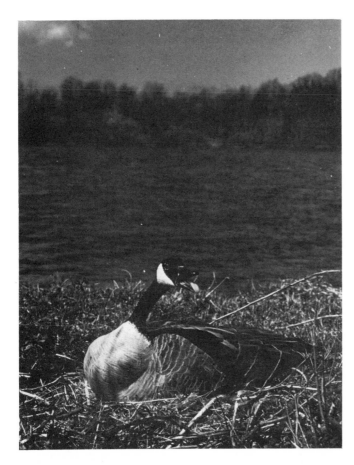

THE ART OF DEFENSE. For one brief moment, the intrusion of a rival bird transforms a stately egret (above) from an alert angler into an aggressive knight in white feathers as the invader is confronted and then repelled in a flurry of ritualistic behavior. At left, the Canada goose convincingly strikes out at the photographer in defense of her nest.

89

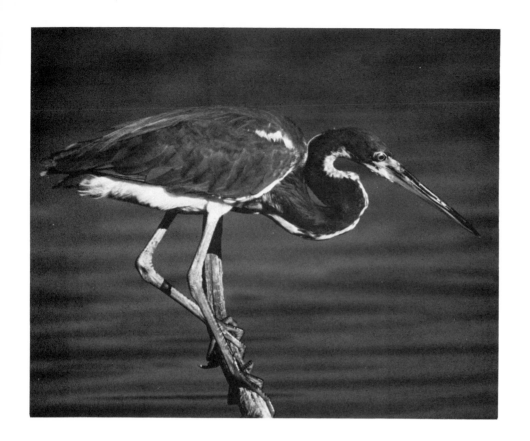

THE HUNTERS . . . Long of bill, long of leg, and long of neck, the fish-hunting tri-colored and green herons pictured on this page must also be tactically long on patience if they are to nab the wary fish below.

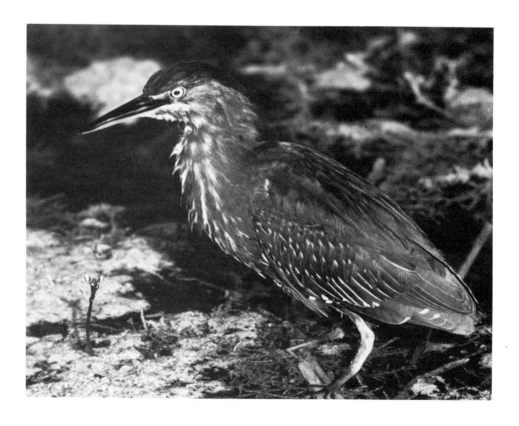

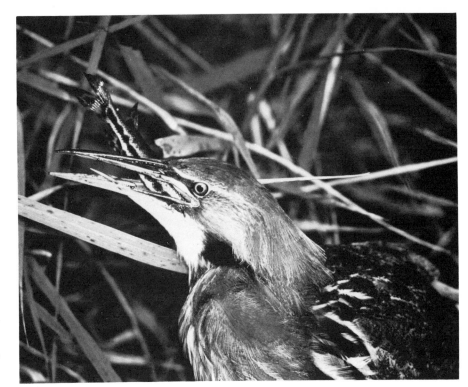

... THE HUNTED. The birds have evolved as a class of omnivorous feeders. Their daily nourishment may be extracted in anything from berries to carrion, everything from worms to other birds. The American bittern, above, uses its plier-like bill to snare fish, frogs, and even crayfish. On the other hand, the limpkin, shown below, uses its downcurved bill first to pluck fresh-water apple snails from the water and then to extract the fleshy mussel from beneath the shell.

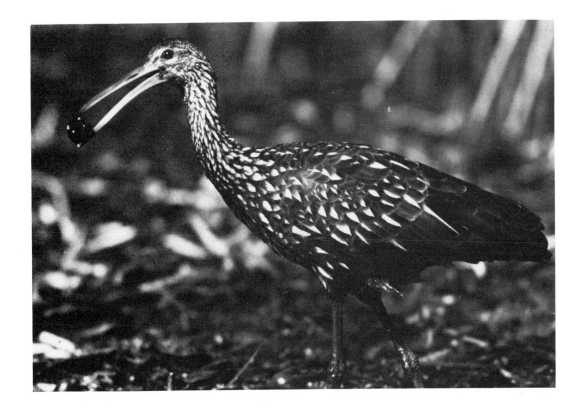

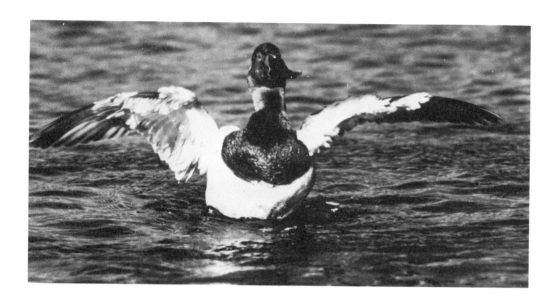

TAKE-OFFS AND TOUCH-DOWNS. A rare canvasback (above) takes off for a roosting spot far more secure than the narrow river upon which it has been feeding this day. When an arctic tern touches down on land, as shown below, it must do so with a great sigh of relief, for no bird flies farther than this champion migrator, whose annual round-trip flight may be of 20,000 or more miles.

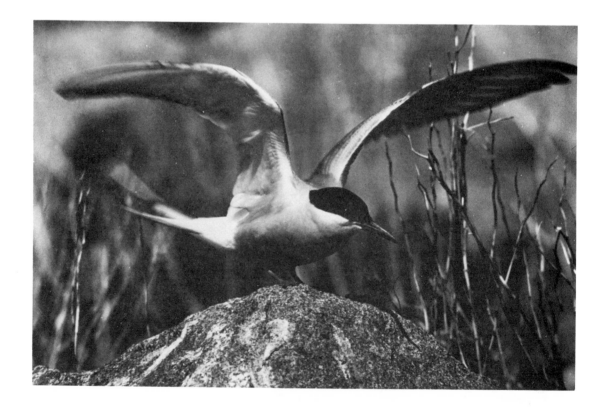

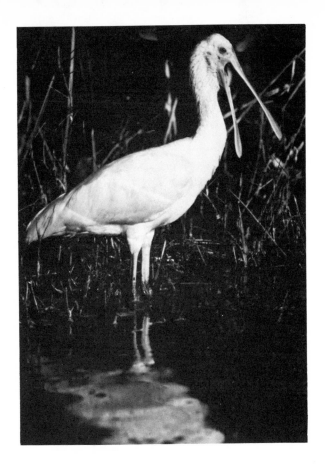

THE ODD COUPLE. Few birds possess stranger bills than the pair pictured here—the black skimmer and the roseate spoonbill. The skimmer (above) uses its razor-thin lower mandible to slice the waters of lakes and ponds to stir up fish, whereas the spoonbill's spatulate proboscis possesses sensitive nerve endings that probe the shallows for smaller marine organisms.

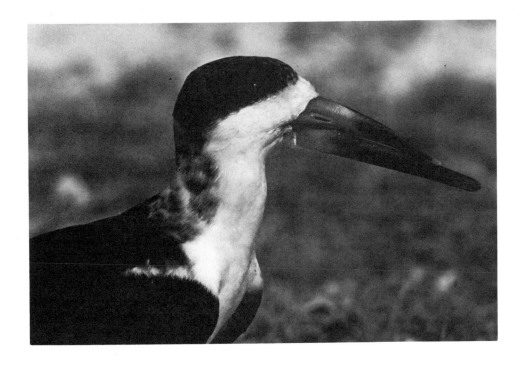

The endless hours of devotion and care expended by many birds upon the nest and the young is legendary. In the case of pileated woodpeckers, both male and female share the chores of excavating and then tending the home.

While the baby robins at right impatiently strain their necks for the delicacies being served by a dutiful parent, the young blue jays shown below wait patiently for their parents' return.

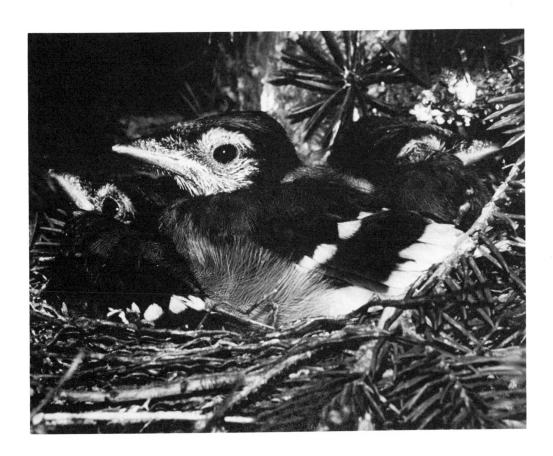

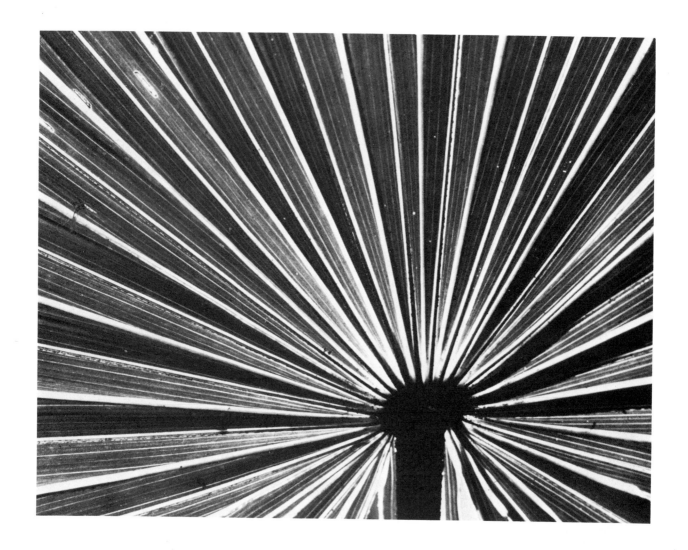

W HEN YOU ARE CONSIDERING the union of the
mechanics of science and the aesthetics of
art, it is important for you to understand that both
must do their share to create an effective picture.
For that reason, half of this chapter will be de-
voted to the mechanical controls available to
you on cameras, lenses, and accessories, while
the other portion will examine those composi-
tional concerns that can improve the aesthetics
of a photograph that is already mechanically
correct.

Shutter Speeds

Unless your camera has a mirror lock-up, the
shutter speed dial is the *only* regulating control
you possess on the camera body. Do you simply
set your shutter speed dial at 1/125 and leave it
there? Or do you creatively employ its selection of
options to achieve the effect you are seeking? Do
you manipulate your fastest shutter speeds to
freeze the motion of a bird in flight? Do you know
how fast a speed is required to stop the gentle

CHAPTER SIX

Developing composition and control

bobbing and weaving of flowers? Are you aware that motion *across* the plane of the film demands faster shutter speeds to freeze it than does motion *toward* the camera? Do you totally neglect the other end of the spectrum, the slow shutter speeds? Exposures of 1/8 of a second or longer, much longer, are an absolute necessity if you want to transform the surf striking a rocky shoreline into a frothy pattern of flowing liquid. With your shutter speed dial set at *B* (bulb), time exposures of a minute or longer can produce eerie shades of

color and strange patterns of motion before dawn and after dusk. Your shutter is capable of at least a dozen different speeds. How many do you employ? You photograph a waterfall at 1/15 of a second and then leave it. Why? Your eyes cannot possibly see what effect you have achieved. Why don't you take another sequence at 1/8 of a second? and yet another at 1/2 of a second? Provide yourself with a choice; with a series of three (or more), you can now select which pattern of motion you most prefer.

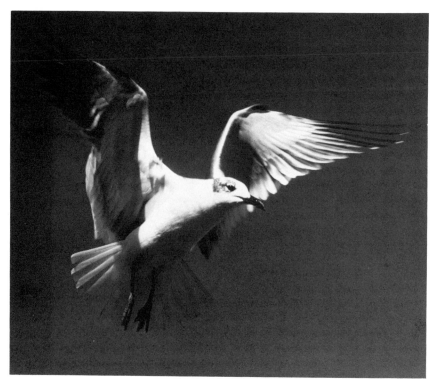

Figure 6.1A

Figures 6.1A, B, and C
(A) Fast shutter speeds can freeze the path of motion. (B) Slow shutter speeds can expand the flow of motion. (C) Inadequate shutter speeds can send you searching for a new hobby.

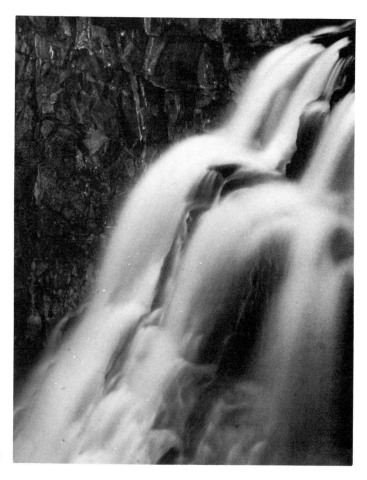

Figure 6.1B

98

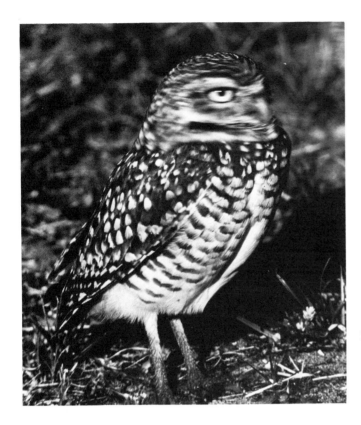

Figure 6.1C

At extremely slow shutter speeds (one second or longer) and at very fast speeds (shorter than 1/1000 of a second) the chemicals in the film do not react to light as quickly as they do at more normal exposure times. This innate inability of the film, known as *reciprocity failure*, will cause a shift of color in your images unless you compensate by allowing additional exposure either by opening your lens diaphragm or by leaving the shutter open longer. Changing shutter speeds means changing diaphragm settings, and that means altering your depth-of-field. So let us shift gears and move onto this concept so closely intertwined with shutter speed selection.

Depth-of-Field

The term *depth-of-field* refers to that distance stretching between the nearest and farthest points in a photograph that are in apparently sharp focus at any given aperture. For example, if you are focused on an object eight feet away from the camera and you have used techniques that will be described shortly to bring into sharp focus everything from five to fifteen feet, then your depth-of-field is ten feet. In considering depth-of-field, you should be aware that in the strictest sense only that material that lies in the same plane as that upon which the lens is focused will be sharp. But subject matter not in this single plane of focus can also be made to *appear* sharp by creating more of what we label *depth-of-field*. The artistic use of depth-of-field can only be decided upon by the individual photographer. When a great expanse of sharp objects is desired, you will shoot for a large depth-of-field. Conversely, when you require that only one central point be in sharp focus, you will demand from your lens a narrow depth-of-field. However, before depth-of-field can be aesthetically employed to enhance your photography, you should know that this phenomenon is technically controlled by three distinct factors:

1. size of lens aperture,
2. focal length of lens, and
3. distance from camera to subject.

Point 1: When we refer to the opening (aperture) of the lens, you must know that as you *decrease* the size of the lens aperture (from *f*/8 to *f*/11, for example), you *increase* depth-of-field. So, if all other variables are equal, a small aperture of *f*/16 will yield more depth-of-field than a large opening of *f*/4.

Point 2: The principle here states that as the length of the lens *increases,* depth-of-field *decreases.* If you use both a 100mm lens and a 500mm lens to photograph a subject from the same distance at the same lens aperture, the shorter-length 100 mm lens will bestow much more depth-of-field on your subject than the much longer 500mm lens.

Point 3: If you use the same length lens at the same aperture to photograph a subject, both from ten feet away and then from twenty feet away, the latter photograph will contain greater depth-of-field because depth-of-field *increases* as camera-to-subject distance *increases* and, of course, *decreases* as camera-to-subject distance *decreases.*

In addition, these factors all interchangeably relate to one another in a precise mathematic progression that is startlingly simple. For example, if we photograph something from ten feet away and use a 100mm lens at *f*/8, we can obtain exactly the same depth-of-field by photographing from twenty feet away (twice the distance) with a 200mm lens (twice the length) at the same aperture. Should we remain at the same distance of ten feet and use both the 100mm and the 200mm lenses, we can obtain the same depth-of-field by halving the aperture on the 200mm lens. If the 100mm lens was set at *f*/4, the 200mm lens will give the identical depth at *f*/8. On the other hand, the 200mm lens also set at *f*/4 will give only *half* the depth-of-field because it is *twice* as long. Since this is not designed to be an exercise in mental gymnastics, you might justifiably raise the age-old photographic objection: "So what?"

Although this may seem to be an inordinate amount of attention paid to a relatively simple

Figures 6.2A, B, and C
The *increasing* depth-of-field in these photographs results from *decreasing* the lens aperture from *f*/5.6 to *f*/11 and finally to *f*/22, respectively.

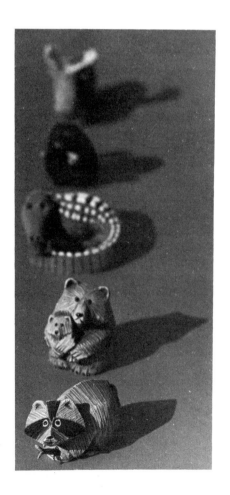 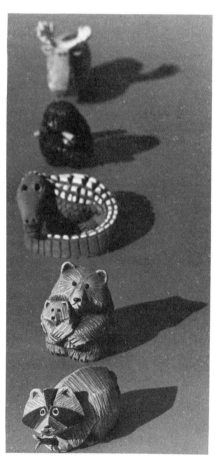 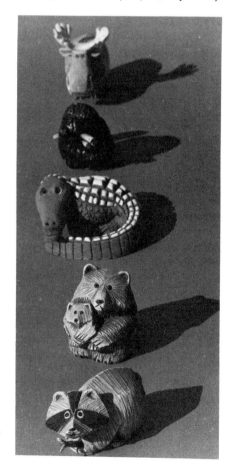

concept, I do not think that such respect is out of place when you consider the fact that depth-of-field is one of basically only two mechanical controls on your camera/lens unit to achieve artistic effects. Indeed, there are a number of photographic benefits to be derived and a host of errors to be avoided by first understanding and then effectively controlling the various aspects of depth-of-field. For example, you might shoot a chipmunk at 1/125 of a second at $f/11$ and thereby bring into focus a background branch that now appears to grow right out of the animal's head. Instead, why not shoot at 1/1000 of a second at $f/4$ and throw that distracting element into an unrecognizable blur? On the other hand, insufficient depth-of-field can be the major source of disappointment in pictures that displease the human eye because of out-of-focus portions, especially those located toward the front of the frame. If you cannot obtain sufficient depth-of-field to blanket your entire subject from nearest to farthest planes, the wise decision will be to sacrifice some depth toward the rear rather than the front of the subject, because the human eye will be far more forgiving of background softness than it will of foreground fuzziness. Maximum depth-of-field is certainly to be encouraged when using a foreground tree to frame a distant scene. An unsharp tree may so drastically distract your viewer's eye as to totally negate other meritorious aspects of your photograph. Macro photographers also generally shoot for maximum depth-of-field to render their tiny subjects pleasing to the audience. But sometimes, even in this world of close-ups, depth-of-field in extraneous material can be a distinct disadvantage. When photographing macro subjects, you normally want a great amount of depth-of-field so that your entire subject is at least recognizably sharp. This may dictate the use of a very small lens opening, such as $f/22$, to bring an entire blossom or tree frog into sharp focus. In the process, though, you also bring more and more of your background into sharper focus. Sometimes you can partially solve this problem by backing away from your subject and using a longer lens that will throw your background so badly out of focus that it will not compete for attention with your main point of interest. You might further find very useful the following three simple little tricks, which can overcome severe impediments to depth-of-field such as high winds, very low light levels, or vast differences between closest and farthest planes of interest.

When subjects such as flowers or leaves nod violently in the breezes, you may be forced to concede a great amount of depth-of-field by using a very fast shutter speed to photographically stop the motion. Under calmer conditions you might shoot at 1/30 of a second at $f/16$; but today's winds force you to employ a shutter speed of 1/250 and a diaphragm opening of $f/5.6$. You can help your camera by creating as few planes as possible between it and the subject. By positioning your camera parallel to the main plane of the subject, you reduce to a minimum the number of planes that need to be sharp. In this basic repositioning, an aperture of $f/4$ may now do for your depth-of-field what $f/11$ could not accomplish previously.

When the available light is so low that you cannot achieve your desired depth-of-field, you can maximize whatever amount you do have by learning *where* to focus on your subject. $F/8$ is not always $f/8$. If we position three photographers using the same length lens at the same aperture from the same distance, it would seem logical to assume that they all would obtain the identical depth-of-field. In terms of a physically measurable distance such as one inch or twenty feet, this will be true, but the twenty feet of one of the photographers will be far more effective depth-of-field because one of our imagined lensmen understands that at normal (non-macro) focusing distances, one-third of the depth-of-field extends in *front* of the plane of focus while two-thirds stretch *beyond* that imaginary (yet very real) line. For the sake of keeping the present mathematics uncomplicated, let us postulate a mushroom whose cap is three inches from front to back. What a coincidence that at $f/16$ we see that we can provide the film with exactly three inches of depth-of-field!

Photographer Number One photographs the mushroom by focusing on the very closest point. Mistake! Our formula tells us that one-third of the depth-of-field will be in front of that point while two-thirds will extend beyond it. This means that our first photographer has wasted one inch (one-third of our three-inch depth) of focus on the ground in front of the mushroom while sharply portraying only the front two inches (two-thirds of our three inch depth) of the subject and leaving the final inch somewhat fuzzy.

Photographer Number Two focuses on the hindmost part of the mushroom. Wrong again! This time one inch of the rear part of the subject

Figures 6.3A, B, and C
All three of these photographs were made with an aperture of f/11, but the lens
in the first was focused on the eye of the raccoon, in the second on the bear,
and in the third on the moose. Notice the resulting changes in the depth-of-
field of the various figures.

will be sharp, two inches in the front will be fuzzy, and the other two precious depth-of-field inches have been thrown away upon the background. What should be done to capture the entire mushroom sharply?

Photographer Number Three shows us by focusing one inch into the cap of the mushroom, thereby picturing the complete fungus in sharp focus. The entire three inches of depth-of-field have been effectively used because one-third (or one inch) extends in front of that plane and two-thirds (or two inches) stretches beyond. It appears obvious that one plus two equals three and the whole mushroom is sharp! F/8 is not always f/8!

As one approaches macro distances, this formula alters somewhat, and the ratio in front of and behind the plane of focus becomes 50-50. Because of this, in close-up situations, you should focus halfway into your subject and not a third of the way into it as just described. In either situation, if your camera is equipped with a depth-of-field preview button, you can look through your viewfinder and actually see what is and is not in focus.

One final tip to aid and abet depth-of-field, especially with scenics wherein you may be photographing subjects that stretch from ten feet to infinity, concerns itself with those almost totally unheeded scales on the lens barrel that define how much depth-of-field is present at all the various f/stops for each particular lens. Frequently these bars will indicate to you (but only if you pay attention to them) that your depth-of-field at a particular aperture reaches *beyond* infinity. But there isn't anything beyond infinity. By rotating the lens barrel back in the direction of closer focusing distances until the infinity symbol aligns itself with the line corresponding to the f/stop being used, you can bring closer subjects into sharp focus while not losing those at infinity. In this manner you greatly extend your depth-of-field.

In any event, *you* are the photographer. *You* must remain in control of the situation unfolding before you. *You* must decide which technique will

102

best suit your intentions and needs, particularly in reference to neglected backgrounds.

Backgrounds

The classic background is the one that goes completely unnoticed; in its simplicity it is almost powerful. *Control of background* means not only to control depth-of-field, but also to deal with light, color, and lines. How much of a background appears in or out-of-focus depends on how much depth-of-field you have created. Backgrounds can be reduced to pleasant abstractions by a number of techniques. You can use a large aperture setting or you can employ a longer-length lens; you can even compose some subjects in such a way that the nearest background is distant enough to be rendered unobtrusively blurry.

Light subjects composed against light backgrounds or dark subjects against dark backgrounds tend to merge into each other and lose their separation. By positioning light against dark,

you provide contrast and force the subject to stand away from its background. To achieve this may require that you look for a special vantage point, an effective angle. More considerations on background control will be explored in Chapter Eight. Yet one other problem of backgrounds (and subjects too) does arise here in the form of our final technical control—exposure.

Exposure

Exposure refers to the amount of light that has been allowed to reach the film. Too much light (either by too large a lens opening or too slow a shutter speed) creates overexposure; too little light (resulting from too small a lens opening or too fast a shutter speed) creates underexposure. As I mentioned earlier, I use a one-degree spotmeter to establish my exposures. Under sunny conditions I always read for the highest light value of my main subject to ensure a rich, saturated slide. Although this measurement should not be employed for

Figure 6.4
Common dirt has produced here an uncommonly effective background for grasses weighted down by a backpack of frost.

black-and-white film, in color slide photography it is invariably more effective to underexpose your picture than to overexpose it for the following reasons. First, the saturation of color values produces a contrast that visually heightens the illusion of sharpness. You can readily prove this to yourself by focusing on a stationary object and then shooting one frame one half a stop underexposed and a second frame one half a stop overexposed. Since you will not have changed focus, lens, or shutter speed, any differences in apparent sharpness must have derived from exposure. Secondly, the human eye will be far more forgiving of somewhat darker, underexposed objects than it will be of the same themes overexposed. You have all seen this in practice when your slide projector failed to drop the next slide and the blinding white screen caused your audience to squint and shield its eyes. The human eye is optically attracted to light areas and repelled by dark ones, but your failure to keep your light areas under firm exposure control will, in slight overexposure, create hot spots to draw the viewer's eye away from the subject and, in extreme overexposure, will repel the eye because

they are beyond our capacity to reduce them to an optically manageable level. Finally, by exposing for the high light value you will so underexpose darker extraneous material that you will heighten contrast notably and coerce your viewer's eye to the lighter subject. This is especially noticeable when shooting a very light subject, such as any of the pure white herons and egrets of the Everglades, against a dark background, such as dark green vegetation. To record both the bird and the foliage exactly as the eye has seen them is an impossibility with color slide film, because on a sunny day the range of light values exceeds the capacity of the film to handle it. Since you cannot render both the dark and the light ends, it appears obvious to me that you must expose for the bird. The bird is your main subject; if it weren't, you would have shot the leaves or grass without the bird in front of it. Exposing for the white of the bird will substantially underexpose your foliage, an effect that I like except on those occasions when the divergent light values so greatly exceed the latitude of the film that the bird and environment display an unusual color cast. In cases such as this, you must recollect our discussion of when

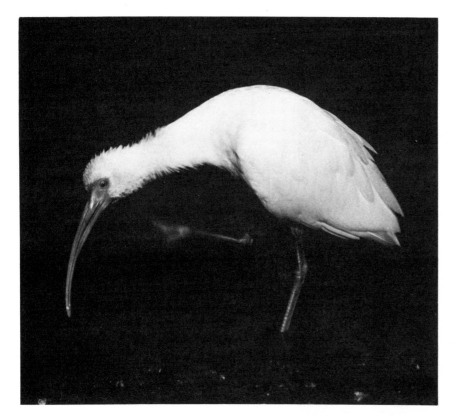

Figure 6.5
Correct exposure of the preening ibis has severely underexposed the darker watery background; the viewer's eye must look at the brighter subject.

to and when not to shoot; your knowledge of such conditions will then prevent the occurrence of the error.

Other choices for determining correct exposure include using the meter in your camera. But with most cameras there are certain conditions that can fool the meter, such as a white flower growing against a background of very dark soil. The meter could be tricked by the dark areas, especially if you are not close enough to the plant. The meter may interpret this scene as lacking in light and will tell you to open the lens eye to admit more light. The result could easily be a severely overexposed white flower that had much more light reflecting off it than the ground. You can help to correct this potential error by getting much closer to your subject and by filling the frame with the white flower, so the dark ground will not be able to influence the meter. You can also use the palm of your hand as a light meter. Tilt your hand to coincide with the angle at which the flower is receiving its light; use your camera to read the light falling onto your hand. You now have established a point of reference; for subjects lighter than your hand, you can decrease exposure; and for those darker, you merely increase exposure slightly. If you do not trust your hand, be aware that Kodak has created an official hand known as a gray card. The gray side represents the same light value as that measured by your light meter. By reading the gray card and interpreting the results as you did with your hand, you will also obtain accurate exposures.

Many beginners who lack confidence resort to a commonly used technique known as *bracketing* to ensure correct exposures. This term refers to the practice of taking three exposures of each subject: The first exposure is made at whatever setting the light meter indicates, the second is underexposed, and the third is overexposed. In this way, according to the theory of bracketing, at least one of the images will record a correct exposure. I personally abhor this technique because it is an implicit admission that, at best, I will salvage a ratio of only one out of three pictures. I have invested thousands of dollars in equipment, and I have experienced years of practice. Such a concession rubs an exceptionally sensitive nerve in me; if I can do no better than one out of three, I think I should be looking for another profession. Bracketing has been traditionally urged in increments of one full *f*/stop, *i.e.*, if you are shooting

for correct exposure at 1/125 of a second at *f*/8, a second exposure should be made at *f*/5.6, and the third at *f*/11 with the same shutter speed. By bracketing in increments of one full *f*/stop (whether by changing shutter speeds or lens diaphragm), you are changing the light by 100 percent. If you are going to bracket, I would definitely urge increments of no more than one half of a stop on each side of the meter's reading.

My only concession to bracketing is to do so when shooting directly into the sun. I do not have any way of knowing which pattern of flare or star-bursting will be most effective, so I am willing to give in somewhat under these conditions. Otherwise, I am using a sophisticated meter to sensitively measure my exposures; I so thoroughly trust it and my experiences with it that, until the light changes, all exposures are made according to its single reading. The years of use make me so confident of its accuracy that I am willing to live or die by what it tells me. But the beginner who is using a new camera for the first time would be well advised to bracket exposures until further use of the camera and familiarity with a variety of lighting conditions become as trustworthy as they are for me. Also, if you have flown to Greece for a once-in-a-lifetime vacation, I would heartily recommend that you bracket to avoid tragic exposure errors that will be revealed only upon your return home. Remember, one or two extra frames of film, even multiplied by 200 occasions that you may bracket, amount to a much cheaper expense than another plane ticket back—with still no guarantee of the exotic lighting or spectacular clouds that enticed you to shoot in the first place. As a final note, I feel that you might want to use bracketing as long as it is helpful, but at some point you should be able to throw it out just as the victim of a broken leg one day casts aside the crutches no longer needed.

Format

One of the most frequently neglected considerations in nature photography is the type of format to be employed. If you are using a square-format camera, you have no choice and therefore no problem. But most other newcomers to photography leave me with the feeling that their 35mm

cameras will operate only in a horizontal plane and that, if they turn their cameras vertically, all the chemicals in the film will rush together, scramble the emulsion, and wreck the image forever! Although it is undeniably true that the controls on today's 35mm cameras are located in such positions as to support that belief, you must transcend that minuscule physical inconvenience and learn to use your camera vertically. I try to impress upon my classes that the world is a vertical subject. Trees climb vertically to the light; mountains thrust vertically toward the sky; shorebirds stroll vertically across the beach; rivers wind vertically into the distance; telephone poles, build-

ings, and even people are vertical subjects. My suggestion is to shoot *everything* vertically unless there is some noticeable reason to shoot horizontally. The horizontal format is fine when you have an expanse of sand dunes stretching laterally across the desert before a purple range of distant mountains, but more often the lines of nature will dictate that you use the vertical format. By so doing, you will accentuate the lines of nature already inherently present in the subject, and in the process you will produce an image of far greater visual impact. Compare the two shots of southern Utah's Delicate Arch (Figures 6.6A and 6.6B); to me, the horizontal picture is almost totally out of

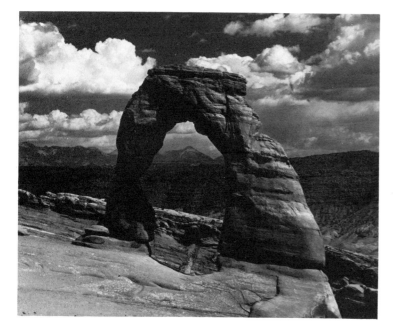

Figures 6.6A and B
The horizontal vs. the vertical format, as seen through Delicate Arch.

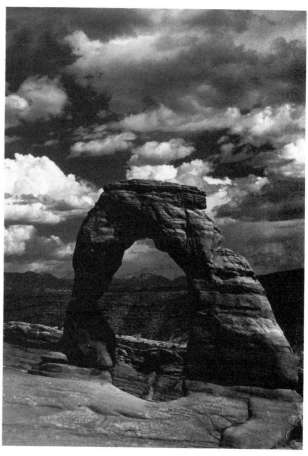

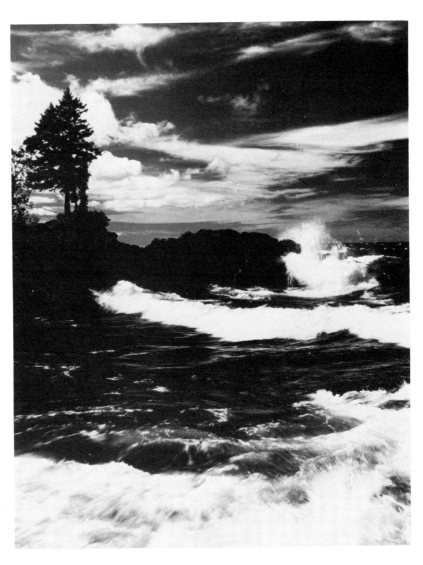

Figure 6.7
Unwanted human artifacts forced the use
of the vertical format to make this photo-
graph appear totally natural.

the question. On some occasions, the reason for your choice of format will not be so obvious, as in Figure 6.7. You may wonder why I selected the vertical format on this day when Lake Superior attempted mightily to drown me and my equipment. Well, just one hundred feet or so beyond the solitary trees on the rocky shore was a summer cottage complete with lawn chairs and beach balls. Believe it or not, lawn chairs and beach balls tend to destroy the illusion of wilderness.

But regardless of the format you select for your scenics, as a general rule, you should try to avoid splitting your landscapes into even halves. Such composition tends to produce a static picture lacking in drama and proportion. Rather, by watching the placement of your horizon line, you can create images that either give a feeling of closeness or vastness to your audience. By locating the horizon line low in the frame, you give the illusion of vast, wide-open spaces. Such a technique is well employed when you have superb cloud formations scudding above your panorama. Conversely, by situating the horizon line high in your slide, you give the feeling of closeness and greater contact for your viewers. This practice can successfully eliminate much of an uninteresting, cloudless sky or do away with most of the dreary whiteness of a backlit scene with a bald sky.

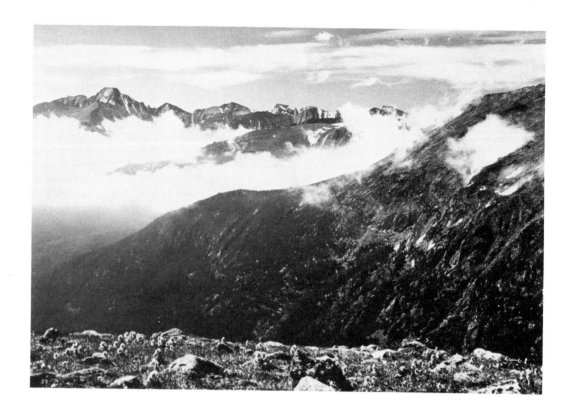

Figures 6.8A and B
Notice the different feelings created by a photograph with a skimpy sky as
opposed to those created by one with vast heavens.

The Golden Mean and the Law of Thirds

Throughout the history of art, whether it be painting, sculpture, or architecture, a startlingly consistent ratio between the long and the short dimensions of any given creation has steadily revealed itself. This proportion, 1.6 to 1, has been called *The Golden Mean;* its continued emergence in a variety of media regardless of culture, social structure, or historical setting lends it a great credibility in the increasingly accepted-as-art world of photography. What references does The Golden Mean establish for nature photographers? How can this effective compositional technique enhance natural images?

To answer these questions properly, let us first establish the simple mathematics of the numbers. A frame of 35mm film measures 36×24 centimeters, or a ratio of 1.5 to 1, closely approximating The Golden Mean. If we were to take this rectangular piece of film and divide it into equal sections for a Tic-Tac-Toe grid, we would have dissected our film into nine smaller rectangles that partition the film into thirds both horizontally and vertically. By placing our main subject matter at any one of the four intersecting points, we would have located it at one of the thirds positions, *i.e.,* a place where there is a ratio of 2 to 1 (⅓ above, ⅔ below; or ⅓ left, ⅔ right). Once again we very closely parallel the 1.6:1 ratio of The Golden Mean. By slightly raising or lowering a horizon line, by slightly moving an animal left or right, we can imitate this ratio exactly. This simple practice will give a better flow of lines that will at once bestow a substantial compositional improvement upon your photographs. But I do not wish anyone to become a slave to this or any other law. Thus, once you have mastered its basic concept, you will recognize when it is time to violate the law in allegiance to a greater law. I think that everyone would agree that a pleasant composition is the result desired by us all. To achieve that, the photographer does whatever is required. Sometimes I like to emulate the technique of the painter Winslow Homer and slim my skies to no more than a sliver—a piece of sky there only to provide needed contrast for the scene in the foreground. On other occasions, I may want to include a spectacularly lit or stunningly shaped cloud for-

Figure 6.9

The radiating pattern of a palmetto frond well illustrates effective subject placement in adherence with the law of thirds.

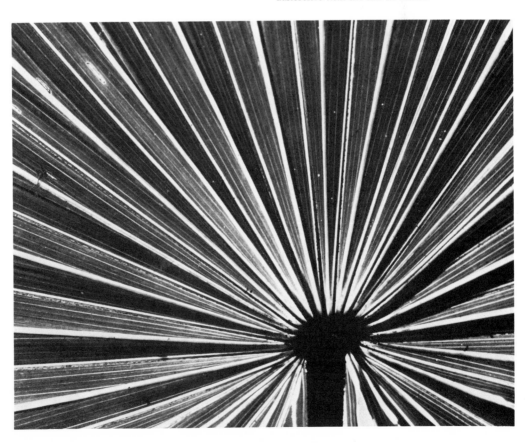

mation that means I will be forced to divide my picture in half. If the cloud is *the* factor that makes the difference between acceptable and powerful, I will unquestionably do it in violation of the half-and-half composition that I discouraged earlier.

If we mentally look back to our film grid, we can once again conjure up the four intersecting points; in our minds we could easily label them as bottom left, bottom right, top left, and top right. Now we can more easily consider when to use each placement for different subjects. Let us project a duck swimming from our right to the left. If we place the duck's head at the bottom left intersection, it will appear to be swimming out of the picture. The better choice would be to position it at the bottom right intersection and allow it room to swim *into* the frame. Compositionally, animals are invariably arranged more artistically when they appear to be moving into rather than out of the frame. You readily achieve this by leaving more space in front of the animal than in back of it. If the duck's bill is pushing against the edge of the slide mount, it is leading the viewer's eye right out of the frame, as opposed to a duck whose tail feathers are nearer the frame's edge and whose head leads the audience's eye into and then through the picture.

Although the remainder of this sentence is a blatant oversimplification, you could envision the bottom intersections (whether horizontally or vertically) as useful for earthbound subjects and the upper ones as effective placement points for airy things representing phenomena above us. Imagine our same duck flying; I would now rather see it placed at one of the upper intersections. Of course there will always be exceptions. The swimming duck may look better at an upper intersection if it is navigating across the golden reflection of a cypress tree stretching beneath it; the flying duck may be better positioned at a lower intersection if it can be silhouetted against a painted sky above. But at least with knowledge of the concept, you will again be in control; you will be the judge. Employment of the basic theory of The Golden Mean will eliminate the static character from many of your photos. Recognizing the validity of The Golden Mean will enable you to realize when the mean does not justify the end!

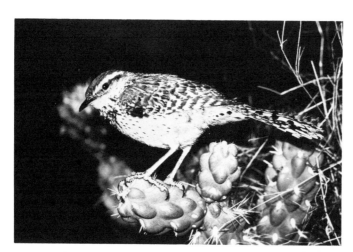

Figures 6.10A and B
With the help of a cactus wren, we see how much more pleasing is a composition that allows an animal room to move into a photograph than one in which the creature looks as though it is being pushed out of the picture.

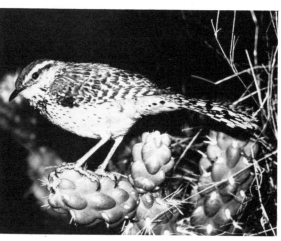

Lines

When we consider the meaning and importance of lines in photography, we can be referring to either the actual physical shape of the lines of our subject or the manner in which we compose whatever lines are resident in our photograph.

In considering the shape of any line for aesthetic use in photography, I have long been of a belief that can be summed up in one terse sentence: A straight line is a dead line. A photograph of a snake lying as straight as a yardstick not only presents a rigidly inanimate picture of the animal, but it also lacks frame-filling impact because of the unusual proportion ratio of the animal's body. Contrast such an image with another picture of the same snake in which the body is posed in smooth, rounded coils or at least with its neck bent, ready to strike. In the same light, compare two photographs of a long-necked bird such as a Canada goose: One captures the neck held straight up; the other records the same neck held in the posture of the flowing *S* curve. Unless the animal's eye reveals it as particularly alert, the former may look static and too geometric, while the latter will appear more alive, less rigid, more appealing. Again, a straight line is a dead line. Compare a telephone pole with a gnarled pine; contrast a farm canal with a winding river. Traditionally, the *S* curve, classically seen in the female body, but for our purposes embodied in the neck of a goose or the path of a river, has appealed because of its fluidity, softness, and animation.

Once you have included such lines in your photos, you must still consider your placement of these assets or they will be wasted. Remember our Tic-Tac-Toe grid? Almost invariably, you will best use your curved lines by positioning them in such a manner that they first lead your viewer's eye into and then through your photograph, but certainly not directly out of it. Effective samples might include: footprints diagonally crossing both the crusty snow of late winter and the emulsion of your film from bottom right to top left intersections; hills or mountains steadily ascending in elevation from left to right; a cautious squirrel whose flowing, bushy tail is balanced by a neck while straining for a handout.

Figure 6.11
A great blue heron poised to strike—a perfect example of the *S* curve.

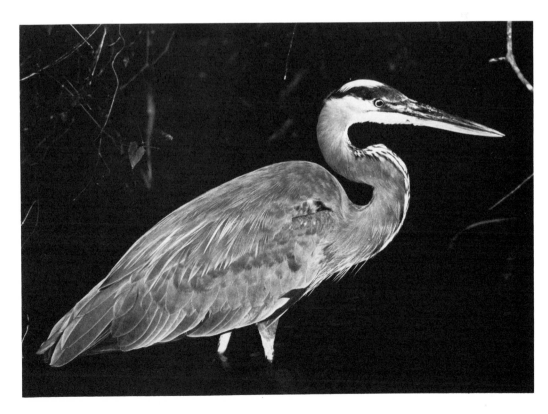

I have indicated that a straight line may normally be viewed as an aesthetically dead line, but the fact remains that some of nature's photogenic features are composed of straight lines—a russet cattail head, the repetitive trunks and shadows of the lodgepole pine forest, and a fallen log. You can still employ such lines favorably by emphasizing the geometric nature inherently present or by using a wide-angle lens to distort perspective. You can even go a step further if you will just realize that there is no law which decrees that you must hold your camera level. Although you would not want to tilt the horizon line of a mountain range, you might desire to tilt your tripod head for certain subjects, as I did for the image of the cattail in Figure 6.12. The straight-up posture in which I found it seemed too rigid for such vibrant life. By slightly slanting the camera, I

manufactured a mild diagonal thrust and some feeling of motion with tension.

Symmetry/Asymmetry

When you hear the word *symmetrical*, do you think of something regular and quite equal in the distribution of its parts, such as the pattern of a checkerboard or the weave of a plaid fabric?

When you hear the word *symmetrical*, do you think of something dull and static, such as the unimaginative arrangement of flowers in a vase or rows of fruit cocktail on a grocery-store shelf?

When you hear the word *symmetrical*, do you think of something well-balanced and aesthetically proportioned in its component parts, such as a wood carving of a muscular torso or an arrangement of living-room furniture?

If you are surprised to find that you answered yes to all three seemingly different questions, then I think you have an incipient grasp of what we shall consider here. The term *symmetry* can conjure up both positive and negative connotations in its description of objects of art or daily life; ironically, the word that means exactly the opposite, *asymmetry*, can also refer to either the total absence of aesthetics or a technique to achieve dynamic balance.

In photography, I think that positive symmetry derives first from pleasant compositions. Beyond that, I like to think of two other types of *aesthetic symmetry*—that of *color* and that of *form*. Beach pebbles freshly bathed by a wave and the fall foliage of ivy on a lodge wall can both fulfill the requirement for symmetry of color, while symmetrical forms abound everywhere in the mineral, plant, and animal kingdoms. Negatively, too much symmetry of composition, referred to as *bullseye composition*, can be a major detriment. We shall investigate this flaw more thoroughly in Chapter Eight. Pleasant, positive symmetrical composition is often achieved by isolating only one member of a subject, *e.g.*, a single flower or a lone peak. But another symmetry, known as *asymmetry*, can accomplish even more effective balance and composition: by positioning one flower on the right against two on the left, by balancing one large peak with a chain of smaller ones. Asymmetry can also achieve its goal of aesthetic composition by counterplacing a heavy line against lighter ones or by muting powerful colors

Figure 6.12
A rigidly vertical subject rendered more dynamically angular by tilting the camera.

ing quality; failure to fill the frame is a detracting shortcoming. Perhaps the difference is only subjective and merely a question of degree, but I don't think so.

You can know that you are experiencing the use of negative space when you feel vastness, solitude, or loneliness in an image—a lone bird against the giant ball of the sun, a cloudless sky as backdrop for a single tree in the middle of nowhere, or a solitary clump of cattails surrounded by an expanse of open pond. On the other hand, when you feel the confusion of too much space devoted to extraneous background or the chaos of too many lines and patterns, you are probably viewing a photograph that would have benefited had the photographer moved optically or geographically closer to the main subject. When the unfilled space remains truly unfilled, you probably have an example of negative space; but when the space not occupied by the subject is "almost filled"—by material recognizably out of focus, by distracting hot spots, by cluttered conditions—you probably are looking at a slide that should be cast into the cylindrical file. Negative space is often used on a grand scale; negative space is often used to allow room for an appropriate quote on a poster, a greeting card, or a full-page magazine spread.

Figure 6.13
This single open geranium blossom is asymmetrically balanced by the cluster of smaller unopened buds.

with pastels. There can be symmetry of distances, symmetry of sizes, and symmetry of shapes—all ironically brought about by asymmetry. The variety is limited only by your ability to "see"—to see not only at macro and infinity distances but particularly at those mid-distances farther away than macro range but closer than the infinity setting of your lens.

Negative Space

Throughout this book we have considered the importance of filling the frame with your subject, so perhaps we should mention here how the lack of filled space can be a beneficial technique as well. The positive concept of *negative space* (a large area with no subject matter) can be rather readily separated from the negating flaw of merely almost-empty space. In short, *negative space* is an enhanc-

Figure 6.14
A tiny fern struggles to survive on a wide expanse of volcanic lava—one example of the possible use of negative space.

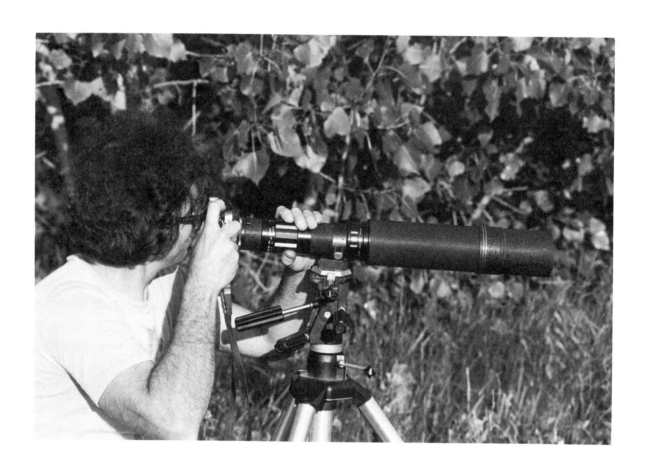

I HAVE HEARD IT SAID that the best way to capture a maximum number of natural images is to go into the field, pick yourself a prime location, sit down, and wait. One need not go to the mountain, for the mountain will come to you. Indeed, I have such favored places. I can think of Anhinga Trail in the Everglades, the geyser basin of the Firehole River in Yellowstone and, most especially, a fifty-foot pond outside Detroit. I wouldn't care to count how many peaceful hours I've spent by that little pond just sitting, watching, and photographing. Water snakes and garter snakes; Blanding's and painted turtles; green frogs, bull frogs, and mating American toads; muskrats and even voles; dragonflies and fritillaries; mallards and Canada geese; grackles and red-winged blackbirds; they've all taken their turns before my cameras. In the spring, the trees that edge the pond are visited by Baltimore orioles, scarlet tanagers, indigo buntings, and red-headed woodpeckers. In the summer, duckweed, looking like a manicured golf green, covers the pond. In the fall, the trees and shrubs are tanned bronze and gold by a mellow sun before they shed their coats in anticipation of the coming winter drought. In winter, an insulating blanket of snow and ice provides

CHAPTER SEVEN

In the field

many prisms of reflected light, brand new vistas. Everyone involved in nature photography should have such a place for all seasons.

THE SENSE OF WANDER

It is indeed true that one need not hike the world to satisfy one's cameras; but there are other needs to satisfy and I for one can only sit for so long before I must hike. When I am in the field to photograph, I do not believe in hiking somewhere just for the sake of saying that I've been there. In every twenty-four hour day there is only so much energy available to each of us. Energy not expended on physical exertion is that much more energy to be diverted to aesthetic goals. I am willing to expend whatever energy is required to obtain a desired image, but if I can capture by the side of the road the same picture that others may trek ten miles to reach, I figure that I have all that remaining energy to channel elsewhere.

But there are other birds and there are other turtles. Other woods beckon; other ponds invite;

and I follow. In me, the sense of wander is strong. Who knows what lies over the next hill? What awaits my camera around the next curve in the trail?

WHAT TO CARRY AND WHAT TO WEAR

Although a number of companies manufacture an assortment of bags, packs, and cases with which to carry your equipment into the field, I personally find none of them acceptable because they all demand that your lenses and cameras be packed away and then removed before you can start to shoot. By that time, many of your pictures will have packed up their appeal and disappeared into the air. After seasons of experimenting, I have arrived at a setup that allows me to have three cameras comfortably settled on my tripod, ready for the diversity of situations I most normally

would shoot. I have purchased two simple accessories for my tripod that permit the triple-camera trick to rest on my right shoulder, while at the same time leaving the other hand free to climb or to reach for a fourth camera around my neck or even to carry another camera designed for hand-held-strobe photography.

The first gadget is a simple bar containing two independent tripod sockets of its own and a thread that screws into the tripod's head. Hence, two cameras are easily mounted where only one could be handled by the tripod itself. The third camera, usually equipped with bellows or other macro equipment, sits on an offset located at the base of the tripod's forward leg. The offset consists of an arm clamp to extend it outward and a ball head that yields flexible adjustments for close-to-the-ground subjects and negates the need for carrying a second, smaller table-top–type tripod. The two cameras on the tripod head bear the two lenses that I feel will be most necessary to capture the most elusive moment of the area I'm hiking. The moment I am most prepared for is the

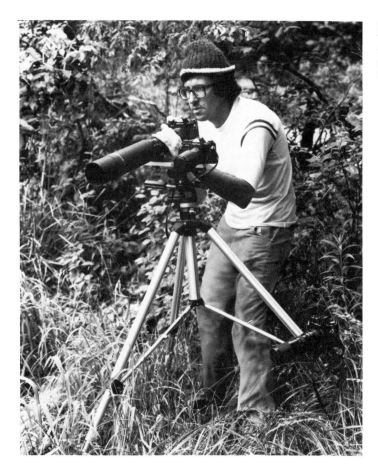

Figure 7.1
The author/photographer in the field with tripod and camera readied for a variety of natural moments.
Photograph by Otis Sprow.

Figures 7.2A and B
My double tripod bar—loaded and empty.

fleeting one that I am least likely to encounter. If wide-angle lenses are mounted on the cameras to record stable scenics and I come upon an animal, I lose precious moments making the switch; but, by mounting the telephotos that will reach out to the mobile animals, I save the time and can still switch to another lens to photograph a stable mountain, a permanent rock, or any other feature that permits adequate set-up time. The result of this philoso-

phy is that in a place such as the Everglades, where birds are likely to be my prime target, two long-focal-length lenses (400 and 500mm) adorn the double bar. At sunrise, my two zoom lenses occupy the bodies so that I can readily move from wide-angle (45mm) to telephoto (200mm) capacity, depending on sky conditions. Not only does the double bar give me the output of twice as many exposures and prevent the need for reload-

117

Figures 7.3A and B
My front tripod leg offset—bare and full.

ing film at a potentially critical time, but it also allows the chance for virtually simultaneous use of different lenses and the option of loading two different types of film in the bodies.

Working in the field should be a proposition concerned with all-around comfort and ease of operation. I always wear my baggiest pants—the pair I least care about, the pair with the biggest pockets to cache extension rings, extra film, or a polarizer. Cotton clothing is desirable because it is soft and allows the skin to breathe; in more rugged terrain, where you may brush against cacti or other thorny plants, denim or corduroy is preferred for its outer toughness. Your jacket should be one that you won't object to setting on the ground to afford protection for lenses or to provide a blanket for you to lie upon. Some photographers even carry along a plastic trash-can liner for this purpose. Shoes or boots should, of course, be comfortable but tough; if they are waterproof, even better. You can't be timid about treading muck or wading into shallow water for some of your pictures. In areas where poisonous snakes

are likely to be encountered, boots extending well above the ankle make the best sense. For all rugged hiking surfaces, footwear with gripping tread will be appreciated. Some hikers may create more comfort for their feet by inserting into their boots cushioning sole pads. In any event, *common sense* and *comfort* are the key words.

For those days when you will be shooting under such inclement conditions as rain or snow, extreme cold or excessive heat, you will want to afford your body and camera body sufficient protection. For cold weather, thermal underwear and thermal socks can help greatly in retaining body heat, especially in the extremities of hands and feet. If you choose not to use this clothing, remember that for maximum insulation, many layers of lighter clothing trap body heat better than a single layer of heavy clotheswear. If your camera is to be exposed to severe cold for any extended period of time, it too should be contained in some insulating material and only withdrawn for the moments of shooting. Protection for face and hands, the two most important body

areas in photography, is more difficult because headware can't restrict your vision, and even flexible gloves must be removed to focus, compose, and set a diaphragm. Some winter walkers protect their faces with masks that have openings for eyes, nose, and mouth. I normally wear only a yarn beanie for my head; along with my jacket hood, it affords some protection for the ears and acts as a shield for my eyes when focusing. For hot weather, loose, cotton clothing is best for it allows air in and perspiration out. On rainy days it is probably more important to protect the metals of camera and lens than your own skin. Waterproof vinyls or plastics serve just fine; I simply carry a plastic trash bag to act as a hood for my cameras.

In conclusion, what you carry and what you wear should in no way physically intrude upon your aesthetic intentions as a photographer. If the agony of a sore shoulder is going to hasten your tempo along the trail, then maybe you should look for a new way to carry your equipment into the field. If the discomfort of damp feet or cold fingers is going to send you scurrying for the car, then perhaps it is time that you invest in a new nature photography wardrobe.

WHERE AND HOW TO FIND PICTURES

In the pursuit of nature photographs, one of two basic systems may initiate your search. Perhaps we could label the contest "Serendipity vs. Science." The approach of Serendipity may be thought of as one in which we place ourselves in a desirable natural environment and then go about seeing what we can find; finally, we take whatever pictures nature sends our way. The approach of letting Good Fortune at least partially control your destiny lends excitement and an air of the mysterious to the hike; the unexpected photograph may suddenly appear at your feet in the form of a toad hopping after insects or in the treetops as a cluster of backlit leaves accentuated by the shadow of a solitary spider. With this attitude, you are somewhat forced to maintain your senses in a state of attention. In addition to your sense of sight, sounds and scents will also alert you to the presence of other potential images. Personally, I greatly enjoy this approach because I do not tend to become jaded and I do tend to recognize more options open to me and my cameras.

In contrast, the approach of Science will enlist information already gleaned elsewhere before entering the field to photograph. Driving to work, you notice that the thistles are in bloom; after 5 P.M. you visit the field and set up your macro equipment; there you wait until the butterflies that also must inevitably visit duly return. A park naturalist informs you of the whereabouts of a woodchuck den; you locate the burrow and then designedly camp there for the purpose of photographing the young as they tentatively emerge to explore their new world before your lenses. An article in today's paper reports that the first migrating ducks have returned to the local river; that weekend you'll be there with them.

I personally feel that both methods have their application. In reality it may even be impossible to separate them so blatantly as we have above for the sake of analysis. Once Serendipity has revealed a cocoon, Science will take over and lead you there at the proper time of day with the necessary equipment. After Science records the cocoon, Serendipity may provide a bird descending to feed upon the larva. In your photography, let the method of the moment prevail; allow the one to enhance the other.

DAWN: THE BEST TIME OF THE DAY

To be a successful nature photographer, I've found that it is necessary to rise rather early, most of the time, as many birdwatchers do, an hour or two before the sun itself. This allows me to reach a destination and then set up for whatever looks appealing on a given day. Although my body is not too sure about the benefits to be derived from rising at four or five in the morning, my mind attempts to convince it that the photographic advantages are numerous. Of course, there's always the possibility of being treated to a glorious sunrise—when scarlet skies are echoed by the placid waters of a lake forsaken by all but the marsh animals and me. But, more important, at least for my photographic purposes, is the fact that it is only then that you will find the plants emerging from their nocturnal bath of dew; it is only then, in another season, that you will find frosty filigrees adorning a fresh new world; finally, it is only in these pre-dawn hours that many of nature's creatures are active, creatures whose acquaintance is never made by noontime nature photographers.

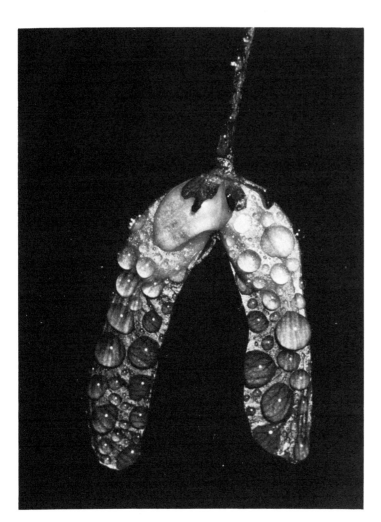

Figures 7.4A and B
The oft-neglected rewards of dawn . . . frost and dew.

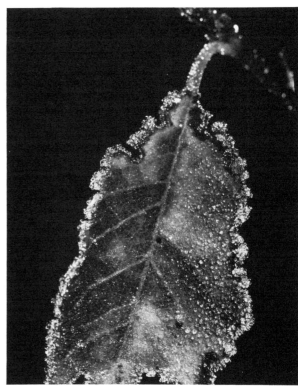

120

Dawn is pre-eminently the moment of water and the moment to photograph it. You do not find fog, dew, and frost at four in the afternoon. Only during the pale hours of dawn, when her maneuverings are least detectable, does this Merlin like sorceress Water dig deepest into her bag of tricks. Loren Eiseley has written well of her: "If there is magic on this planet, it is contained in water."* By winter she staunchly travels as snow, frost, or ice; by spring she is an impostor in a gown of fog, dew, and mist. She may rest calmly in lakes, or she may tumble madly over rock cascades. She whimsically changes form—from stable solid to fluid liquid—this enchantress water who deviously lures the film from your camera. By spring she turns limpid drops of dew into sparkling natural pearls; by fall she laces invisible vapor into frosty festoons on multihued foliage. No one dares to question or imprison this bewitching charmer; the only way to capture her elusive, golden personality is on the film's silver emulsion.

To a nature photographer, ignoring dawn is paramount to an airplane pilot's ignoring the radar. Any nature photographer worth the mud on his or her stomach will tell you that it is the *only* time of the day—for light and for mood, for plants and for animals, for cameras and for photographs. Dead weeds strike stark poses against the sky; frost grips their pods, and dew bathes their stems. The metabolism of cold-blooded animals immobilizes everything from spiders and moths to frogs and turtles. Birds forage for the day's sustenance and many mammals return from their prowlings of the previous evening.

Yes, it is true that the same lighting effect begins to occur toward sunset, but the day is old and used up. Without its morning moisture, the scene has begun to dry up; the earth is ready to repose, ready to refresh itself with the sleep that will once again renew the magic of tomorrow. By the time of sunset, there are human footprints in what was earlier pure snow or sand. By the afternoon, people have abandoned work; sailboats speckle the water and fishermen line the shores of lakes. The contrails of evening jet flights crisscross the sky. No, it is just not the same. The difference between sunrise and sunset is the difference between fresh and stale; vital and gasping; growth and death. Sunset *may* be rewarding; but sunrise *is* bountiful.

*Loren Eiseley, *The Immense Journey* (New York: Random House, Inc., 1946).

WEATHER OR NOT: PHOTOGRAPHY IN THE FOG

Unquestionably, nature's finest dawn creations arrive when the diaphanous mists of spring shroud the earth in mystery and the searing fogs of early summer veil the planet with curtains of hidden beauty. My finest images consistently come out of conditions such as these, conditions almost invariably avoided by the beginning photographer. Morning after morning I find myself alone in this most photogenic of landscapes. This mist is reserved for only the early cameraman; to those who tarry in slumber, the mist is only a word . . . a phantom often rumored but never seen.

To photograph in a mist bank at dawn is to work in nature's fairyland. But you need purchase no ticket, merely expend the effort. Forsake the warmth of your bed before sunrise for the damp chill of the hills and valleys along the river where the mist is born. Endure the added weight of a tripod and extra lenses. In this fantasyland, the light of the dawn sky radiates an unearthly rainbow of colors in no need of any photographic filters. Passed through oblique layers of an atmosphere laden with fog, mist, and haze, the moody pre-dawn sky paints an indigo canvas until the sun bursts upon the day with a palette of gold. The shapes that have been obscured by the swirling mist are now magically transformed into startling photographic forms by the silhouetting sun. For a nature photographer, there is nothing to equal such a day; it is the Super Bowl of nature photography. Fog condenses everywhere, on the crown of Queen Anne's Lace, on spider bodies, and even on the lens of the camera. Fog mutes the sun, and, as it lengthens the dawn, it dramatically extends the moments of photographic excellence in a proportion directly related to how thick the fog is. With the arrival of fog, a commonplace landscape acquires the aura of a photographic paradise.

Images abound everywhere you look; subtle shapes and moods tempt you to capture them all on film as fast as the swelling fog engulfs the landscape. You can shoot scenics into a sun tempered by the vagabond vapors; with slide film, read for the brightest value *off* the sun and its main radiance; avoid those compositions in which the range of light is too great to be handled by the film's latitude, or else you may create too much

of a black area that will detract from your misty feeling. Look for situations in which you have a more even scale of light values. Even though the sun rises higher into the heavens, you can still photograph as long as the fog disperses the sun's golden ingots through the trees. You can portray animals in a romantically moody setting reminiscent of the day of creation. Again, read for the brightest area about them so long as it is not the hot white ball of the sun. You can photograph numerous macro subjects. Isolate the most aesthetic seedhead; on especially cool, damp dawns, watch (and photograph) the hoarfrost release its rigid grip and, in deference to the sun, soften into dew; within seconds, watch that dew evaporate before your eyes and in submission to the winds float contentedly away. Frost, dew, nothing; when projected with a dissolve unit, such a sequence presents a powerful visual impact on the screen and on the viewers' hearts.

Although fog is to me far and away nature's grandest expression of photographic opportunities, any other unusual weather patterns also present stellar chances. When July storms brew over the desert, an anger-laden atmosphere drives incredible cloud formations over the mountains; an eerie light haunts the landscape. Where is your camera? On rainy days, water soaks into the soil and into the cell structure of plants, thereby saturating bark, leaves, and berries with a rich spectrum of colors never seen when the sun is shining on a dry landscape. Where is your camera now? The cold, heavy air of winter voids the atmosphere of much of its particulate matter and compresses haze right out of the picture; the crystal sharpness of such a January morning keenly delineates the sleet that has glazed the nude forms of barren trees. Shouldn't you be taking pictures?

Lowest on the list of photogenic weather conditions are those days when the sun is shining brightly from a blue sky punctuated with big, fluffy cumulus clouds. If this condition is not prevalent, too many beginners leave their cameras at the motel. Although a pleasant postcard image can result from this lighting (if you use a polarizer), it is often too flat, especially when the sun is high in the sky, bleaching the scene's color. Indeed, take some of these postcard pictures, but also do not neglect the more spectacular opportunities presented on other days. In short, the more unusual the weather conditions, the more chance you have for a striking photograph.

A SEASON FOR ALL

Summer

Just as the early hours of the day offer the prime hours for photography, I've found that the seasons progress likewise. In the northern latitudes of my Michigan home, summer is essentially an inactive, drab season for nature photography. By the end of June, with the exception of some future field wildflowers, nature photography is basically at its lowest ebb. Now a mature, dense green, the foliage of the great hardwood forest lacks the fresh, vibrant appeal of spring green. The ground vegetation has matured and now hides many of the birds and small mammals. Most of the birds have raised their young, molted the finery of their spring plumage, and now feed in scattered isolation with no nest to tend. The mammals too have lost the sleek coats that protected them through winter and early spring. Numerous invertebrates attack their furs and give them an unkempt, disheveled look. Mosquitoes, black flies, and other pesky insects abound. School has recessed, and too many tourists crowd natural sanctuaries. The streams of spring have dried, and the fogs of dawn have traveled elsewhere.

Figure 7.5
Field flowers, such as this thistle, and insects, such as this visiting butterfly, offer some of summer's brighter photo opportunities.

Those are the reasons why summer is my least favorite season. It is the one that sends me winging elsewhere. As an ex-teacher, I used to find my summer vacations photographically best spent in the magnificent mountain areas of the far west, where cool nights and warm days make an ideal vacation setting and where greater photographic opportunities surround the camera enthusiast in the form of abundant wildflowers, big-game mammals, and unequalled scenery. Later in my photographic evolution, I also came to an appreciation of the awesome weather systems of the desert at this time of year. As strange as it may seem, for years that is where I headed—to experience and photograph the stunning storms that take over this alien environment during July and August. Now that I photograph and write full time, I prefer to occupy the summertime with my commitments to my writing assignments and to cataloguing or programming the material photographed during the other three photographically more profitable seasons. However, I do understand that for most of the people not involved in photography as their profession, summer is the only season when the kids are not in school or when vacation time may be taken. So, if you can't get to the mountains and you don't want to visit the desert, perhaps you can explore to your best advantage the photographic opportunities afforded by the seashore and to a lesser degree by the beaches along the lake of your cottage. You might look for water patterns, curved coastal lines, shore birds, shelled creatures, and unique vegetation.

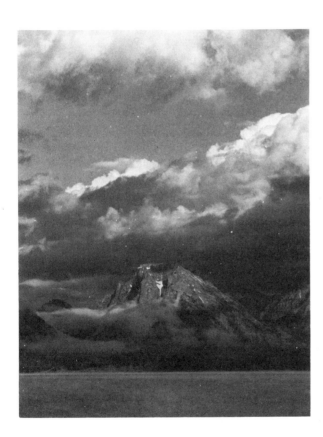

Figures 7.6A and B
Scenes of Summer: No season offers more glorious chances for spectacular cloud formations than the volatile days of summer.

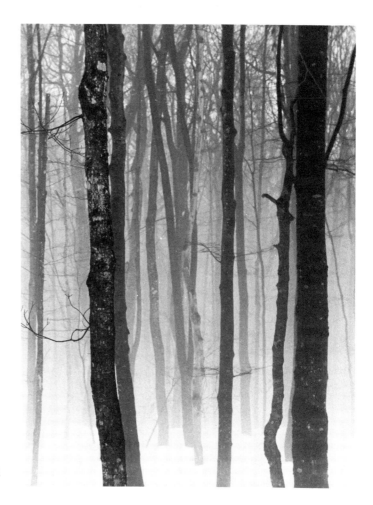

Figures 7.7A and B
The Snow Season: Winter in the woods reveals the subtle moods of passing storms and the struggle of wildlife to survive the scarcity of food supplies.

Winter

I am *not* a cold-weather person. Most of my winter photography is done in and around the friendly environs of Miami or other latitudes of equal southern exposure. Basically I leave winter to the skiers, the ice fishermen, and the rest of Jack Frost's hardier relatives. I understand and even appreciate the beauty of this season, but, in my generosity, I remove only a handful of pictures and leave the rest to those better able to endure sub-zero temperatures, biting winds, and endless days of overcast skies. But I would be forced to admit that even winter does have its finer moments. On those rare days it is great just to be alive and walking in this wonderland. Crisp blue skies provide clean backdrops for the frost-bound needles of the pines or the icy arms of the patriarchal trees. Snow glistens, ice sparkles, and winter proves to be only as dead as the spirit of the one

Figure 7.7B

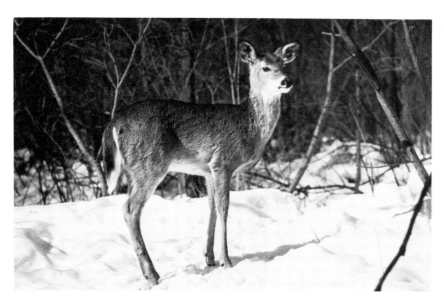

who walks with her. For there now commences a parade of birds that introduces to us a whole new cast of characters who have for the most part remained backstage until now. Juncos, downy woodpeckers, cardinals, nuthatches, and other non-migratory birds search the woods for the life-sustaining seeds and hibernating insects that will nourish them until the cornucopia of spring appears. This is the prime season to set up your own feeding station or to stake out the ones at nearby nature centers if you want to photograph these birds from close distances. But these birds are only the supporting actors. The real star of the winter parade of birds is a diminutive bundle of energy rather soberly dressed in grays, blacks, and whites that we call a black-capped chickadee. The dreariest winter weather can't dampen this bird's enthusiasm; with any patience at all you can teach it to eat from your hand or even to pluck a sunflower seed from between your teeth for a super photograph. For me, the chickadee is the greatest joy of any winter walk in the woods.

Essentially, I view winter as a twofold challenge to the photographer. First, it challenges the imagination; the nature photographer's job becomes one of finding pictures in those places where most people don't even see places. Secondly, winter boldly challenges your stamina. Can you stand the cold long enough to attempt to record what may well be a once-in-a-lifetime moment?

In addition to the personal mental and physical confrontations issued by winter, there are also concomitant problems for the camera. In extremely cold temperatures, prolonged exposure to the elements can stiffen interior lubricants. Shutter speeds may be slowed and yield overexposure; on the other hand, excessive reflections from the snow and the predominant masses of white inflate the light meter's reading and produce black, rather than green, pines along with purple, rather than blue, skies. You can help reduce this exposure problem by filling the frame with your pines, or by going closer to read them and then retreating to record the picture as desired. You might even tilt your camera upward to read only the sky and then underexpose within the latitude of the film. Care should be taken, as film may become brittle and crack. Also, transferring film from frigid winter degrees to warm room temperatures may cause vapor in the air to condense on and spot the emulsion. But with normal winter weather and normal precautions, these are unlikely occurrences that should not prevent you

from sallying forth. However, if you will be doing any extended photography in sub-zero temperatures, I would suggest a letter to your camera manufacturer's technical department asking for recommendations on proper measures to be employed under such conditions as you anticipate.

In spite of the blustery opportunities outlined above, I feel that even the most ardent winter walker eventually tires of the season; and, just when you think you can endure no more, a warm breeze finally wafts its way up from the south, bringing with it a welcome sound and a most welcome sight. The sound is that of tinkling, melting ice, and the sight that of free-running water in the land once more. These rapid changes that characterize the thawing season not only offer great photo possibilities, but they also herald the arrival of spring—my second favorite photographic season. Spring—a season for all cameramen! Spring: the season of delicate wildflowers; the season of baby birds straining their necks for the life-sustaining food gleaned by solicitous parents; the season of life returning to the once-withered earth.

Figure 7.8
The spirit of winter is exemplified by the friendliness of this black-capped chickadee.
Photograph by Bob Collie.

Spring

If I could choose just one word to characterize spring and its photographic opportunities, I would unquestionably select the word *life*. It is in evidence everywhere you and your camera look: in the subtly colored scales of young tamarac cones, in the glossy-shelled eggs of a horned lark, even in the sap flowing freely from a wound in an aspen tree. You can discover spring's life (and more photographs) in the bud of a tightly packed sumac awaiting the precisely right moment to burst forth, in the blossoms of our fast-vanishing American elms, and even in the uncurling forms of young fiddlehead ferns. For the cold-blooded clan, spring issues a new lease on life—and for your camera new opportunities to photograph sun-bathing blue racers, duckweed-covered frogs, turtles surfacing from the pond's insulated bottom, snakes anxiously searching out their first meal after emerging from their long winter's nap, and an infantry of other reptiles and amphibians.

But the soldiers of spring do not capture an immediate victory. Only begrudgingly does the snow give way, giving you glorious chances to photograph two seasons in one image: skunk cabbage pushing through ice, robins fluffing their feathers on snowy branches, and buds attempting to molt a straitjacket of frost. But every blade of grass and every unfolding leaf prove that the white-clad warriors of winter have little chance against the invading green army. The green uniform of spring is a special green; fresh and vivacious, it virtually screams to be photographed, particularly when it is backlit and the sun delineates the new foliage's delicate venation.

Spring is pre-eminently the season of the birds. The males sport their finest breeding plum-

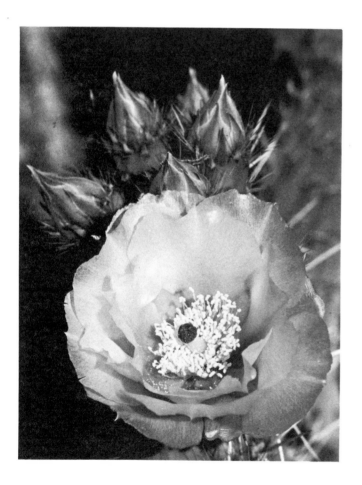

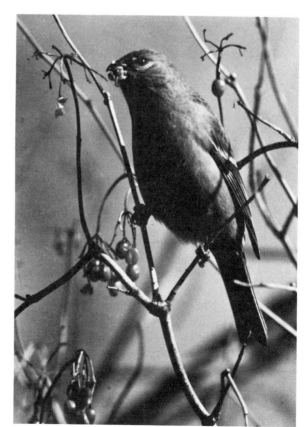

Figures 7.9A and B
Life is the dominant feature of spring. Search for it everywhere; photograph it in everything from the buds and blooms of a prickly pear cactus to the berries and birds of the north woods.

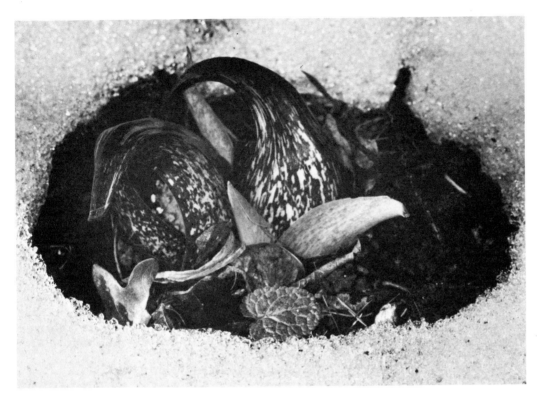

Figure 7.10
The remarkable skunk cabbage generates its own heat to ignite the spring season amidst the solid objections of winter's frozen crystals.

age. You can photograph them singly or en masse as they attempt to successfully navigate the northward migration. Once arrived, each species seeks out the sites best suited for its kind to nest—more photographic opportunities. Bound by centuries-old instinct that ties them to the nest, the eggs, and the young, the birds must return. You must be more careful, more ethical than ever not to disturb them or the nest either by staying too long or by removing their camouflage. Such behavior leaves them easily susceptible to attack by predators such as raccoons, foxes, or even other birds.

The earth's moment to repopulate itself comes in spring, with the newest generation of pioneers to tread the soil and the latest daring astronauts to sail the air. That makes spring your season to revitalize your image library, in both quantity and quality. Young animals abound, so there are likely to be chances to photograph spotted deer fawns, playful fox kits, and masked raccoon youngsters. Spring spawns another remarkable diversity of life and photographic opportunities in the form of myriad insects. There are insects with translucent wings, insects with bizarre antennae, and insects with iridescent colors. These are animals that demand close-up equipment to reveal their intricacy, animals that require a setup with the mobility to move as actively as they do, animals that compel you to stalk them in the earliest of hours, when their engines are stalled by the lack of the sun's propelling fuel. As all these life forms learn the ways of the earth and the ways of survival, your patient camera can capture them in all their humor, anxiety, and clumsiness as they explore the world for the first time. Perhaps you may even be witness to the ultimate moments of life and death.

Beyond the emergence of life, spring has so much more to offer. Spring is misty dawns and spider webs hung with dew; spring is rushing waterfalls and melting snow; spring is a storm looking back to December and surprising a cattail looking forward to June. For you, the nature photographer, spring should be the sound of a shutter clicking repeatedly and the sight of a new collection of transparencies as fresh as the season itself.

Autumn

I still must give my number-one ranking to autumn, no matter how bountiful spring is. The flowers of July have long since ripened into the seeds of September. Every hillside blushes with the crimson hues of oak and maple. In the microcosm of a single leaf is found all the glory of an entire woodland turned to gold. For me, the fall color display heads the list of autumn's photogenic aspects. The show begins in the treetops with the very first yellows, and progresses its way down the trunks with the delicate pinks of dogwood before reaching a spectacular culmination in the flaming reds of the harlequin maples. Certainly this autumn pageant must be rated as one of nature's most sensational shows. Every tinted leaf lends a touch of magic to an otherwise common scene—and a touch of magic to every image handled properly. Think back lighting; for scenics, keep a polarizer on your lens at all times; on sunny days, underexpose your slides to saturate color; move in closer—on only the finest leaves, on only the most colorful mushrooms, on only the brightest berries.

The well-known nature author Edwin Way Teale once wrote: "Before the work of the day, taste the poetry of the day." If he is right, then there is no better time to read natural verses, no better season to transcribe them onto film. Unfortunately, too many photographers tend to look to the infinite for the spectacular shot that illustrates these words when so often it is to be found in the infinitesimal. Throughout autumn, a macro lens should be your constant companion—an associate photographically picking the ripening berries of hawthorn, bittersweet, and cohosh; a comrade photographically collecting spiny caterpillars, frost-tipped leaves, and deadly amanita mushrooms; an assistant photographically gathering the acorns and burdocks dispersed by animals along with the pods of milkweed and thistles scattered by the wind.

For others, autumn is once again the time of their life's greatest journey. Even though the birds are certainly the best known of the migrators, I think an even more amazing story for your camera to search out is the one told by the delicate-winged monarch butterfly. Banded individual monarchs indicate a flight of distances truly remarkable for such a fragile insect. In the right location, you will see them turn the trees in which they roost to orange trees before they move on the following dawn. For the greatest fliers, the birds, fall offers one last moment to rest before they too head out across a trackless sky. One day cold north winds work their way to the ponds; diminishing hours of sunlight signal biological changes in the birds' bodies. Soon the sky appears to wear a skein of necklaces as all migrating species head unerringly southward, many of them for lands they've never seen before. This is your chance to capture them—as silhouettes against a rising or setting sun, as patterns of movement, as blurs of color, as voyagers of the universe when the daytime moon is visible with them in the same frame. Special mobile equipment, such as the Novoflex system discussed earlier, greatly increases your odds for success. Fall also sees the birds clad once again in their finest attire. As they feed upon the abundant seeds and berries of autumn in preparation for the impending trek, you have another chance to create a colorful photograph if you will patiently wait by these needed provisions.

Other wildlife, such as squirrels and chipmunks, bears and marmots, raccoons and skunks, are busy fattening themselves on every food in sight before entering a state of hibernation. They too have donned their go-to-sleeping clothes—thick, shiny coats of fur to protect them from the bite of winter's bone-chilling nights of darkness. Positioning yourself by fields of clover, near nut-bearing trees such as oaks, hickories, and walnuts or close to similar larders of natural foods, will greatly enhance your prospects for success. So will a long-length telephoto.

But the best of all of autumn's animal activity is ushered in by the battles of the mating season for ungulates such as the white-tailed deer, the bighorn sheep, the moose, and the elk. From Maine's snowbound woods to the golden meadows of Yellowstone, the air resounds with their challenging snorts and bugles. Dawn trembles with their head-to-head batterings. Antlers and horns lock in ritualistic combats that will ensure the survival of the species' finest. From these confrontations there should also result some of your finest images. A motor drive or an auto winder, along with very fast shutter speeds, is almost a necessity to record the highlights of the fast-paced action.

Caution: Keep your distance. At this time of the year, these animals and others, such as the bison, are at their most dangerous. Ruled by chemical messengers that have flowed in their blood for un-

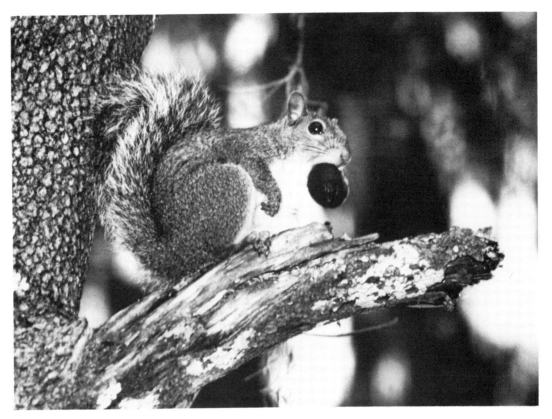

Figure 7.11
Many mammals enjoy their final meals before hiberation during the busy days of autumn. Station yourself near likely feeding spots and wait for visitors such as this squirrel that apparently has its mouth full with a hickory nut.

counted eons, they are unpredictable, dangerous, and potentially lethal weapons against whom you have little, if any, chance should they decide to charge. I have seen foolhardy, ignorant photographers kicked by elk and charged by bison. Moose in rut have been known to tree intruders for hours. You are entering their arena; you are playing the game by their timeless rules; *you* are the intruder. Your failure to understand, accept, and respect this very real fact of life can readily lead to your demise. I personally want to live to see the results of my work, and I would like to be around to do it again. Finally, and in many respects this is the most discouraging of all, is the fact that, should there result a confrontation within a park environment in which a bear or a moose does claw, assault, or maim an intruding human, it is the animal that will be drugged, removed, or destroyed as the offender. We have reserved only the tiniest fraction of our land for these creatures that are at least as much a part of

our national heritage as the Statue of Liberty or Independence Hall. Within this framework, surely an innocent animal should not have to pay with its life for the folly of unthinking, inconsiderate photographers.

This flurry of fall activity is all conducted against the backdrop of a color-laden landscape that radiates a warmth that the mercury of the thermometer cannot hope to equal. In the west, every hillside and mountain slope seems to glow with aspen gold; in the great northeastern hardwood forest, a variety of colors exceeds the words to identify them—coppers, crimsons, and carmines—cherries, peaches, and lemons—coffees, cinnamons, and chestnuts—even an occasional cyan or magenta. Against it all, there is the perpetual greenery of the firs, spruces, and pines, the startling contrast of the white-barked birches. So autumn ends as it began. With camera in hand, little wonder I crown it my champion. Would that it could last a lifetime.

THE ECOLOGICAL CONSCIENCE

At some point in time, I think it is imperative for you to recognize that whenever you enter the field with your camera, you are in one very real sense the visitor to the world of nature. The continued existence of these natural systems should be viewed as more significant than your image of the same. You cannot keep so uncommon a bird as an osprey off her nest for hours on a cool day when the temperatures threaten the life of the developing embryos; it is more important that the endangered osprey have three eggs with a chance to hatch than for you to have a picture of her. Just think for a moment: What would you rather have—your best friend or merely a picture of that friend? It is a grossly unfair trade in which the life of your subject is forfeited in exchange for a paltry picture.

In the same light, your fifty-member camera club cannot simultaneously tromp after a single prime flower and in the process flatten all other vegetation in the wake. I find it offensive that some photographers will rip up yards of one plant to rid its shadows from another they deem more worthy. This should not be misconstrued as representing a holier-than-thou attitude. I am not against "policing" an area to improve your image. I do not think that removal of a photographically obtrusive dead branch from a small waterfall in Wisconsin will alter the flow of the major water systems of the Mississippi Valley. Nor do I think that snipping a few blades of grass away from your mushroom will upset the ecological balance of North America. However, I am opposed to the permanent, indiscriminate removal of native vegetation simply to eliminate some shadows; I am outraged by the disturbance of a bird's nest to such a degree that the birds abandon the young to die.

In short, I am confident that, if you are genuinely interested in and concerned about the nature you are photographing, your own gut-level intuition will tell you when you are abusing and when you are respecting what is before your camera and about your presence.

Photo essay: the pond

A pond. An apparently insignificant pond. Insignificant to all but those who know it. The ambitious nature photographer will recognize such a treasure for what it is. Some of what my pond is to me may be seen in the following photos.

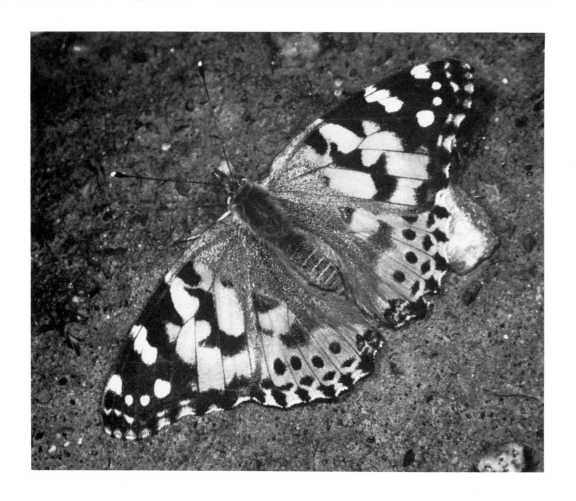

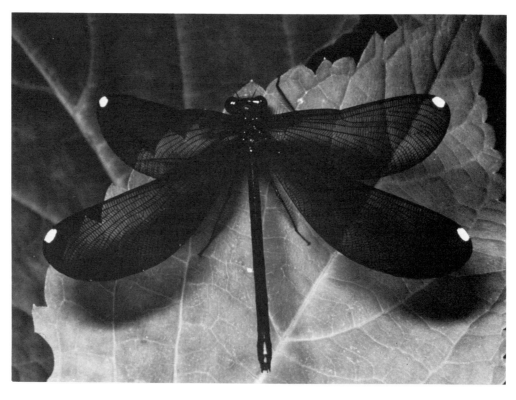

Insects such as the broad-winged damselfly (top) hunt the abundant water insects and then pause to rest on the vegetation about the pond. Above, a butterfly laps nutrients from the spongy ooze at the pond's shore.

Photograph (top) by Otis Sprow.

Among the seldom seen, more uncommon visitors to the pond are the
flamboyant Ctenucha moth and the retiring, but poisonous, Massasauga
rattlesnake sharing this page.

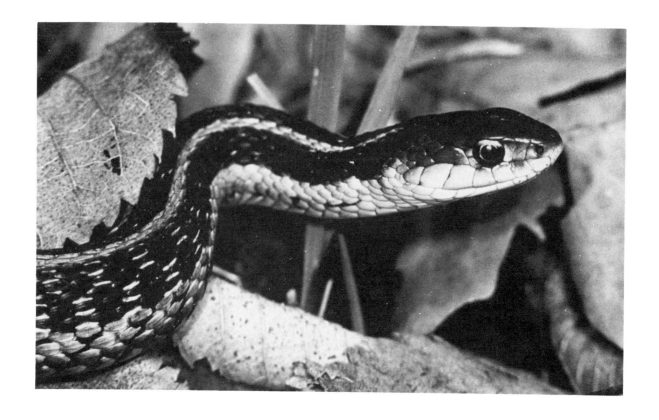

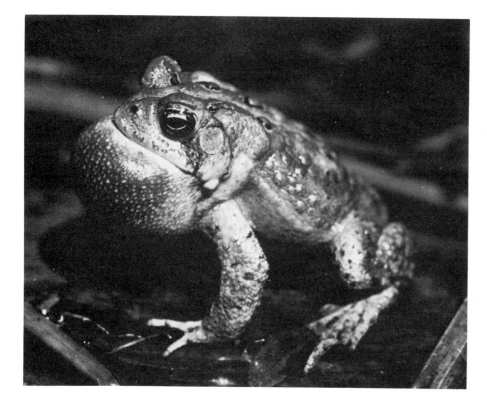

(above) Garter snakes glide effortlessly through the forest duff to hunt the smaller amphibians that inhabit the pond and its environs.

(left) Each spring, the pond's waters resound with a rippling chorus of singers, including the American toad.

Red squirrels convert fallen trees to rodent highways linking
the woods and the water.

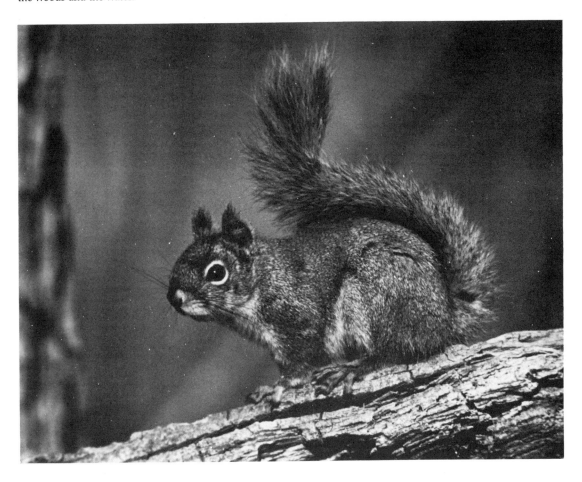

(left) The footprints of late winter are evidence that Canada geese have meandered this way.

(below) Bent reeds employ their triangular forms and shadows to describe geometric patterns in the pond's cover of snow.

(opposite, top) Were he not so common, the strikingly handsome mallard drake would certainly command more of our photographic attention at the pond.

(opposite, bottom) In the spring, Canada geese wade the pond to feast on the sumptuous cover of anxiously awaited duckweed.

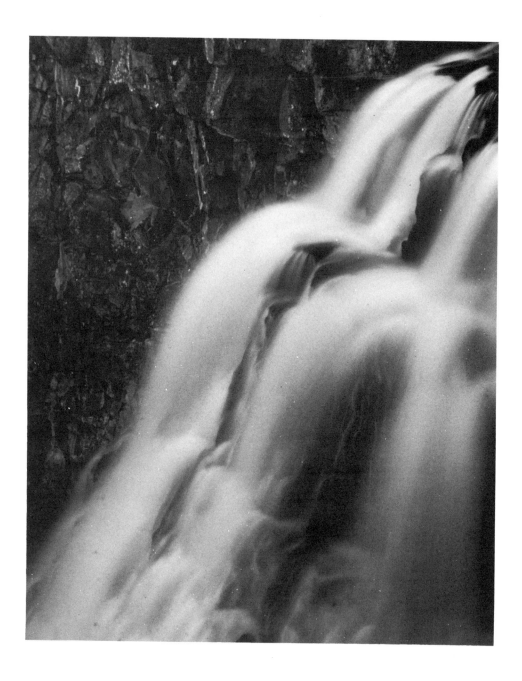

N OW THAT I HAVE TAKEN THE TIME and the effort to set down what I consider to be a series of valid guidelines for nature photography, my advice in this chapter urges you to go forth and break *every* rule you have ever heard or read in an attempt to create something special. Traffic laws establish speed limits for vehicles, but no one objects when an ambulance carrying an injured person violates those limits. So in photography, once the basic rules have been comprehended and practiced, their violation can effectively produce some unusual natural images. "Breaking the rules" is preeminently the arena for intriguing experimentation. What results can you obtain by exaggeratedly extending your bellows? What can you achieve by combining two polarizers? What extra-lensory perceptions can you create with the use of a zoom lens and long exposures? The words here are few; the opportunities are many. In short, if I were to paraphrase Browning, I guess what I am trying to say is: "Let your photographic reach exceed your grasp or what's a camera for?"

CHAPTER EIGHT

Breaking the rules:
for better and for worse

EXTRA-LENSORY PERCEPTION

How many times have you heard that you should focus your lens carefully? Well, I am suggesting that there are those situations in which you will deliberately *not* want to focus. Look at the reflections of sunlight striking the surface of a lake at sunset—nothing but straight lines. I suggest that you rotate your lens barrel into a position badly out of focus and release the shutter at the fastest speed needed to keep the lens diaphragm wide open if you want to transform those dull lines into a treasure chest of Spanish doubloons.

How often have you read *not* to shoot into the sun, to keep the sun over your shoulder, shining onto the face of your subject? I am telling you that if you *don't* shoot into the sun, you'll never define the elegant shape of a great blue heron perching on a mangrove. If you *don't* shoot into the sun, you'll never create a natural starburst, and you'll never throw a stream of controlled flare across an image. If you *don't* shoot into

Figure 8.1
The facts: 500mm lens; diaphragm wide open at
f/4.5; shutter speed of 1/1000 of a second.
The fantasy: the photograph accompanying
this caption.

the sun, you'll never transform the Green River of Colorado into a silver thread on the screen!

How many teachers (including me) have warned you to keep your camera steady? If it's not on a tripod, make sure it's supported—against a tree, padded by a pillow, on a shoulder. But now I am suggesting that this next fall you should find yourself a colorful patch of autumn foliage and *purposely* shake the camera—if you want to create a kaleidoscopic pattern of colors on your film. Use a polarizer to block light and to let you employ longer shutter speeds to blur the image more. Try sweeping your camera in the shape of an *S* or a reclining *8,* or even in the jagged pattern of small saw teeth.

Over and over, the photo manuals advise you to shoot at fast shutter speeds, 1/125 of a second or faster if you're not on a tripod. But I'm

Figure 8.2
To disdain back lighting is to deprive oneself of unique photo moments, such as that of this gull touching down on its favored rock along the shores of Isle Royale in the northwest corner of Lake Superior.

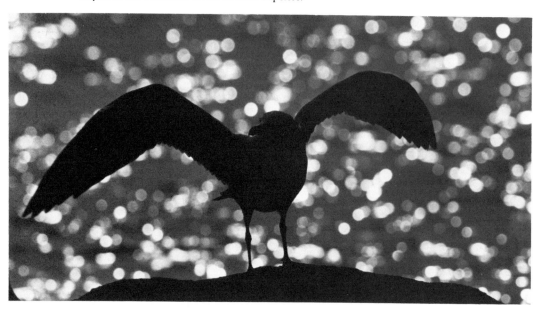

encouraging you to go out and *intentionally* slow your camera's shutter for twelve-second or longer exposures if you wish to create a flowing path of cotton candy from an unnoticed stream. Such slow shutter speeds can further enlist the aid of the wind to combine motion and time. With your camera on a tripod, you can unite the technique of slow shutter speeds suggested here with that of motion suggested above, and allow the blowing air to create a natural pattern of motion for you.

FRESH PERSPECTIVES ON OLD THEMES

Whatever special techniques you use, whatever aspect of nature photography captures your interest, I think that the best advice I can possibly give you is to learn to see the world from fresh perspectives. You are not the first one to point a camera in the direction of a beach, butterfly, or a burl; since your subject will not be unique, you must add some new dimension that is. In the beginning, this attitude might embody itself in the form of a fresh physical perspective, such as lying on the ground to get the lowdown on some wood ducks that have been lured by scattered corn. Later, if you can afford it, you might want to experiment with the fresh optical perspective provided by an exotic fisheye lens. But I think you will find that the most significant approach of all is the visual

expression of the fresh perspective that is uniquely you. This will reveal itself on the film as a fresh mental and emotional perspective that results from a combination of your feelings and attitudes toward nature, united with your knowledge of the camera and your skills as a photographer.

The best way I know to illustrate this concept is with Figures 8.4A, 8.4B, and 8.4C. God alone knows how many millions of tourists have snapped the view in Figure 8.4A how many billions of times. Of course, it is the traditional view of Old Faithful Geyser in Yellowstone National Park, taken on a day when the sun was not shining and 6,999 other camera buffs were recording the same view as you (hard to believe yours is not unique, right?). But suppose *you* rose earlier, when the cold air of the high mountain elevations sails on a collision course with the erupting geyser's boiling water and steam. The natural result (Figure 8.4B) is an incredible burst of condensation that produces a photographic result captured by far fewer photographers. Going even another step further, let us imagine that *you* rise earlier than those other 6,999 visitors. *You* get up before the rising sun. You position yourself in such a way that Old Faithful is backlit by the rising sun. You wait for the breaker of dawn to smile above the distant tree line. You have now created a witch's cauldron (Figure 8.4C). You have taken a commonplace scene of the American landscape and transformed it into an unearthly vision seen only by the most enthusiastic of picture people.

Figure 8.3
Get the best photographs of many smaller plants and animals by viewing them from the fresh perspective of ground-level photography.

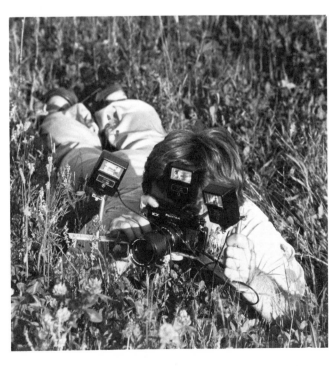

Figure 8.4A

Figure 8.4B

Figure 8.4C

Every visual you produce is a photographic fingerprint of you, and there are no other fingerprints exactly like yours. With whatever respect may be due, I have no desire at all to consciously emulate any of the "masters." If I did, I would be nothing more than a secondclass imitator of Ansel Adams, Edward Weston, or whoever. Instead, I prefer to view the works of others, draw from them what I consider admirable, and then add the dimension that is uniquely mine. If I have any abilities, the result should theoretically be an improvement over either one's individual work. As you incorporate this philosophy of fresh perspectives into your photography, I think you will begin to see that the same subject is never really the same at all. By switching lenses, by varying light direction, by returning to the same location in different seasons, by changing geographic lo-

cation, you can produce new images of old subjects. As you practice this principle, I think that you will come to better realize what I outlined earlier—that every picture you take can serve a useful purpose, a purpose dictated only by you and your needs.

A SHEEP IN WOLF'S CLOTHING

So far, we have examined a number of approaches that permit creation of new and different images that are exciting and out of the ordinary. Henceforth in this chapter we shall investigate a number of common errors that generally originate from an

idea well-conceived in the mind but poorly executed in the camera. If we were to invert a popular proverb, I think we could fairly state that photography is really nothing more than a sheep in wolf's clothing. Photography is basically very simple, but too many beginners are frightened away by the apparent complexity of a jargon bandied about by a few initiates to justify their own importance. Do not feel threatened by words whose syllables may outnumber the images of the one speaking them. Do not feel incompetent because you do not know everything about everything in photography. You have a lot of company. Remember, photographers are measured by photographs. Elimination of the handful of common mistakes discussed here will outweigh all the pomp of all the words.

1. *Closeness.* The photos of most beginning photographers suffer from a lack of impact that can usually be traced to the fact that the subject simply does not command enough attention in the frame because of lack of size. I try to teach this

basic concept with an exaggerated maxim: Get as close as you can—and then go two steps closer. You've just got to fill the frame with your subject, especially in 35mm photography, where you are working with a piece of film whose $1 \times 1\frac{1}{2}$ inch size can ill afford to be cropped any more than necessary. As you fill more and more of the frame, there is less and less space for background and its accompanying distractions, considered next.

2. *Background.* It is so easy to involve yourself so thoroughly with your subject that you completely neglect to pay any attention to your background. After all, who's going to notice the background? Ideally, the answer is "no one"—if it has been properly controlled. Therein lies the secret to a great background—it remains unobtrusively a background, attracting no one's eye. As soon as the background distracts from the subject or attracts the viewer's eye, it has become a problem. As an analogy, think of an art collector who has at last saved enough money to purchase a long-sought-after Rembrandt; proudly it is hung on the wall in an ornate (maybe even gaudy?) frame.

Figures 8.5A and B
Improved compositions and photographs with greater impact commonly result from moving closer to a subject and isolating on a single element, a fact evidenced by these photographs of chaotic clusters of berries and a solitary fruit.

Figure 8.5B

Friends come to view the art piece and remark, "What a gorgeous frame!" If they are looking at the frame and not at the painting, our buyer would have done just as well to hang the empty frame. In the same way, if your audience is viewing your background and not your subject, you might just as well have shot only the background or nothing at all.

I have found the use of confusing backgrounds to be about the most common error among my students. Hot spots burn everywhere; branches leap from an animal's head like chaotic antlers; light-colored subjects merge against light backgrounds and dark subjects disappear into dark backgrounds. Distracting lines intercept a potentially interesting pattern, or too much depth-of-field brings the background into a focus sharply competing for attention with the foreground point of interest. Other background errors include: overexposure when the foreground contains darker subject matter that should disappear when you move closer, fill the frame, and eliminate the background; crooked horizon lines that should have been leveled; and pieces of unnoticed litter that should have been removed. These and similar faults can be readily eliminated with the aid of our trusty friend the tripod. If your camera is on a tripod, you don't have to worry about dropping or mispositioning it; instead, you can carefully check the viewfinder to catch and then correct these detracting blemishes on your images.

3. *Format.* I dread to think of how many times I have commented in class that this slide or that print is just crying out to be vertical. I have touched earlier on this problem, but if experience is a valid yardstick, I do not think it can be overemphasized. If you are in doubt about the selection of your format, shoot your projected image *both* horizontally and vertically. At least then you will have a choice. Also remember that magazines, books, and other publications are essentially vertical. If you would like your photos to filter into this world, shooting them vertically will paint a rosier picture for your chances.

P.S.: Don't forget to leave some open space at the top of your verticals where the publication can insert its logo and name for the front cover!

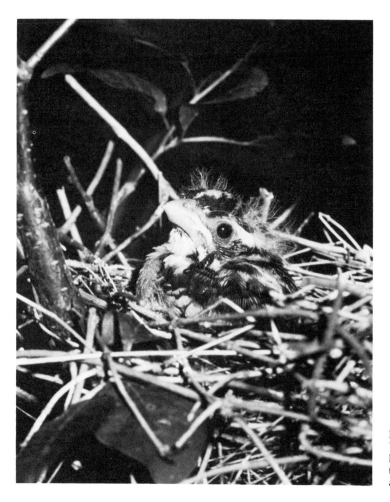

Figure 8.6
Want Junior here to be a cover girl? Give
her a chance by leaving ample vacant space at
the top for publications to insert their name
and logo.

4. *Composition.* Most beginning photographers
try to include too much material and too many
concepts into a single photograph. The result is a
creation that is confusing, chaotic, and lacking in a
central point of interest. If you have ten things to
say on film, don't try to contain all ten of them in a
single frame. Instead, let one image convey one,
and only one, precise concept; then create nine
more photos for the other nine ideas. Generally, I
have found that the simpler the composition of an
image, the more powerful its mental and emo-
tional effect, the more dramatic its visual impact.

Another extremely common compositional
error is that of *bullseye composition.* Too many be-
ginners consistently locate their subjects in the
dead center of the frame, right in the middle
square of our Tic-Tac-Toe grid. With but a few
exceptions, such compositions are totally static.
Beginners have composed their subject exactly
where they focused upon it; no doubt that ten-
dency is increased by the fact that the camera's
focusing screen is located in the center of the

viewfinder, but you must learn to transcend that
inclination and keep in mind the rule of thirds and
The Golden Mean, which we discussed earlier.
Bullseye composition also commonly results from
not being close enough to the subject; for some
reason, the photographer appears to feel that the
location of the subject in the middle of the frame
will override the empty space around it by
equalizing it. The next time you find yourself
creating a bullseye composition, it might be wise
to ask if you are indeed close enough to your
subject. In any event, the result desired is a
pleasing composition, and, if that demands
bullseye location, then so be it.

5. *Sharpness.* Because most beginners do not, or
will not, use tripods, their images essentially lack
the critical sharpness needed for reproduction in
the highly competitive world of the professional.
The refusal to employ a tripod often necessitates
in the mind of the beginner the use of higher-
speed films, and this in turn further denigrates the
reproducible capacity of their images. There is no

doubt that the countless hours of lugging a tripod have bent my shoulders, but that three-legged wonder has also assured far greater clarity and crispness for my transparencies. In addition, the tripod assures the continued use of Kodachrome 25 film, the sharpest 35mm color film made; it further permits the use of slower shutter speeds and thereby provides more depth-of-field sharpness when needed.

6. *Exposure.* Today's advanced light-metering systems have done away with most drastic errors of exposure. In the context of our classroom, I have noted that the majority of pictures are exposed acceptably, but not dynamically. The error may be interpreted as one of degree; many novices have not learned to interpret what their light meter is telling them. *All* light meters are *measuring* 18 percent gray, the middle of the scale of light values; but not all subjects are *reflecting* 18 percent gray. Your exposures will be richer and more aesthetic if you will note when your subjects are of the same average light value as that measured by the meter; then you will understand that a subject much lighter requires less exposure, while a much darker theme demands notably more exposure. In addition to being aware of different light conditions inherent in the subject, the beginner needs to know that exposure practices must change as climatic conditions do. The underexposure that I advised earlier for sunny days will not work on cloudy days. The saturated color obtained on the first day will be muddy color without detail on the second day. Light acts differently under cloudy conditions, so you must expose differently, *i.e.,* as the meter indicates. Do *not* underexpose if you wish to maintain the subtle, pastel colors of such times.

Other, less common mistakes also regularly appear during my classes' critique sessions. There is the bad selection of the plane of focus, and there is the failure to capture a highlight in an animal's eye. We occasionally see a slide with an odd color cast to the film, no doubt the result of using outdated film or film that has been exposed to excessive heat. More rarely, we see a slide that has been chopped in half by someone who failed to synchronize a flash at the correct, or slower, speed indicated on the shutter speed dial. Lastly, we even encounter mistakes that result from faulty equipment that has not been cared for or is in need of repair for inaccurate shutter speeds or perhaps a light leak somewhere in the body.

But whatever mistakes do appear, each and every one individually and collectively erodes a well-conceived rock of an image until it is no more than a poorly executed grain of sand.

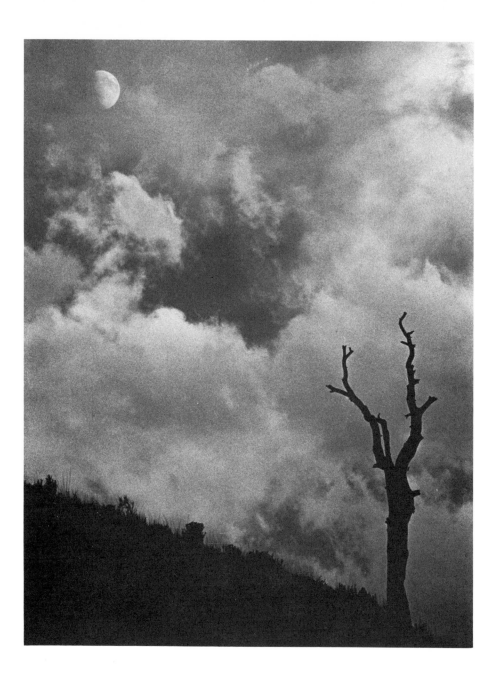

I AM CONSTANTLY PERPLEXED by the careless manner in which many photographers treat their images once they have left the camera. Inside the camera, all precautions have been taken: The lenses are clean, the body is dust-free, and the camera is on a tripod. But once the film is processed, slides and prints are indifferently left exposed to dust, light, heat, and scratches, or they are tossed into closets, brown bags, and other ill-suited receptacles. It seems apparent to me that at least as much care should be taken with a treasure once it has been found as was employed to search it out. Everyone has a favorite system of storage; for me the key to good storage depends on the handling of three factors—space, protection, and retrievability.

STORAGE

If you shoot as many transparencies as I do, a paramount consideration is the effective use of space. I cannot afford to fill a room with contain-

CHAPTER NINE

After the camera

ers ineffectively utilizing available space. So I use metal boxes that measure only two inches high, seven inches wide, and less than fifteen inches long. Each box contains thirty group compartments that together allow me to store some 700 slides in a minimal space. In addition, such boxes nicely satisfy my other two requirements. First, since they are metal, they restrict light and moisture, two major enemies of the film's processed emulsion. Even though the film's chemistry has been relatively stabilized, it is still not eternally protected from the adverse effects of light. Take

two identical slides; store one in a box and tape the other to a southern-exposure window; watch the image on the glass disappear before your eyes. Secondly, moisture, especially in humid climates, threatens your film with rings and possibly provides one of the nourishing conditions for certain fungi to begin their growth. Though unlikely, there is no need to help accelerate processes that occur naturally.

Lastly, this system allows ready retrieval. The outside of each box is labeled with a number. Numerically the boxes are arranged in a geogra-

phic pattern that moves from west to east. A simple notebook tells the locations included in each box. On the inside lid of each container is taped the sheet of paper provided with the box. Neatly divided into the thirty matched sections of the box, it is easy to label and simple to read. Within each area represented I follow a simple pattern of themes. Let us say we are sorting Grand Canyon, Petrified Forest, and Sunset Crater from Arizona. Each park will contain a variety of slides sorted in a consistent order that reads as follows:

1. Scenics
2. Sunrise/Sunset
3. Macro
4. Wildlife
5. Plants
6. People
7. Miscellaneous

This works nicely for me, but the system matters not; what is important is the regular pattern you establish. As your collection grows, you will better see the need for imposing a systematic order that you can depend on for ease and access. As you advance and some of your best material is in the hands of magazine editors, you must also maintain a system of who has what where. All images sent to magazines should be posted by certified or registered mail. The postal receipt will serve as a general reminder; your own catalogue listing the individual pictures submitted will precisely identify the material that is out and will alleviate your fears when you cannot find a prized visual in its proper container.

Those who shoot negative film will find available a host of clear strips, glassine sheets, and waxen envelopes to protect their film. A not uncommon error among beginners is to write on the container with the film inside; depending on the implement's point and the pressure applied, such writing can easily transfer irrevocably onto the film. Either label the sleeves *before* inserting the film or purchase a soft writing crayon designed for that purpose.

As with your slides and negatives, certain precautions must be taken to ensure the longevity of your black-and-white prints. They should be stored so as to avoid the same enemies: heat, light, and humidity. When considering how to mount the black-and-white print, some zealots aim for what is referred to as *archival permanence*. Of the

two types of black-and-white papers, resin-coated and fiber based, only the latter is at this point in time considered capable of such longevity. Resin-coated papers are generally considered *not* suitable, since they are not so long lasting and are subject to fading. Archival mounting necessitates the use of ragboard and tissue 100 percent free of chemical acidity. Ideally, the prints would be stored with similar slip sheets between the sheets of photographic paper and contained in a box of the same pure materials. Those looking for permanence to last their own lifetime will be more easily satisfied with a number of cold-mounting, pressure-sensitive systems or the heat-sensitive, dry mounting process.

REMOUNTING

No matter what type of camera you employ in your nature photography, from 35mm SLR to 8 × 10 view camera, you will be locked into the ratio of that single format. In the case of the 35mm camera, the film piece measures 24 × 36 centimeters, or a ratio of 1:1½ between short and long dimensions. The 8 × 10 view camera gives a ratio of 1:1¼, whereas a 2¼ system may provide you with a square sheet of film whose ratio is 1:1. But the facts remain that not all of nature's subjects correspond to the ratio of your system, not all of nature's creations are square, and not all of nature's variety even fits The Golden Mean. Some mammals and birds may indeed match the 1:1½ ratio, but an elongated snake may have a ratio of 1:20, and a 400-foot-tall redwood may be displaying a ratio of 1:40.

You can help subjects such as these and many others to express their dimensionality by remounting your slide after processing. Remounting can also allow you to reposition a subject that is not well composed. This will most often show up in your photographs of animals when you have had to work quickly to catch the animal before it leaves. The important thing is to get the picture first; poor composition may be corrected later, but no picture means no composition at all. Remounting will further permit you to crop out extraneous material; maybe there's too much background, or maybe there's a hot spot somewhere that can be hidden by a smaller mount. Lastly, a new mount might level a slide with a slightly uneven horizon line. A number

of commercial manufacturers produce either pressure-sensitive or heat-sensitive mounts that will help to approximate more closely the ratio of unconventional subjects. Other mounts will reduce the size of your original rectangle, change it to a square, or provide a "gimmick" opening such as that of a keyhole or a heart that might be usefully employed when framing a fitting subject or when matched to a suitable narration in a slide presentation.

Some photographers elect to reposition their slides in thin glass mounts to afford total protection for the valuable film piece. This method guards against fingerprinting during handling, defends the film from airborne dust, and prevents the film from possible buckling during projection. Despite these advantages, I prefer not to use glass for the following reasons: First, moisture in the air squeezes between the glass sheets and the film, thus producing rainbowlike circles known as *Newton rings*. Even when using glass advertised as anti–Newton ring glass, I have found this flaw to surface. Secondly, with the film directly against the glass, moisture may cause it to adhere, and missed particles of dust or grit may scratch the film or project onto the screen. Finally, though it's unlikely, should the glass be broken, your film may be cut or even destroyed. For these reasons I still prefer the seemingly unprotected, open-faced mount. Although there is no concern with Newton rings or glass breakage, I must be careful about dust and fingerprints. The open mount also allows me to clean my most valued slides with a film cleaner that produces an anti-static shield and helps to keep the film from growing brittle or cracking after repeated projections in slide shows where heat and light wear the film.

Another pair of often neglected concerns in remounting is the square versus the rounded corner mount and the cardboard versus the plastic mount. Whenever possible, I always prefer the square-corner cut, which, with its print-in-frame look, appears cleaner, crisper, and more professional to me. For much the same reason, I also choose plastic mounts over cardboard cuts. The latter frequently show the ragged edges that may result from a too-old die's cutting through the paper's pulp. It has also been my experience that plastic mounts are not subject to the warp of cardboard; this prevents misprojection of slides whose cardboard corners may eventually fray and finally jam a projector at the most inopportune of times. Although such occurrences may have small

statistical probabilities, I see no reason for taking any unnecessary chances that may spoil your reputation as a fastidious photographer.

THE AUDIO/VISUAL PRESENTATION

For most of my career as a professional photographer, one of my greatest joys has, surprisingly, not always derived from the actual field photography, but rather from the return home when the slides are edited, woven into an audio/visual presentation, and shared with those who have not been so fortunate as I to have spent weeks or months hiking and shooting in such magnificent areas.

Most of you must know that "audio/visual presentation" is no more than downtown language for "slide show," and when most people hear "slide show," they exhibit a number of nervous tendencies. For many, the phrase *slide show* conjures up a host of unpleasant memories: the night when your neighbor showed them for a record-setting three hours, forty-nine minutes, and twenty-six seconds. In itself a real torture, this shattering performance was accompanied by an imaginative narration that no doubt went something like: "Here's the wife standing by . . . and here she is sitting in front of . . . this time the kids walked past the . . . and here's Jane next to . . ." All of this is accomplished, of course, as a cathedral-like hush hangs over the assembled throng. What a shame that such a potentially exciting sharing experience turns to such a social and photographic disaster.

So many precautions and techniques so easy to implement could have turned this catastrophe into a pleasant evening's entertainment. I would like to consider the audio/visual presentation from the same two levels that we have approached the photography: physical and aesthetic. Even though you may view yourself as an amateur motivated only by the praiseworthy feeling of wanting to share your experiences, you can readily make a professional-looking presentation with little more effort. Ensure your success by employing simple techniques that require only skills of common sense for the most part and not specialized expertise. To begin, let's go back to your trip itself. I'm sure that in the overwhelming number of nonprofessional situations, you took pic-

tures as they appealed to you; almost certainly you did not take a vacation whose sole or main purpose was to assemble a slide show with a predetermined cohesive theme accompanied by stirring music and a poetic narration. No, far more likely is the fact that you took whatever pictures you wanted and then, upon your return, looked for a way to present them.

Herein lies your first job: editing. To begin, you must view your slides, cull the rejects, and then sort the possible entrants. An indispensable aid for viewing transparencies is a simple lightbox or a slide sorter, a framed plastic sheet diffusing the light of an incandescent bulb. Available in a number of sizes, these boxes allow you to view only a few or a large batch of slides at once. I like the size that holds 40 slides for simultaneous sorting, because it allows you to assess an entire roll of thirty-six exposures at one time. Once the slides are displayed, put aside or even destroy those that are irrevocably flawed. Bad exposures, poor focuses, and other technical flaws should be rejected immediately. You may want to save some of them for personal reasons, but under *no* circumstances do you project them for an audience. Your apologies for their shortcomings cannot ever overcome the physical defects. As soon as I see a flawed image, I take it off the viewer, crease the emulsion with a noticeable crack so that I am not tempted to retrieve it, and finally dump it into a wastebasket. Now that you have eliminated the obvious failures, you have reduced your potential number of show members to a more manageable level. Projector viewing of these will further reveal less noticeable flaws such as processing marks, dust spots, or slightly missed focuses. The next step will be to cohesively sort your saves by subject matter. As this process advances, some perceivable themes should begin to emerge in front of your eyes and in your mind. Do you have a lot of animals or an abundance of flowers? Are there too many sunsets? Are all your slides horizontal? Is there a variety of perspectives, from infinity scenics to macro close-ups? In general, you want an overall feeling of what you do and do not have photographically. This will dictate the coordination you will make with the feeling you wish to convey with your words of narration and possibly the music you will select to enrich the total presentation. Do you want your presentation to be factual? entertaining? comical? emotional? Is your narration intended to give a feeling of time? of place? of wonder? of adventure? Whichever ap-

proach you select, you must come up with a cohesive story line that will be perceivable by your audience. You offend their mentality and you break their concentration when you interject a single slide left over from last year's trip to Niagara Falls into this year's show on the state parks of California. Once the story line has been established on the basis of your available slides (including the ones you may yet create by copying from maps, brochures, and so on), you will endeavor to wed your words to your images. As the slide portrays a visual landscape, so your script paints a conceptual mindscape. You attack your audience on two levels, the union of which produces a far greater impact than either one pursued independently.

Remember, the skill of your editing may be the most valuable of all. *Do not* show too many slides; if a mistake in quantity is to be made, show too few slides, not too many. Always leave your audience wanting to see more, not wishing they had seen less. This provocative tease will have them asking when you plan to do it again and not creating excuses for missing your next presentation.

If you play music, be judicious in your selection. Your slide show does not automatically gain stature just because you add music. Vocal accompaniments behind a narrating voice can be very distracting, especially if levels are not properly mixed; too high a level of instrumental sound can also drown out the voice of the narrator. Music whose tempo has no relation to the mood or beat of the slides is an equal mistake. Listen to music at the public library; play the local radio stations that specialize in jazz, country, classical, or rock music. With patience, you will uncover an appropriate musical companion piece. There are even albums of sound effects and musical specialties recorded at commercial studios and made available by photographic publications for the express purpose of accompanying slide shows. These albums contain everything from a mooing cow to an accelerating jet, from the down-home sounds of the country to the rush-hour cacophony of the big city. Investigate them well; they merit your attention.

Once you have established all of your aesthetic values—the slides are sequenced, the narration is completed, the music is recorded—do not neglect the physical aspects of your presentation. Have you cleaned the slides? Dust flecks can be very disturbing, especially as they are pro-

jected in their enlarged version on the screen. An antistatic film cleaner can help, as can negative brushes or cans of pressurized air. Have you rehearsed the presentation to make certain that all of the slides are in the correct sequence and properly registered? You could be blushingly embarrassed by a narration that describes Mammoth Cave but a slide that portrays your companion eating lunch or an inverted image of a black bear from the Smokies that seems to be standing on its head! Have you checked that the length of the projector's lens will project a correctly sized image for the distance involved? If it projects too large an image or will not focus at all, you've got more problems. I would recommend a zoom lens of four- to six-inch length; I've found that it can nicely handle situations ranging from a home living room to a business-meeting room to a public auditorium.

If you are not projecting at night, have you made arrangements for a room that can be darkened effectively? Few things can be more annoying than trying to look at a slide whose light is overpowered by brighter sunlight entering the room. If you know that you will be projecting in a room impossible to darken completely, I would suggest that you request or purchase a lenticular screen. It possesses a very highly reflective lined surface that provides a bright, sharp image that doesn't so easily disappear in brighter lighting situations. I will project on nothing else when I am making a presentation. In addition to its brightness, this screen permits wide lateral seating capacity, again because the image does not so easily lose brightness or sharpness, as do other screens, for those in the audience sitting far to the sides of the screen. The only drawback I have found to the lenticular screen is for those sitting too close. For them, the lined structure of the material becomes apparent, especially if the screen is one that has been repeatedly opened and closed. If possible, with such a screen, your front row should sit no closer than six to eight feet away.

Whatever type screen you select, make certain that it is aligned in an imaginary line parallel to the projector. If you must aim your projector diagonally across a room at a 45-degree angle to the wall, then your screen should be positioned at that same angle at the other end of the room. Failure to create this parallel condition between projector and screen will result in the loss of image sharpness, and as the disparity of the angle increases, so will the distortion in the rectangular

shape of your slide. Yet another type of optical distortion will be introduced by tilting your projector's elevation leg too high with magazines, books, or other padding. Drastically lifting the front of the projector will project onto the screen slides exhibiting a distortion known as *keystoning*. You cannot mistake the effects of keystoning— the lines at the top corners of the image will appear to be diverging away from each other. Your slide will be projected with a tapered look wider at the top than at the bottom.

Have you tested your projector? Projection lamps do not last forever. Do you have even an approximate idea of your bulb's life span? How many of these hours are already consumed? Is the auto-focus working? How about the remote release? The reverse? All seemingly obvious considerations, but how quickly the functional absence of just one can weaken your presentation and its impact.

If your interest in slide presentations greatly expands, you might seriously consider the purchase of a *dissolve unit*. This is a machine that links two or more projectors and thereby permits the simultaneous projection of more than one image and the gradual fading of one slide into another without the possibly disturbing fraction-of-a-second black interlude of a single projector that is reputed to tire the eyes of viewers. The dissolve unit allows many aesthetic effects to be achieved that are limited only by the characteristics of your model and your creativity in combining and putting in sequence images in conjunction with words, music, and mounts.

PRESENTATION OF THE PRINT

When the time rolls around to enlarge your favored slide or negative into a print for personal pleasure or public exhibition, as much care should be exercised in the creation and presentation as was devoted to the original. Should you wish to attempt your own darkroom work, it should perhaps be immediately pointed out for those who lack space and/or money that a "darkroom" for black-and-white use need not be totally dark except when handling undeveloped film. A simple test for a makeshift darkroom is to insert a piece of paper onto your easel, place a coin on the

light-sensitive side, and leave it there for a few minutes. Your next step is to develop the paper. If there is no evidence of a circular image where the coin sat, then your "darkroom" is sufficiently light-tight for black-and-white work.

Basically, you will employ your darkroom for two jobs: to develop your film and then to print your results. For film development you will require the following standard equipment: a changing bag (your flexible, movable darkroom), a developing tank in which to process the film in darkness, a thermometer to maintain proper temperatures, and jugs of some sort to act as liquid containers for the necessary chemicals—a developer, a stop bath, and a fix. In addition, you will require as a washing aid a hypo clearing agent and, to guarantee spot-free drying of your prints, some Photo Flo drying agent. For printing, an enlarger will be needed, and, most importantly of all, a high-quality enlarging lens. You will require trays, preferably one size larger than the paper you will be using; *e.g.*, for 8 × 10 prints, buy 11 × 14 trays. When printing black-and-white prints, you will have the choice of using either *RC (resin-coated)* or *fiber-based* papers with surfaces that range from mattes to textures to glossies. *RC* papers must be washed at once, and if they are not removed from their wash at or near the proper time, they will not dry flat. In contrast, *fiber-based* papers may be left in standing water and then washed elsewhere at a later time. Some valuable accessories might include a grain focuser, to expedite focusing, and a timer. Although a clock is recommended for consistency of results, it is not a necessity, as is evidenced by the fact that Ansel Adams, the acknowledged master of the black-and-white print, uses a metronome. Finally, an indispensable aid for any beginner would be Kodak's publication entitled *Darkroom Data Guide.**

If you do not perform your own darkroom work, a professional lab with which you have open lines of communication is a must. A darkroom technician who insists on printing to personal standards and not to your specifications is useless. Your printer must have an eye for color and a meticulous, dust-free environment in which to work. Once you have discovered such a treasure, the decisions on how to employ it are yours.

* Eastman Kodak Company, *Kodak Black and White Darkroom Guide* (Rochester, N.Y., 1979).

First, do you want a print made directly from a slide, via an internegative, or from an original negative? Direct positive printing processes such as Cibachrome by Ilford yield an image of superb sharpness, vivid color, and unequalled stability of the image. Other photos with high contrast or soft, subtle colors may be better handled by a 4 × 5 internegative with greater latitude. If you are uncertain about your choice, your lab should be able to provide professional advice. A second consideration is size reproduction. Basically, size is irrelevant, since it is so totally dependent on the area where it is to be displayed. An 11 × 14 print may be too large for an office desk, but a 40 × 60 mural may be too small for a major museum wall. Much of your decision as to size will be determined by the quality of your original. Flaws barely visible in a 1 × 1½-inch slide become readily apparent by the time they are enlarged to 16 × 20 or even smaller. Was your camera on a tripod? If not, and you are expecting a sharp enlargement, your chances steadily diminish with size.

Once you have a finished print, you must decide if you want to simply flush mount it in a frame or if you would like to enhance it with the addition of one or more layers of mat board. *Flush mounting* means that the print will have no borders; it will fill the frame from edge to edge. *Matting* the print means that the photo will float as an island between surrounding walls of neutral or accenting mats. Should you flush mount your print and put it behind glass, you must contend with moisture between the print and the glass, which can with time damage the surface. When print is to touch glass, I would suggest the use of a protective surface spray. Available in a variety of styles from matte to glossy, this layer of spray will not only afford protection from moisture, but it will also allow you to actually wash the surface of your print with a mildly damp cloth, should you decide to display it without any frame or glass. Matting, on the other hand, encounters no such problems. The layer(s) of mat(s) provides a buffer zone for the print. When I exhibit prints, I almost always present matted photos, both to enhance the mood of the picture and to entice the potential buyer with a larger piece tastefully arrayed in colors that will possibly coincide with the decor of an office or the color of a home sofa.

Although the traditional museum approach has been to mat in white, gray, or black, I far prefer to use colored boards that bring out colors already present in the photograph. I also prefer

double matting over single matting. A general rule for this procedure is that the top color should represent the color you want to predominate in the print, whereas the inner liner should subordinately accent the outer mat. If you wish your print to look lighter, an upper mat with a darker color will help to achieve that; if you want your print to appear darker, use a lighter upper mat. In the case of very dark prints (such as a large silhouette, for example), a light mat will be distractingly overpowering. Since the human eye is attracted to light rather than dark, your viewer's eye will see nothing but mat board. With experience you will learn to avoid common errors. Do not let the mat overwhelm the print. When double matting, avoid very light liners in conjunction with much darker upper mats, or else you will create an "owl's eye" effect that draws the viewer's eye to the bright liner. Do not exhibit ragged, unprofessionally cut corners. Mats cut with a razor blade look uneven and demean the print. A professional mat-cutting machine not only cuts perfectly straight, but it also bevels the board.

If prints are to be presented behind glass, many people insist on non-glare glass. In fact, non-glare glass is only less-glare glass. With double-matted presentations, I strongly recommend against it because it reduces sharpness and so totally diffuses focus when the print is viewed from an angle that the print starts to disappear from sight. When the print is mounted against glass, this material is fine, but otherwise I would avoid it. I would also shun plexiglass, which has gained stature because of its light weight, because it is approximately twice as expensive as regular glass and because it is so easily scratched. I choose to use standard picture glass, which is free from process flaws and does not suffer from the drawbacks just discussed.

The final touch for your print is the frame. I look upon the frame as something to contain the image and separate the piece from the wall on which it is hanging. Frames that attract more interest than the photograph should be avoided. I prefer to exhibit in contemporary metal frames. They have a clean, modern, uncluttered look about them that fits many applications. I have also successfully used shadow boxes for certain domestic jobs, and barnwood frames for rural, antique themes to be used in rustic setting of cabins or dens.

Whichever selections you make, be careful to take normal precautions with your print. Do not display it where the bright sun will strike it for much of the day, and also do not exhibit beneath hot, bright spotlights for extended periods. Under normal room lighting conditions, your print will give you many years of viewing pleasure.

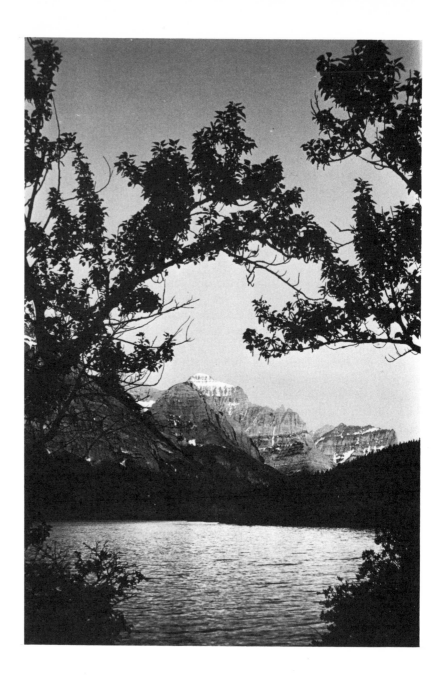

I HAVE NOT TRAVELED EVERYWHERE in North America, but there are few places that I have missed. I have photographed from the subtropical warmth of Florida's Everglades to the perpetually frozen slopes of Alaska's Mt. McKinley, from the surf-splashed shores of Maine's rocky coast to the sun-baked arroyos of Arizona's scorched deserts, and almost everywhere in between. Obviously, there are some places that appeal more than others, places to which I constantly return because they prove to be both continually exciting and photographically productive natural environments. Every selection such as this involves a

great deal of personal preference. The object of this chapter is not to start any arguments about what place should or should not have been included; rather it is an attempt to share with you some of those extra-special places where I have found the combined photographic opportunities to provide dawn-to-dusk exercise for my cameras and me. For one rare animal or one special bird, my favorite place might be a college campus where an endangered species nests or my own patio where my natural-stump bird feeder attracts a variety of songbirds to within 85mm lens range.

The ten havens I have selected go far beyond

The top ten: a personal sampler

such specialization. I have chosen them because they provide more than reasonable opportunities to do scenic, wildlife, plant, and macro photography. In addition, I have tried to present at least a fair geographic sampling and not limit myself to all those treasures of the Rocky Mountains that I prize so dearly. I am sure that you have favorite areas of your own, especially on a local scale; I am sure that you have photographed in some or all of the places I have picked. You may think I am out of my mind for inserting one and leaving out another. No doubt some of you will decry the omission of a Yosemite or the Grand Canyon, while others among you may be delighted by the inclusion of a personal favorite whose values you thought weren't sufficiently appreciated. Be that as it may, without any further apologies and defenses, I present my top ten:

1. *Yellowstone National Park* (Wyoming, Idaho, Montana): The Impossible Dream. There is no place on earth like it. The world's first and America's largest national park also unquestionably rates as the finest to me. An incredible array of watery phenomena challenges your camera—rushing rivers, rampaging waterfalls, turbulent

geysers, seething hot springs. Condensation around the geyser basins turns Yellowstone into an inferno of steam and mist; as you walk through a landscape punctuated by the pungent aroma of sulphur, you can't help but feel that you are walking through Hell. Scenery abounds; from the largest alpine lake in our country to Minerva's Terrace, what I consider to be probably the most beautiful inanimate object I have ever photographed; from the ever-changing Grand Canyon of the Yellowstone to the rolling meadows of Hayden and Lamar Valleys.

Make sure you carry a wide-angle lens to capture the clouds; also keep a telephoto close at hand to record the abundant wildlife that includes the American elk (more properly called by its Indian name *wapiti*), bison and moose; pronghorn, mule deer, and coyote; migrating waterfowl such as Canada geese, numerous species of ducks, and the once severely endangered trumpeter swans. Some 70 percent of the park's visitors come during the months of July and August. If possible, avoid this paradise at that time; it is Yellowstone's poorest season. In addition to the crowded facilities, there is the least to photograph. Save your vacation for the golden hours of fall after Labor Day or for the time around Memorial Day when the sun is just beginning to withdraw winter's white coverlet to expose the mountain wildflowers. Best of all, if possible, is a trip on the snow coach for a winter visit through a snow-draped fantasyland. Yellowstone: truly an impossible dream; number one; forever.

2. *Everglades National Park* (Florida): From December through March, there is no place I would rather be. The combination of south Florida's superb winter climate and the abundance of Everglades' spectacular wildlife make this sanctuary for me the only one to mount a serious challenge to the supremacy of Yellowstone. If you said that Everglades is for the birds, you would be exactly right. It *is* for the birds: for great blue, little blue, green and tri-colored herons; for snowy, great white, and cattle egrets. All are to be expected and they can all be photographed. Normally, a 400 or 500mm lens will be sufficient, but in some instances even 135mm will be too long. Years of protection have reduced the birds' fear of man, and their approach distance can be astonishingly close.

Along Anhinga Trail, you will surely encounter the bird who bestowed its name upon the trail, along with coots, gallinules, grebes, bitterns,

and a host of other wildlife ranging from anoles and water snakes to raccoons and the American alligator, the star attraction. Along the main park road there are hawks and crows and vultures. Farther southwest in the park, there are opportunities for many of the subtropical birds that we in northern climes never see at home: roseate spoonbills and wood storks, brown pelicans and white ibis.

Finally, with endless patience and a long enough lens, there are endangered species that almost no one sees, regardless of where home is: bald eagles, ospreys, and reddish egrets. Although the scenery here is not the eye-shocking spectacle of western mountains, it possesses a unique beauty of its own—this river of grass accented by cypress and mangrove trees. If you have the opportunity, a plane ride over this primitive wilderness is a must. In flight are revealed the intricate patterns of the waterways through the mangroves, the sparkling color of landscapes such as Cape Sable and the rookeries of birds nesting in astonishing numbers. Add to all of this the uniqueness of a subtropical flora containing gumbo limbos, orchids, mahoganies, and bromeliads, and you can readily comprehend why Everglades merits both my number-two ranking and our every effort to preserve it intact for future generations.

3. *Glacier National Park* (Montana): This is one of our vastly underrated parks, by all except those who know it. Because Glacier's location in the northwest corner of Montana along the Canadian border lies essentially out of the main tourist paths, except for those on their way to Seattle or the Canadian Rockies, visitation is not what one might expect . . . and that's just another bonus for me. Here, in my opinion, is the most spectacular park road in America. As it winds to nearly 7,000 feet, Going-to-the-Sun Road passes emerald moose ponds, waterfalls that have had to be diverted beneath the pavement, and stunning mountain peaks that display a reddish or purplish tint because of their content of copper. At Logan Pass you can watch weather systems developing in the west brawl with those of the east for control of the Continental Divide.

An abundance of wildflowers dots the slopes as the snows recede. They span the spectrum of colors from the roses of monkeyflowers to the yellows of pendant columbines, from the sanguine crimsons of Indian paintbrush to the creamy whiteness of the erroneously named beargrass. Wildlife is plentiful: hoary marmots,

Columbian ground squirrels, and ptarmigans are among the smaller; bighorn sheep and mountain goats are the two main attractions among the big-game mammals. Although most of the park visitors limit themselves to the sections of the park accessible from Going-to-the-Sun, they do themselves a major disservice. From the Kiowa Pass road, spectacular vistas soar before you, and once you leave the car, you can see hiking trails radiate across the forested slopes. At Many Glacier is to be found some of the finest hiking and backpacking country in our national park system.

The trails beckon photographers, too. To view and photograph unbroken stretches of Rocky Mountain wilderness from the peak of a glacial ridge cannot in any way be compared to photographing from a car by the side of the road. Adjoining Glacier on the Canadian side is our neighbor's Waterton Lakes National Park. For an inspiring climax to an unforgettable experience, you should take an evening cruise on the waters spanning the international border. As you look up, you will be surrounded by jagged peaks, and, as the evening sun begins to set, a chill will be sent into the air and chills of another sort down your spine.

4. *Arches National Park* (Utah): Unlike the three parks that have preceded it, Arches, I believe, should merit position number four if for no other reason than just one of its features—a magnificent work of wind and water, sun and sand known as Delicate Arch. The time and the elements have here combined to erode the sandstone into a masterpiece that unites the strength of the boxer with the grace of the ballerina. With all due respect to Yosemite Valley, the Grand Canyon, and others, it is, for my money, the number-one scenic view in our national parks. With the La Sal Mountains in the background and the bald rock domes in the foreground, Delicate Arch provides the photographic *coup de grâce* to a geologic spectacle beyond comprehension. The rather arduous hike required to discover its hiding place is well worth every drop of sweat, every strained muscle, to bask in its radiance at sunset. But this red-rock desert land contains much more of photographic interest. Big Balanced Rock makes a massive sunrise silhouette while a host of other rock voodoos provide an assortment of startling shapes and patterns to back light solo or in tandem.

More natural arches liberally sprinkle this weird landscape than any other place on earth. Names such as *Parade of Elephants, Double O, Turret,*

and others fairly describe their imagination-provoking shapes. In the Courthouse Wash and elsewhere, you can look for a host of lizards, including the brightly marked leopard lizard, basking in the sun and then retreating into shade as they attempt to regulate their body temperature. In the plant world, stalks of yucca struggle to survive in the sand, junipers showcase clusters of berries, and splashes of bright orange lichen adorn the rocks. By spring there are desert wildflowers, and winter will occasionally see light snow dust the ground. The outstanding values preserved in this hostile environment merit your serious photographic attention.

5. *Haleakala National Park* (Hawaii): When is the last time you saw a group of people literally stand up to cheer and applaud sunrise? Well, on the crater rim of the world's largest dormant volcano, such behavior is not an uncommon occurrence. It is said of Haleakala, loosely translated as "House of the Sun," that it is the most beautiful place in the world to view sunrise, especially from the crater floor. You will do well to take entire sequences of the procession of the rising sun. When projected on a dissolve unit, the results on the screen will produce a moving spectacle second only to the actual event.

On your descent to the floor of the crater, you will pass volcanic cinder cones flaunting hues of wine and magenta from their blackened coals. Before you, truly incredible cloud formations will billow through The Gap. In this prehistoric scene, you can almost sense that if you should turn at just the right moment you would see a thunderous dinosaur step out from behind one of the cones. The silence is awesome; it virtually explodes in your ears. If it snowed here, I'm absolutely certain that you could hear the individual flakes land. Though devoid of practically all life, the crater does harbor silversword, an exotically beautiful plant that grows here and nowhere else in the world except for remote regions of Mauna Kea on the island of Hawaii.

Bring a wide-angle lens. It will capture a perspective in this land where clouds pose as mountains, oceans pass for clouds, and your sense of perspective registers "tilt."

6. *Wind Cave National Park* (South Dakota): Once, the vast prairies of mid-America stretched to the horizon and thundered beneath the ponderous beat of the millions of hooves of massive herds of bison. Today, heavy agriculture and light

industry have replaced much of that grassland, but in a small corner of South Dakota is preserved a remnant trace of that pristine scene. Named for the cave that was accidentally discovered by a military patrol that heard the whistling noise emitted from a small entrance, Wind Cave has a real spectacle that lies not underground, but above ground.

I know of no place where you will have a better opportunity to photograph the sleek pronghorn antelope, the fastest land mammal in North America, and the delightful black-tailed prairie dogs whose piercing barks alert an entire colony to the presence of danger. There will also be chances for bison, deer, and elk. In this land where east meets west, an astonishingly high number of bird species pass through during migration.

In season, there are prairie wildflowers; for scenics there is always the special beauty of the gently rolling terrain. Forests of pine darken the distant landscape and give much of the area its popular name of the Black Hills, but your inquisitive camera will reveal on the film a spectrum of colors far more diverse in nature.

7. *Saguaro National Monument* (Arizona): Here, in southern Arizona, lies a rugged wilderness, home to the largest of all cacti—the giant Saguaro, sometimes attaining heights of nearly fifty feet and weights approaching 20,000 pounds. This monster of the desert offers a variety of photographic opportunities: its multi-armed body a grand silhouette, its flowers a delicate contrast to the massive body, its trunk and crotches home to owls, woodpeckers, doves, and other nesting birds. But dozens of other smaller, less noticed (until you bump into one) cacti share the habitat: teddy-bear cholla with its clusters of deadly spines (think back lighting), prickly pear with its ruddy fruits, and barrel whose orange blossoms nestle amidst a fortress of hooked spines. These are but a few that you will want to get close to—but only with your lens!

Scenery is plentiful in the form of the lighting that paints the mountains by dawn and dusk. When spring arrives, the desert wears a carpet of colors that no Indian weaving ever approached. By summer, the desert receives most of its meager quantity of rainfall. Though the water is scarce, pictures at this time are not—clouds, rainbows, lightning. Wildlife is harder to come by; it is there and it is even there in an abundance unsuspected

by those who speed across the desert in mid-day when the animals have retreated to shade or subterranean burrows to escape the despotism of a relentlessly tyrranical sun. You may see a vulture exposing its body to the sun with wings spread to kill the bacteria, fungi, and lice it may have acquired from feeding upon carrion. Or, you may glimpse a lizard scurrying with upraised tail for a new shelter. To photograph the other wildlife, you will have to wait for dawn and dusk, when the desert truly comes alive—with the sounds of foraging birds, with the hum of insects, and with the silent opening of flowers.

Those accustomed to the world of the woods may feel uneasy in this environment. I love the desert, and I think you will too if you will give it a chance and if you will remember that it is a demanding environment. Not only must you find protection to shield your film from the oppressive heat, but you must also be aware that you are constantly evaporating water at an astonishing rate unperceived by you. Carry water with you at all times; drink it even when you are not thirsty. Wear a hat to shade your face, and light-colored clothing to shield your skin from the sun. Do not strain or push your endurance until you have become better acclimated. Taking care of your personal physical and emotional environment should greatly enhance your natural and photographic enjoyment of this spectacular ecosystem.

8. *Acadia National Park* (Maine): The photogenic, rocky shore of the Atlantic highlights this preserve of inland lakes, green woods, and tidal pools. At Otter Point you can stand mesmerized in a hypnotic trance at the edge of a wave-battered coast where the surf endlessly breaks against the rocks before retreating to the sea. Your photography here demands a polarizer in order to record the aquas, turquoises, and azures of the ocean's varying depths and to slow shutter speeds for the spraying patterns of the crashing waves. At Sand Beach you will come to a deeper appreciation of the versatility of the 35mm system as you attempt to photograph everything from driftwood, bank swallows, and surf scenics to starfish and barnacles in the tidal pools.

Throughout the park, herring gulls pose and preen against a foggy Atlantic Ocean. The drive to the top of Cadillac Mountain offers a panoramic view of a grand spectacle below. At the Bubbles—a pair of hills—you can relax and photo-

graph in one of the most peaceful vistas I have ever enjoyed. Add to all of this images depicting man's interrelationships with and dependence upon nature in the forms of fishing boats and lobster pots, and you have truly discovered one of the treasures of the East.

9. *Bear River National Wildlife Refuge* (Utah): Here, just sixty miles north of Salt Lake City, lies one of the greatest migratory waterfowl refuges on the continent. During fall migration, if the birds resting on the water were rocks, you could walk across the impoundments without ever wetting your feet. Less than forty years ago, the numbers of birds reached into the mind-staggering millions. Today, those numbers, though substantially reduced, are still very impressive. Driving the auto-tour-route dikes that bisect the manmade impoundments will carry you to within 500mm range of yellow-headed blackbirds, black-crowned night herons, western grebes, ruddy ducks, and so much more.

Flocks of white pelicans fly in daily from their resting grounds in the Great Salt Lake to feed here in single file. Throughout spring, photographers migrate here from across America for the unrivalled chances to photograph black-necked stilts, American avocets, snowy plovers, willets, and other nesting shorebirds. Here you will want to have a window mount, and you will quickly learn to appreciate the capacity of your vehicle to act as a blind. In addition to the abundant bird life, the mountains outside nearby Brigham City offer fine scenic opportunities during times of seasonal snows and fall colors; the jagged peaks further provide interesting silhouettes for the commonly brilliant skies of sunrise and sunset.

I believe that Bear River deserves the company of the eight giants preceding it solely on its own merits, but I have included it for another reason as well. I would like it to introduce to many of you the unheeded glories of our National Wildlife Refuge (NWR) system. Hundreds of these units dot our country's landscape. While our national parks suffer from a plethora of people and overburdened facilities in season, the national wildlife refuges go almost unnoticed. Although the refuges generally do not offer the scenic spectacle of the parks, they far more often than not present greater opportunities for wildlife, especially the migrating bird species that these sanctuaries were originally designed to protect. After Bear River, a dozen of my favorite

national wildlife refuges would have to include the following (listed in alphabetical order):

1. Aransas NWR, Texas
2. Bowdoin, NWR, Montana
3. Brigantine NWR, New Jersey
4. Horicon NWR, Wisconsin
5. Laguna Atascosa NWR, Texas
6. Malheur NWR, Oregon
7. Mattamuskeet NWR, North Carolina
8. Okefenokee NWR, Georgia
9. Santa Ana NWR, Texas
10. Seney NWR, Michigan
11. Tule Lake NWR, California
12. Wichita Mountains NWR, Oklahoma

You can learn more about the location and features of these and our other refuges in a book entitled *The Sign of the Flying Goose* by George Laycock.*

10. *Kensington Metropolitan Park* (Michigan): Who? Where? Why? In southeast Michigan, only thirty miles from Detroit, lies a sanctuary where I have worked briefly as a seasonal naturalist and endlessly as a photographer. As with Bear River, I believe that Kensington merits its high ranking on its values alone, but I also feel it deserves attention for another reason. In these days of fuel shortages and staggering gas prices, we are all going to have to find places closer to home in which to practice our photography. I've included Kensington so that you may realize that there *are* such places near wherever you live—from Maine to Montana; from North Dakota to South Carolina. But Kensington is no token inclusion.

In my part of the country, where speeding steel machines with names such as Cougar and Rabbit and Roadrunner race across a concrete sea, I take great joy in knowing that there still burst from the grasses *real* pheasants painted with *real* feathers, and *real* sky hawks with powers of acceleration and handling that no sports car can hope to imitate. At Kensington, only half an hour from America's sixth-largest city, you can still see an occasional osprey, migrating whistling swans, and even a rare bald eagle once or twice a year. Turkey vultures have been seen nesting here; the bird list numbers in excess of 150 species. When the feeders are placed along the trails in autumn, white-tailed deer cautiously wander to within twenty

* George Laycock, *The Sign of the Flying Goose* (Garden City, N.Y.: The Natural History Press, 1965).

feet or less of anxious spectators. Noisy red squirrels compete with blue jays for rulership of this passing kingdom.

Swamps and marshes in this park harbor everything from orchids such as the yellow moccasin flower to Michigan's only poisonous snake, the shy and retiring Massasauga rattlesnake. Mature forests of mixed oak, beech, and maple create their expected fall spectacle and throughout the rest of the year provide shelter and food for raccoons, chipmunks, and songbirds. Numerous duckweed-covered ponds jump to life each spring with the songs of bull frogs and American toads, and the proverbial sounds of silence of the turtles. A resident flock of Canada geese remains all year, aided by an aerator that maintains one large pond with at least a small section of open water throughout the colder calendar months. Even the glaciers long ago left their gift to Kensington—in the form of the gently rolling hilly landscape whose slopes today provide home for red foxes, cottontails, and woodchucks; bloodroot, hepatica, and trillium.

To appreciate an area such as Kensington, one must be at heart among the city, but not of the city. It is a unique world—an Island of Life in the Sea of Megalopolis.

THE NATURE PHOTOGRAPHER AS GUARDIAN OF THE ENVIRONMENT

In a world debilitated by double-digit inflation, strained by international tensions and haunted by the devastating spectre of total nuclear holocaust, what inspiration, what validity, what message, if any, can possibly come from the world of frogs and rainbows and ferns? In his masterful book *Life on a Little-Known Planet*, Howard Evans poses a hauntingly simple, yet deceptively terrifying answer in the form of a question: "In fact, is nature necessary to man?"*

Perhaps this question is best stated in its reverse form: Is man necessary to nature? Before the

building of the pyramids, bull frogs were singing in the ponds. Columbus discovers America and bull frogs are still singing in their ponds. A man walks on the moon and the bull frogs sing in the ponds. Natural environments flourished for untold centuries before man appeared on this planet, and they may continue to do so long after our species has departed and bull frogs yet sing in the ponds.

I now believe that the battle to save our natural areas will be won or lost not in the refuges themselves, but in the cities. It is here in our urban areas that the major population centers of mankind reside; it is these people who will make the decisions concerning the future of a wilderness whose significance many do not even understand. Today's conservation ethic fortunately reflects the growing awareness that it is not enough to save only grandiose wilderness areas that most Americans will never see. Today we understand and appreciate that we must save natural areas that are well within the daily grasp of every urban dweller. We need such locations so that people can go there to refresh and truly recreate themselves. I think we need these havens as places where we have a chance to realize that a spider's web is at least as great a work of art as any painting or novel. I think we need these refuges to reawaken in the human race what Rachel Carson eloquently described as "the sense of wonder." Finally, I think we need these sanctuaries to nourish a sorely needed respect for life, all forms of life, no matter how humble they appear to the human mind.

Given this framework of values, the conservationist/nature photographer comes upon the scene with camera in hand to carry forth the message on both the pragmatic and aesthetic levels. I would like to toss out for your consideration the notion that your camera is a tool, a very powerful tool that can be effectively utilized to help save the dwindling natural beauties that you and I would like to continue to enjoy and photograph. I would urge you to let your camera bear witness to the words of Joseph Wood Krutch, a drama critic who late in his life became a student of the desert and who once penned these words: "When a man destroys a work of art we call him a vandal; when a man destroys a work of nature we call him a developer."

Your images of environmental destruction and habitat pollution not only provide blatant

* Howard Evans, *Life on a Little-Known Planet* (New York: E. P. Dutton & Co., Inc., 1966).

Figure 10.1
The persistence of life in the world of machines.

Figure 10.2
A corpse of fish, a jug of oil, and thou?
One picture is worth what?

contrast for a series of pretty pictures, but they also tug at the viewers' emotions and negate the need for eloquent pleas such as this by convincingly showing the value of wilderness and even more significantly by making more apparent the choice of alternate lifestyles available to us humans. In this book you have been equipped with a battery of technical information and a philosophic fuel to start your engine. All that remains is for you to shift your machine into gear and search for those moments that will make for you the ultimate photographic images. Along the way I am sure that you will indeed be rewarded, occasionally even in the form of a pretty picture captured on the celluloid. But more importantly, I think, is the fact that you will find yourself becoming increasingly aware of the diminishing beauty of our planet. Unknowingly, you will find yourself drawn into the struggle to help save this fast-vanishing aspect of American life.

I am confident that you will develop into a more capable photographer; I am certain that you will evolve into a more humane human being, one almost imperceptibly drawn into agreement with John Burroughs, one of the most sensitive and eloquent spokesmen of the early conservation movement in America, as is evidenced by these words from his pen:

> The longer I live, the more my mind dwells upon the beauty and wonder of the world. I have loved the feel of the grass beneath my feet and the sound of running streams by my side. The hum of the wind in the treetops has always been good music to me and the face of the fields has often comforted me more than the faces of men. I am in love with this world.

APPENDIX

Resources

OUTDOOR AND CONSERVATION ORGANIZATIONS

The following is but a partial listing of a number of significant organizations that may be of service to the nature photographer. Many of these groups sponsor workshops, field trips, or classes of interest to photo buffs. In addition to these national groups, you will find on the local level a host of adult-education classes, centers for lifelong learning, and continuing-education programs that offer both photographic and natural-history courses that may enhance your knowledge, skill, and ambitions.

1. Alaska Conservation Society; Box 80192; College, Alaska 99708.
2. American Association for Conservation Information; c/o Chuck Post; Department of Game, Fish & Parks; Pierre, South Dakota 57501.
3. American Conservation Association; 30 Rockefeller Plaza; Room 5425; New York, New York 10020.

4. American Forestry Association; 1319 18th Street NW; Washington D.C. 20015.

5. American Humane Association; 5351 Roslyn; Englewood, Colorado 80111.

6. American Museum of Natural History; Central Park West at 79th Street; New York, New York 10024.

7. American Orchid Society; Botanical Museum of Harvard University; Cambridge, Massachusetts 02138.

8. American Ornithologists' Union, Inc.; National Museum of Natural History; Smithsonian Institution; Washington, D.C. 20560.

9. American Society of Ichthyologists & Herpetologists; Brookfield Zoo; Brookfield, Illinois 60513.

10. American Society for the Prevention of Cruelty to Animals; 441 East 92nd Street; New York, New York 10028.

11. Animal Protection Institute of America; P.O. Box 22505, Sacramento, California 95822.

12. Audubon Naturalist Society of the Central Atlantic States; 8940 Jones Mill Road; Washington, D.C. 20015.

13. Big Thicket Association; Box 198; Saratoga, Texas 77585.

14. Bounty Information Service; c/o Stephens College Post Office; Columbia, Missouri 65201.

15. The Cousteau Society; 777 Third Avenue; New York, New York 10017.

16. Defenders of Wildlife; 1244 19th Street NW; Washington, D.C. 20036.

17. Ducks Unlimited; P.O. Box 66300; Chicago, Illinois 60666.

18. Environment Action; 1346 Connecticut Avenue NW; Suite 731; Washington, D.C. 20036.

19. Environmental Data Service; Washington, D.C. 20235.

20. Environmental Defense Fund; 475 Park Avenue South; New York, New York 10016.

21. Friends of Animals; 11 West 60th Street; New York, New York 10023.

22. Friends of the Earth; 124 Spear Street; San Francisco, California 94105.

23. The Fund for Animals, Inc.; 140 West 57th Street; New York, New York 10019.

24. General Whale; P.O. Box Save the Whale; Alameda, California 94501.

25. Hawk Mountain Sanctuary Association; Route 2; Kempton, Pennsylvania 19529.

26. Humane Society of the United States; 2100 L Street NW; Washington, D.C. 20037.

27. International Association for the Advancement of Earth & Environmental Sciences; Department of Geographic & Environmental Studies; Northeastern Illinois University; Bryn Mawr at St. Louis; Chicago, Illinois 60625.

28. Izaak Walton League of America; 1800 North Kent Street; Suite 806; Arlington, Virginia 22209.

29. National Audubon Society; 950 Third Avenue; New York, New York 10022.

30. National Parks Association; 1701 Eighteenth Street NW; Washington, D.C. 20009.

31. National Wildlife Federation; 1412 Sixteenth Street NW; Washington, D.C. 20036.

32. Natural Resources Defense Council; 122 East 42nd Street; New York, New York 10017.

33. The Nature Conservancy; 1800 North Kent Street; Suite 800; Arlington, Virginia 22209.

34. New England Wildflower Society; Hemenway Road; Framingham, Massachusetts 01701.

35. Save Our Shores; P.O. Box 103; North Quincy, Massachusetts 02171.

36. Save the Redwoods League; 114 Sansome Street; Room 605; San Francisco, California 94104.

37. Sierra Club; Chapter Services; 530 Bush Street; San Francisco, California 94108.

38. Trout Unlimited; 118 Park Street, SE; Vienna, Virginia 22180.

39. United Humanitarians; 16 East Hatcher Road; Phoenix, Arizona 85020.

40. United States Fish & Wildlife Service; Department of the Interior; Washington, D. C. 20240.

41. Urban Wildlife Research Center; 4500 Sheppard Lane; Ellicott City, Maryland 21043.

42. Water Pollution Control Federation; 2626 Pennsylvania Avenue; Washington, D.C. 20037.

43. Wilderness Society; 1901 Pennsylvania Avenue NW; Washington, D.C. 20006.

44. Wildlife Preservation Trust International, Inc.; 34th Street & Girard Avenue; Philadelphia, Pennsylvania 19104.

45. The Wildlife Society; 7101 Wisconsin Avenue NW; Suite 611; Washington, D.C. 20014.

46. World Wildlife Fund; 1601 Connecticut Avenue NW; Washington, D.C. 20009.

ZOOLOGICAL PARKS, AQUARIA, AND BOTANICAL GARDENS

Many urbanites and suburban dwellers may find golden opportunities to hone their photographic skills at local zoos, museums, or botanical gardens. Many of these display animals in natural surroundings and provide glorious chances to photograph otherwise inaccessible plants and wildlife. The following list represents but a tiny sampling of those available to you and your camera.

1. Arizona–Sonora Desert Museum; Route 9, Box 900, Tucson, Arizona 85704

2. Botanic Garden of Chicago Horticultural Society; East Lake Cook Road; Glencoe, Illinois 60022.

3. Brooklyn Botanic Garden; 1000 Washington Avenue; Brooklyn, New York 11225.

4. Busch Gardens; Box 9158; Tampa, Florida 33674.

5. University of California Botanical Garden; Strawberry Canyon; Berkeley, California 94720.

6. Chicago Zoological Park (Brookfield Zoo); Golf Road; Brookfield, Illinois 60513.

7. Cincinnati Zoo; 3400 Vine Street; Cincinnati, Ohio 45220.

8. Crandon Park Zoological Garden; 4000 Crandon Boulevard; Key Biscayne, Florida 33149.

9. Dallas Zoo; 621 East Clarendon Drive; Dallas, Texas 75203.

10. Denver Botanic Gardens; 909 York Street; Denver, Colorado 80206.

11. Denver Zoological Gardens; City Park; Denver, Colorado 80205.

12. Detroit Zoological Park; Box 39; Royal Oak, Michigan 48068.

13. Fairchild Tropical Gardens; 10901 Old Cutler Road; Miami, Florida 33156.

14. Fort Worth Zoological Park & James R. Record Aquarium; 2727 Zoological Park Drive; Fort Worth, Texas 76110.

15. The Garden Center of Cleveland; 11030 East Boulevard; Cleveland, Ohio 44106.

16. Holden Arboretum; 9500 Sperry Road; Mentor, Ohio 44060.

17. The Houston Zoological Gardens; Box 1562; Houston, Texas 77001.

18. Huntington Botanical Gardens; 1151 Oxford Road; San Marino, California 91108.

19. Lincoln Park Zoological Gardens; 2200 North Cannon Drive; Chicago, Illinois 60614.

20. Longwood Gardens; Kennett Square, Pennsylvania 19348.

21. Los Angeles Zoo; 5333 Zoo Drive; Los Angeles, California 90027.

22. Matthaei Botanical Gardens of the University of Michigan; 1800 North Dixboro; Ann Arbor, Michigan 48105.

23. Milwaukee County Zoological Park; 10001 West Bluemound Road; Milwaukee, Wisconsin 53226.

24. Minnesota Zoological Garden; 12101 Johnny Cake Ridge Road; Apple Valley, Minnesota 55124.

25. Missouri Botanical Gardens; 2315 Tower Grove Avenue; St. Louis, Missouri 63110.

26. Mitchel Park Horticultural Conservatory; 524 South Layton Boulevard; Milwaukee, Wisconsin 53233.

27. National Zoological Park; Washington, D.C. 20008.

28. New England Aquarium; Central Wharf; Boston, Massachusetts 02110.

29. New York Botanical Garden; Bronx Park; Bronx, New York 10458.

30. New York Zoological Park; Bronx Park; Bronx, New York 10460.

31. Oklahoma City Zoo; Route 1, Box 1; Oklahoma City, Oklahoma 73111.

32. Philadelphia Zoological Garden; 34th & Girard Avenue; Philadelphia, Pennsylvania 19104

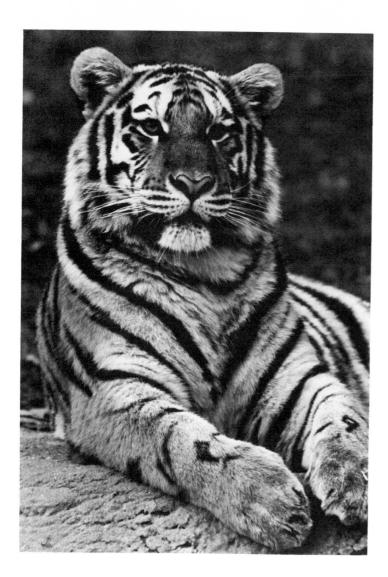

Figures A.1, A.2, and A.3
Where else but at a high-quality natural-habitat zoo could an aspiring nature photographer hope to gather in but a single day authentic-looking photographs of a rare Siberian tiger, an African shorebird, and an exotic fennec fox?

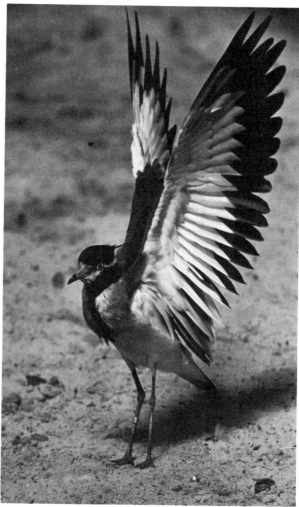

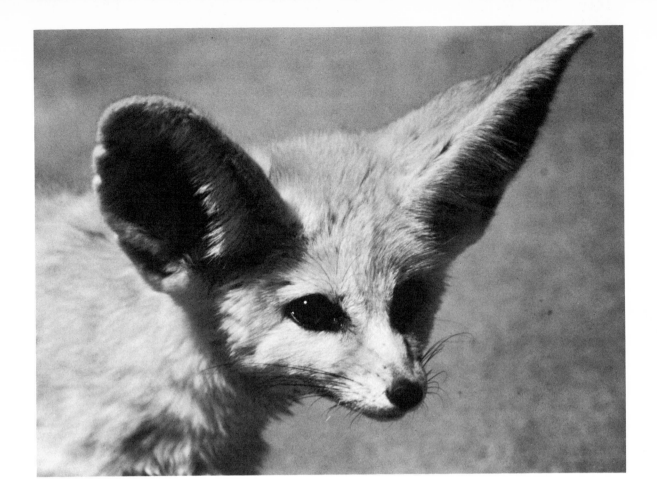

33. St. Louis Zoological Park; Forest Park; St. Louis, Missouri 63110.

34. San Diego Zoo; Box 551; San Diego, California 92112.

35. San Francisco Zoological Gardens; Zoo Road & Skyline Boulevard; San Francisco, California 94132.

36. Sea World, Inc.; 1720 South Shores Road; San Diego, California 92109.

37. John G. Shedd Aquarium; 1200 South Lake Shore Drive; Chicago, Illinois 60605.

38. Steinhart Aquarium; Golden Gate Park; San Francisco, California 94118.

39. United States National Arboretum; Washington, D.C. 20002.

USEFUL BOOKS

The following selected bibliography is designed to expand your horizons on the two levels with which this book commenced—that of naturalist and that of photographer. For your convenience and more ready reference, the bibliography has been divided into those two general, but commonly overlapping, themes.

Nature

BROWNING, NORMA LEE, and OGG, RUSSELL. *He Saw a Hummingbird.* New York: E. P. Dutton & Co., Inc., 1978.

EISELEY, LOREN. *The Immense Journey.* New York: Random House, Inc., 1957.

————.*The Unexpected Universe.* New York: Harcourt Brace Jovanovich, Inc., 1968.

EVANS, HOWARD. *Life on a Little-Known Planet.* New York: E. P. Dutton & Co., Inc., 1966.

KRUTCH, JOSEPH WOOD. *The Desert Year.* New York: William Sloane Associates, 1952.

LEWIS, H. L. *Butterflies of the World.* Chicago: Follett Corporation, 1973.

LINE, LES. *The Audubon Society Book of Wildflowers.* New York: Harry N. Abrams, Inc., 1978.

LINE, LES, and RICCIUTI, EDWARD. *The Audubon Society Book of Wild Animals.* New York: Harry N. Abrams, Inc., 1977.

MILNE, LORUS and MARGERY. *The Nature of Life.* New York: Crown Publishers, Inc., 1972.

OSOLINSKI, STAN. *Michigan.* Portland, Ore.: Graphic Arts Center, 1977.

THE READER'S DIGEST ASSOCIATION. *America the Beautiful.* Pleasantville, N.Y., 1970.

THE READER'S DIGEST ASSOCIATION. *Our Amazing World of Nature.* Pleasantville, N.Y., 1969.

THE READER'S DIGEST ASSOCIATION. *Our Magnificent Wildlife.* Pleasantville, N.Y., 1975.

RICCIUTI, EDWARD R. *Wildlife of the Mountains.* New York: Harry N. Abrams, Inc., 1979.

SANDERSON, IVAN T. *The Continent We Live On.* New York: Random House, Inc., 1961.

SCOFIELD, MICHAEL. *The Complete Outfitting & Source Book for Bird Watching.* Marshall, Cal.: The Great Outdoors Trading Company, 1978.

SHUTTLESWORTH, DOROTHY. *Exploring Nature with Your Child.* New York: Harry N. Abrams, Inc., 1977.

SUTTON, ANN and MYRON. *Wildlife of the Forest.* New York: Harry N. Abrams, Inc., 1979.

TIME, INC. *Life Nature Library.* New York, 1963.

Photography

AUER, MICHAEL. *The Illustrated History of the Camera.* Boston: New York Graphic Society, 1975.

BAUER, ERWIN A. *Hunting with a Camera.* New York: Winchester Press, 1974.

BAUER, ERWIN and PEGGY. *Outdoor Photographer's Digest.* Northfield, Ill. DBI Books, 1975.

BAUFLE, JEAN-MARIA, and VARIN, JEAN-PHILIPPE. *Photographing Wildlife.* New York: Oxford University Press, 1972.

DANZIGER, JAMES. *Interviews with Master Photographers.* New York: Paddington Press, Ltd., 1977.

FEININGER, ANDREAS. *Trees.* New York: The Viking Press, 1968.

FROBISCH, DIETER, and LAMPRECHT, HARTMUT. *Graphic Photo Design.* Garden City, N.Y.: Amphoto, 1977.

HATTERSLEY, RALPH. *Photographic Lighting: Learning to See.* Englewood Cliffs, N.J.: Prentice-Hall, Inc., 1979.

HEDGECOE, JOHN. *The Book of Photography.* New York: Alfred A. Knopf, Inc., 1976.

HOLLAND, JOHN. *Photo Decor: A Guide to the Enjoyment of Photographic Art.* Rochester, N.Y.: Eastman Kodak Company, 1978.

KINNE, RUSS. *The Complete Book of Nature Photography.* Rochester, N.Y.: Eastman Kodak Company, 1979.

KODAK, EASTMAN COMPANY. *The Joy of Photography.* Rochester, N.Y.: Eastman Kodak Company, 1979.

MUYBRIDGE, EADWEARD. *Animals in Motion.* New York: Dover Publications, Inc., 1957.

SCHARF, AARON. *Art and Photography.* New York: The Penguin Press, 1969.

————. *Pioneers of Photography.* New York: Harry N. Abrams, Inc., 1976.

TIME, INC. *Life Library of Photography.* Alexandria, Va., 1971.

WARNER, LEONARD J. *Mammal Photography and Observation.* New York: Academic Press, Inc., 1978.

WILSON, ARNOLD. *Creative Techniques in Nature Photography.* New York: J. B. Lippincott Company, 1979.

Index